LORETTE WILMOT LIBRARY
Nazareth College of Rochester

Dr. & Mrs. Lynn Selke

PISSARRO

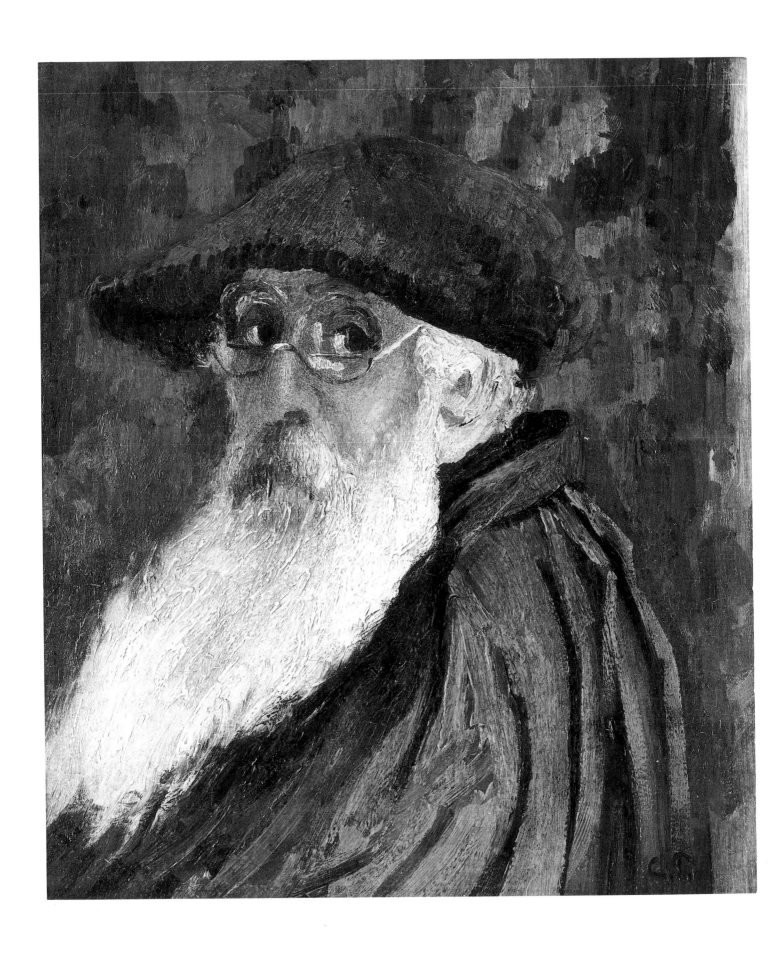

CAMILLE

PISSARRO

JOHN REWALD

———————

HARRY N. ABRAMS, INC., *Publishers*, NEW YORK

Frontispiece: *Self-Portrait.* c. 1898.
Oil on canvas, 13³/₄ × 12⁵/₈″. Private collection

Library of Congress Cataloging-in-Publication Data

Pissarro, Camille, 1830–1903.
 Camille Pissarro / [text by] John Rewald.
 p. cm.
 Bibliography: p.
 ISBN 0–8109–1499–9 : $19.95
 1. Pissarro, Camille, 1830–1903. 2. Artists — France — Biography.
 3. Impressionism (Art) — France. I. Rewald, John, 1912–
 II. Title.
 N6853.P57P58 1989
 759.4–dc19
 [B] 88–39296

Published in 1989 by Harry N. Abrams, Incorporated, New York
This is a concise edition of John Rewald's *Pissarro,* originally published
in 1963. No part of the contents of this book may be reproduced
without the written permission of the publisher

A Times Mirror Company

Printed and bound in Japan

CONTENTS

CAMILLE PISSARRO 9

COLORPLATES

QUAY AND BRIDGE AT PONTOISE *The Tel Aviv Museum* 49

STILL LIFE *The Toledo Museum of Art* 51

THE CÔTE DU JALLAIS NEAR PONTOISE *The Metropolitan Museum of Art, New York* 53

LOUVECIENNES, THE ROAD TO VERSAILLES *Emil G. Bührle Collection, Zurich* 55

THE ROAD TO ROCQUENCOURT *Private collection, New York* 57

SNOW AT LOUVECIENNES *Museum Folkwang, Essen* 59

ENTRANCE TO THE VILLAGE OF VOISINS *Musée d'Orsay, Paris* 61

CHESTNUT TREES AT LOUVECIENNES
 Collection Mr. and Mrs. Alex M. Lewyt, New York 63

PORTRAIT OF MINETTE *Wadsworth Atheneum, Hartford, Connecticut* 65

THE ARTIST'S DAUGHTER *Yale University Art Gallery, New Haven* 67

BOUQUET OF FLOWERS *High Museum, Atlanta* 69

SELF-PORTRAIT *Musée d'Orsay, Paris* 71

THE OISE NEAR PONTOISE
 Sterling and Francine Clark Art Institute, Williamstown, Massachusetts 73

THE HAYSTACK, PONTOISE *Collection Durand-Ruel, Paris* 75

QUARRY NEAR PONTOISE *Kunstmuseum, Basel* 77

THE CLIMBING PATH AT THE HERMITAGE, PONTOISE
 The Brooklyn Museum, New York 79

HARVEST AT MONTFOUCAULT, BRITTANY *Musée d'Orsay, Paris* 81

ORCHARD WITH FLOWERING FRUIT TREES, SPRINGTIME, PONTOISE
 Musée d'Orsay, Paris 83

THE RED ROOFS, VIEW OF A VILLAGE IN WINTER *Musée d'Orsay, Paris* *85*

PARK IN PONTOISE *Collection Mr. and Mrs. Benjamin M. Reeves, New York* *87*

STREET SCENE, PONTOISE *Private Collection* *89*

CHAPONVAL LANDSCAPE *Musée d'Orsay, Paris* *91*

LA MÉRE LARCHÉVÉQUE *Metropolitan Museum of Art, New York* *93*

PEASANT GIRL WITH A STICK *Musée d'Orsay, Paris* *95*

PEASANT WOMAN *National Gallery of Art, Washington, D.C.* *97*

THE APPLE PICKERS *Collection Mrs. Melvin Hall, New York* *99*

YOUNG PEASANT WOMAN TAKING HER MORNING COFFEE
 The Art Institute of Chicago *101*

PORTRAIT OF FELIX *The Tate Gallery, London* *103*

WOMAN AND CHILD AT A WELL *The Art Institute of Chicago* *105*

THE LITTLE COUNTRY MAID *The Tate Gallery, London* *107*

THE PORK BUTCHER—MARKET SCENE *The Tate Gallery, London* *109*

RIVER—EARLY MORNING *The John G. Johnson Collection (Philadelphia Museum of Art)* *111*

BATHER IN THE WOODS *The Metropolitan Museum of Art, New York* *113*

ROOFS OF OLD ROUEN IN GRAY WEATHER (THE CATHEDRAL)
 The Toledo Museum of Art *115*

THE YOUNG MAID *Collection David Bensusan Butt, London* *117*

BOULEVARD DES ITALIENS, PARIS—MORNING, SUNLIGHT
 National Gallery of Art, Washington, D.C. *119*

PLACE DU THÉÂTRE FRANÇAIS, PARIS, IN THE RAIN
 The Minneapolis Institute of Arts *121*

RUE DE L'ÉPICERIE *Metropolitan Museum of Art, New York* *123*

THE SEINE AND THE PONT DES ARTS, PARIS *Kunstmuseum, Basel* *125*

THE PONT ROYAL AND THE PAVILLON DE FLORE, PARIS
 Musée du Petit Palais, Paris *127*

SELECTED BIBLIOGRAPHY *128*

TO THE MEMORY OF

MY FRIENDS

LUDOVIC-RODO PISSARRO

LUCIEN AND ESTHER PISSARRO

C. Pissarro.

IN AN ADMIRABLE POEM devoted to the beacons of humanity Baudelaire has extolled the genius of Rubens, Leonardo, and Rembrandt, of Michelangelo, Puget, and Watteau, of Goya and, finally, of Delacroix. Yet the history of great achievements does not consist of such towering masters alone; it is an uninterrupted chain where the great link hands with the small, where anonymous creators pass the torch to little-known followers who carry it on until some glorious successor invests it with a new and even brighter light. Few phases in this constant conquest of new horizons have been more fascinating and more lively than that of nineteenth-century France. This period began quietly enough in the very days during which Baudelaire wrote his *Flowers of Evil*, but soon it was to produce some of the most salient figures of modern art. Toward the middle of the century their endeavors and clashes, their accomplishments and contradictions were to offer an amazing picture of both vigor and confusion out of which emerged a new style now famous under the name of Impressionism.

Camille Pissarro was the dean of the Impressionist painters, not only because of his age—he was two years older than Manet, who at first put himself at the head of the new movement—but also by virtue of his wisdom and his balanced, kind, and warmhearted personality. While he had no ambition to be a leader and actually was careful to avoid playing a prominent role, he seems to have been the only one who, during heated debates, quarrels, or misunderstandings, was able to rise above petty resentments, prejudices, or hurt pride, and concentrate on the goal he and his friends

were pursuing: the development of a personal vision and of a style capable of rendering their observations of nature, in other words, the assertion of their freedom of expression. Yet he would not have exerted so benevolent an influence on his comrades had he not also been an excellent and modest artist whom they respected and admired. What made his position a particularly central one was the fact that at the outset he absorbed the teachings of his great forerunners, that he always remained accessible to new ideas, that he encouraged those around him in whom unfailingly he

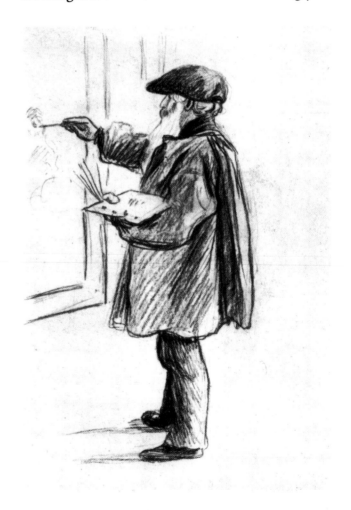

Lucien Pissarro: CAMILLE PISSARRO PAINTING.
About 1885. Conté crayon drawing.
Formerly collection Miss Orovida C. Pissarro, London

9

Saint Thomas Harbor. *Photograph by the author*

By force of circumstances Camille Pissarro was accustomed to speak several languages as a child: French with his parents, Spanish with the Negro population of the island, and also English. (He does not seem to have spoken Danish, the official idiom of Saint Thomas.) Anxious for him not to lose contact with France, his parents decided to send the youth to Paris where, at the age of twelve, he began to study in a small boarding school. The director, a painter of sorts, strongly encouraged the young student's penchant for art; when his pupil was called home after five years, he earnestly counseled him to take "advantage of his life in the tropics by drawing coconut trees," a piece of advice Pissarro followed scrupulously.

Upon his return to Saint Thomas at seventeen, Pissarro became a clerk in his father's store, which was on the ground floor of the house in which the family lived and in which he himself had been born. Though the young clerk had absolutely no taste for business, he received, as he later acknowledged, quite a decent salary. He devoted all his spare time to making sketches, not only of coconut trees and other exotic plants, but also of the daily life surrounding him. Time and again he drew the donkeys and their carts on the sunny roads, the Negro women doing their wash on the beaches or carrying jugs, baskets, or bundles on their heads. In these studies done from life he revealed himself to be a simple and sincere observer.

Whenever his father sent him to the port to supervise arrivals, the young man took his sketchbook with him. While entering the boxes and crates that were being unloaded, he also made drawings of the animated life of the harbor with its sailboats gliding along the blue waters, coasting large, verdure-covered rocks capped by Danish citadels. For five years the budding artist thus struggled between his daily chores and the urge of his avocation. Since he could not obtain permission to devote himself to painting, he ran away one day, leaving a note for his parents. In the company of Fritz Melbye, a Danish painter from Copenhagen whom he had met while sketching in the port, he sailed to Venezuela. As he later said, he "bolted to Caracas in order to get clear of the bondage of bourgeois life." His new friend Melbye now initiated him to the use of color; Pissarro's first paintings and watercolors were made in Venezuela where he also executed count-

discerned originality and promise, and that, at one point, he actually joined forces with the next generation. At the same time he freely admitted mistakes and relentlessly searched to perfect his work, never succumbing to routine, but retaining to the last an admirable freshness of eye and spirit.

Born July 10, 1830, on the Virgin Island of Saint Thomas (which was then Danish territory), Pissarro was the son of a fairly prosperous merchant whose general store was not far from the active and picturesque little harbor of Charlotte Amalie, "capital" of the small island. In 1799 his grandfather, Joseph Pissarro, born in Bordeaux of a Spanish-Jewish family which for generations had been living in or near that city, had married Anne Félicité Petit, a young Parisian fugitive from the French Revolution. A few years later, accompanied by his wife, their children, and his brother-in-law, Isaac Petit, he left France to settle permanently in Saint Thomas. There, Isaac Petit successively married two sisters, Esther and Rachel Manzano-Pomié, also of Spanish descent, though born on the island of Dominica, which was French at the time. After his death, his widow, Rachel, married again in 1826, this time her own nephew, Abraham Gabriel Pissarro, son of Joseph Pissarro and Anne Félicité Petit. Born in Bordeaux in 1802 before his parents set out for the Virgin Islands, he was seven years younger than his aunt and wife by whom he had four sons; the last of these, Jacob, was to choose the first name of Camille.

less drawings in pencil, ink, and wash. Many of these are still dated and annotated in Spanish. Even the form of his name is Spanish, for he often signed *Pizarro*.

The young painter's parents finally accepted the inevitable and agreed to let him go back to France, there to devote himself entirely to the study of art. Thus in the fall of 1855 Camille Pissarro returned to Paris, arriving in time to visit the huge World's Fair where thousands of canvases by artists from many countries had been assembled. In the maze of these innumerable paintings, most of which remained coyly within the limits of trusted formulas and successful recipes, the new arrival soon singled out the few individuals who dared to stray from academic precepts. He was impressed with the works of Courbet, Daubigny, Millet, and Corot. He even went to see the latter who received him kindly and offered to provide occasional advice. (Pissarro seems to have been less attracted by Delacroix and did not try to approach his pupil Chassériau, with whose father, a French consul at Saint Thomas, his own father had done business.)

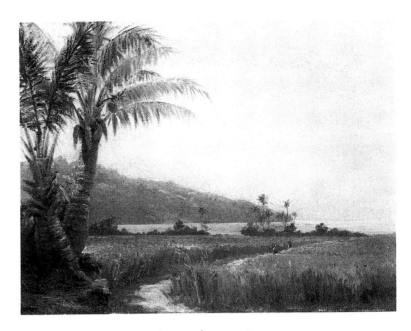

TROPICAL LANDSCAPE. Painted in Paris, 1856. Oil on canvas
Private collection, Washington, D.C.

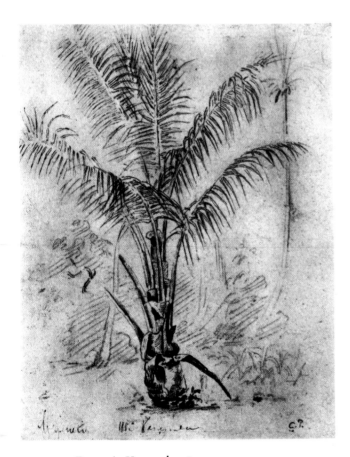

PALM TREE. Drawn in Venezuela, 1853
Pencil. *Formerly Collection Ludovic-Rodolphe Pissarro, Paris*

Pissarro also made the acquaintance of Fritz Melbye's brother Anton, then a well-known painter of seascapes living in Paris, in whose company he began to work. The first pictures he painted in France still bore the imprint of his memories of the West Indies and of Venezuela, though their conventional conception hardly reveals their author's familiarity with his exotic subjects. Soon, however, Pissarro was to turn his back on these picturesque recollections, to study the world around him, a life which—while not completely new to him—nevertheless showed many enticing contrasts with the surroundings he had left behind. In doing so, he found himself thrown into the controversy of academism versus romanticism, of idealism versus realism that was then raging in the Parisian schools and studios.

In order to satisfy his father who obviously wanted his son properly to learn his trade in preparation for a rewarding artistic career, Pissarro seems to have enrolled in the classes of various academic masters where he had occasion to work from live models. But the uninspired teaching of these men and the stifling atmosphere of their courses quickly prompted him to look elsewhere for instruction. The instinct that had driven the inexperienced newcomer to single out Corot for special admiration was also to guide his first attempts toward a personal expression. While he was sensitive to Corot's naïveté and his poetic concept of nature, he

LANDSCAPE. About 1860. Oil on canvas
Collection Dr. John Burton, London

THE ROAD. About 1864. Oil on canvas
Collection Gordon Pollock, New York

was equally taken with Millet's straightforward albeit somewhat sentimental rendition of rural life and was even more attracted by Courbet's almost brutal statements of pictorial truth. Of the painters who impressed young Pissarro, Courbet was the most vociferous and the one most violently discussed.

Courbet was raising his battle cry for a return to everyday reality at a time when academic despotism threatened to smother spontaneity and abolish all intimate contact with nature. Though Corot and his friends of the Barbizon group, laboring in their quiet retreat in Fontainebleau forest, had endeavored to approach nature with open eyes, they had frequently synthetized their impressions rather than portrayed their subjects faithfully. But their attitude, while less radical than Courbet's, was still in complete opposition to the traditional precepts then in vogue, which prescribed that landscapes be conceived as highly idealized sites and demanded that "the artist compose vistas from a *choice* of the most beautiful and the grandest aspects of nature, introducing into them figures whose action is susceptible vividly to interest the spectator,

to inspire him with noble sentiments or to encourage the soaring flights of his imagination." Courbet, in contrast, proclaimed that the beauties of nature need not be passed through a filter of literary or sentimental inspiration, that they should be allowed to appeal directly to the onlooker through the forcefulness and veracity of the artist's rendition, transmitting nature's message without adulteration.

Courbet's position attracted most of the unconventional painters of the young generation but was by no means the uncontested tendency of the times. Courbet's friend Baudelaire, for instance, when requested in 1855 by a fellow poet to contribute an essay to a book on Fontainebleau, replied:

"You ask me . . . for verses on the subject of *Nature*, don't you? On woods, large oak trees, verdure, insects, the sun, no doubt? Yet you know very well that I am incapable of being moved by vegetation and that my soul is in rebellion against that peculiar new religion which will always have, it seems to me, something hard to describe but *shocking* for every *spiritual* being. I shall never believe that the *soul of the gods resides in*

plants; and even should it reside there, I would care only moderately and would consider my own of a much higher value than that of *sanctified vegetables.* I have actually always thought that in flourishing and rejuvenated *Nature* there was something distressing, hard, cruel—something undefinable that borders on impudence. . . . In the thick of woodlands . . . under those arches resembling the ones of sacristies and cathedrals, I am reminded of our astonishing cities, and the prodigious music that rolls along on the summits seems to me to be the translation of human lamentations."

This, then, was the situation that confronted the young Pissarro: he could adopt the road of least resistance, submit to convention and study nature for the purpose of creating "ennobling" images; he could follow Courbet, Corot, and all those who were discovering in nature the source of a direct, pictorial inspiration without any anecdotal preoccupations; or he could turn his back on nature so as to explore man and his fertile mind, a mind that was then embarking upon the industrial revolution, ready to open untold new possibilities to humanity.

It does not seem that Pissarro hesitated long. Whatever he had produced until then, and impersonal though his work may have been at first, he must have sensed quickly that only the humble contemplation of nature would permit him to develop the gifts of which he felt himself possessed. Within a year after his arrival in Paris he began to leave the city—where he shared a studio with a friend—in order to paint in the countryside. When, in 1859, he was admitted for the first time to the Salon, he sent a scene from Montmorency near

ROAD BY THE MARNE RIVER
NEAR LA VARENNE–SAINT-HILAIRE
1864. Oil on canvas. *Maryland Institute (G. A. Lucas Collection), on loan to the Baltimore Museum of Art*

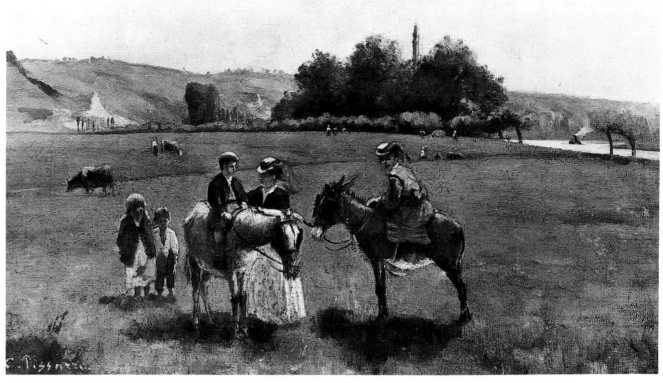

DONKEY RIDE NEAR LA ROCHE-GUYON. 1864–65. Oil on canvas. *Collection Robert von Hirsch, Basel*

Pontoise, famous for its forests. In the catalogue he designated himself "pupil of A. Melbye." That he soon left the well-trodden path of conventional landscape painting is confirmed by the fact that he was rejected by the juries of the next two Salons, in 1861 and 1863 (only after that latter year, marked by the famous Salon des Refusés, were these exhibitions held annually). Pissarro was, among those who showed at the Salon des Refusés, thus establishing clearly that he did not intend to compromise with the requirements of his academic judges, preferring instead to join openly the rebels who were gathering around Courbet and a younger newcomer, Manet.

Whereas Manet had by then achieved a reputation that left him no choice but to participate in the protest exhibition rather than bow to the prejudices of the jury, Pissarro was still an uncommitted beginner who had as yet to create a name for himself. That he so courageously asserted his independence shows how early he traced the road he wished to follow despite the difficulties sure to lie ahead. It also shows that, his

mildness of manners and discretion as an artist notwithstanding, he stood firm where questions of principle were concerned. Since the Salon jury was an altogether objectionable institution and since its biased verdicts endangered all free expression, only one position could be taken, even though this might mean further and disastrous ostracism. Pissarro unhesitatingly took a stand, doing so without grandiloquent poses, just as, later in life, he always followed without deviation the dictates of his conscience rather than the promises of opportunity. And this was particularly praiseworthy because he was not of independent means, as was Manet. Quite the contrary, he was poor, already burdened with responsibilities, and faced with the prospect of being cut off by his parents from whatever support they could give him.

Pissarro's parents had left Saint Thomas a few years after their youngest son's arrival in France. Entrusting their business to a caretaker, they had also settled in Paris. There his mother had engaged a young servant, Julie Vellay, born in Burgundy in 1838. She was eight

years younger than the painter, to whom she bore a child in February 1863, their first son, Lucien. The artist's parents were distressed by this *mésalliance*. His father refused to continue his allowance, but his mother apparently succeeded in providing irregular remittances. Camille Pissarro moved with his small family to La Varenne-Saint-Hilaire on the banks of the Marne, not far from Paris, trying hard to make ends meet. Julie Vellay did not spare herself and often helped harvesters in the field to earn what little money she could.

With a child born a few months before the opening of the Salon des Refusés, Pissarro needed success, but he was not to be spoiled by fate. Some benevolent reviewers of the exhibition did mention his name among those painters whose works they had noticed, that was all. The only encouraging words came from an ardent supporter of new tendencies, Castagnary, who devoted a few lines to Pissarro, saying: "Since I cannot find his name in the catalogue of the preceding Salon [where Pissarro's entries had been rejected], I suppose

that this artist is a young man. Corot's style seems to please him; that is a good master, Monsieur. One should be careful, however, not to imitate him."

It is true that Pissarro had gone periodically to see Corot, had shown him his pictures and asked for his opinion. Corot immediately realized that the young painter was striving for a personal expression and told him: "Since you are an artist, you don't need advice. Except for this: above all one must study values. We don't see in the same way; you see green and I see gray and 'blond.' But this is no reason for you not to work at values, for that is the basis of everything, and in whatever way one may feel and express oneself, one cannot do good painting without it."

In spite of the fact that Pissarro's colors were more pronounced, less silvery than those of his self-chosen master, Corot authorized him to consider himself his pupil. Thus it came about that for the following two years, 1864 and 1865, Pissarro could designate himself in the catalogues of the Salon (where each time two of

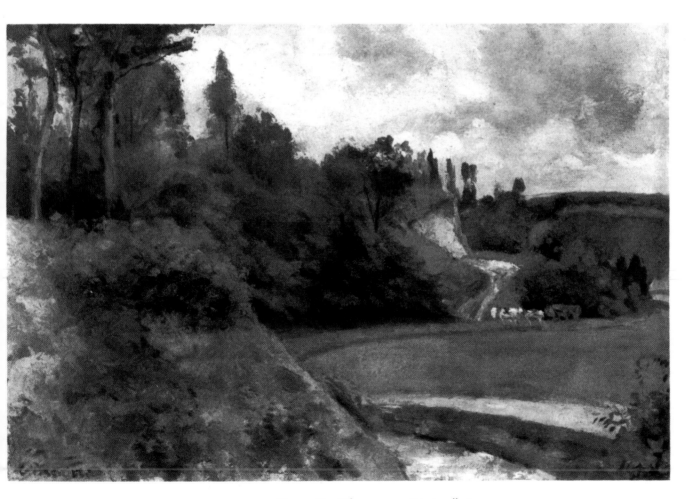

LANDSCAPE. About 1867. Oil on canvas. *Private collection*

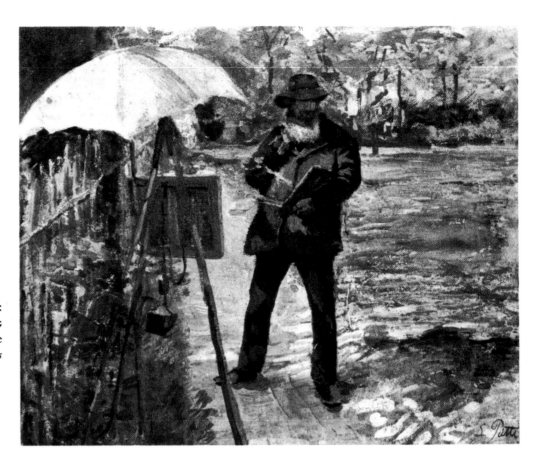

Ludovic Piette:
CAMILLE PISSARRO PAINTING
About 1870? Gouache
Formerly Collection Bonin-Pissarro, Paris

his landscapes were admitted) "pupil of A. Melbye and
C. Corot." But in 1866 he dropped the mention of
Corot as his teacher. It is not known exactly what
happened, except that the young painter had quarreled
with the old master, doubtless because Corot did not
approve of his evolution toward a more realistic style,
derived from Courbet rather than from his own more
poetic interpretation of nature. Having been turned
down by the jury in 1867, Pissarro, the next year,
finally ceased calling himself a pupil even of Melbye.
He was now thirty-eight years old, had long since
deserted the Dane's Parisian studio and was working
in comparative isolation in the vicinity of Paris. What-
ever progress he was making was achieved through
severe self-criticism and unceasing observation of na-
ture, although Courbet's example remained vivid in
his mind. Yet he must have felt that he was no longer
a beginner and should be able to stand by his work
without any reliance on others.

Little by little Pissarro had surrounded himself with
friends, more or less of his own generation. On his
periodic visits to Paris he used to drop in at the so-
called Académie Suisse, a free studio where artists

could work for a modest fee from live models, without
being supervised or corrected. There he had met
Claude Monet, in whom he immediately discovered a
kindred soul, and there also, as early as 1861, he had
noticed the studies of a young painter from Provence
who was mocked by all the others. Cézanne was nev-
er to forget the sympathy and understanding with
which Pissarro encouraged him during his first years
in alien Paris. Soon Cézanne introduced his new
acquaintance to his friends Guillaumin and Zola. When
the latter turned to art criticism in the middle sixties,
he always inserted a few words of praise for Pissarro,
whose work Cézanne had taught him to appreciate.

While roaming about the countryside, Pissarro had
also struck up a fast friendship with Ludovic Piette, a
pupil of Courbet's. In 1864 he went with his wife and
son to visit Piette on his large farm in Mayenne and
later returned there on various occasions, particularly
when he was in financial straits and Piette's hospitality
could help him weather critical periods.

Through Monet, Pissarro met Renoir, Sisley, and
Bazille, all of whom had been Monet's fellow students
at Gleyre's in 1862–63. After being rejected by the jury

in 1867, Pissarro signed a petition with Renoir, Sisley, and Bazille for the opening of a new Salon des Refusés, but to no avail.

Those were difficult years since the hostility of the Salon juries deprived the young painters of their sole means of approaching the general public. There were no dealers interested in their works, few critics who would notice them even when admitted to the official exhibitions (and those who did were not the ones on whose judgment collectors relied), nor buyers willing to invest money in pictures—cheap though they were—by unknown artists who did not curry to their penchant for prettiness.

In 1865 Julie Vellay bore Pissarro a daughter, so that the artist's responsibilities grew despite the absence of any regular income. All he could count on, apparently, was a small remittance from his mother. Some thirty years later, when he considered his son Georges to be a little too extravagant in his expenses for fancy clothes, Camille Pissarro reminded him philosophically: "I knew a painter who had two children, a wife, and 80 francs a month to keep the pot boiling.

Just the same, that fellow and his family ate well, wearing, it's true, shoes only when they went to Paris. . . . You know that painter, and he managed . . . without luxury yet with good meat and good vegetables every day. . . . But then, times have changed!"

Even in retrospect, there was no bitterness; Pissarro was never bitter. He took calamities stoically, preserved his calm (although his wife occasionally accused him of indifference and egotism), and always remained confident that all would turn out well eventually. That life was harsh neither surprised nor discouraged him; he believed in his work and could derive at least some comfort from the knowledge that he was not alone, that he had comrades who followed a similar road while struggling against similar difficulties. He was aware, possibly more acutely than the others, that his endeavors were in keeping with the new tendencies of artistic, literary, philosophical, and even social progress, although these did not yet find general acceptance. The open or tacit resistance with which the privileged classes opposed whatever appeared unorthodox to them inspired Pissarro at an early age with rev-

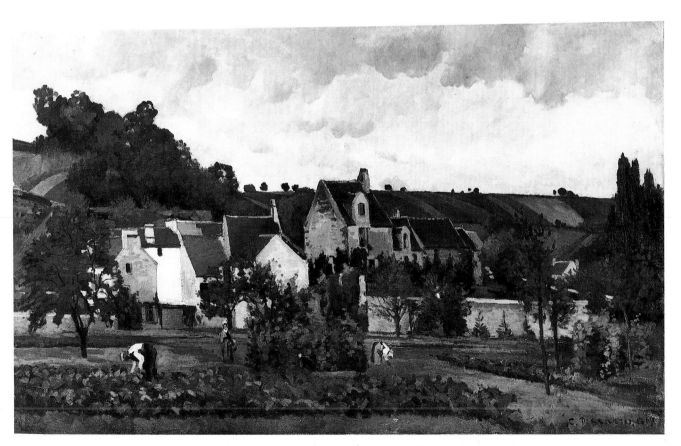

THE HERMITAGE AT PONTOISE. 1867. Oil on canvas. *Formerly Collection Mrs. Chester Beatty, London*

olutionary thoughts; though never politically active, he became an anarchist.

Serious, sometimes solemn, but not without a sense of humor, Pissarro knew how to present his views with logic as well as warmth. The others gladly listened to him at the Café Guerbois near the Place de Clichy where the painters who then formed the Batignolles Group—Manet, Degas, Renoir, Monet, Sisley, Bazille, and occasionally also Cézanne—used to gather more or less regularly in the evenings. Their discussions touched on all the problems that preoccupied the new generation, refractory to artistic and even social conventions. The abuses of the Emperor or the inefficiency of his Director of Fine Arts and the capricious judgments of the Salon juries were debated with the same eagerness as the latest articles by Zola, as the masters of the past and the fame of certain contemporaries, the importance of the recent "discovery" of Japanese prints, the role of shadows or the use of bright colors. Pissarro was more radical than some of his friends when he declared that one ought to "burn down the Louvre," do away with all traditions and pursue valiantly the creation of an art more closely linked to the present times. Anecdotal or historical subjects, then highly fashionable, were despised; one should treat modern subjects, observe contemporary society—as

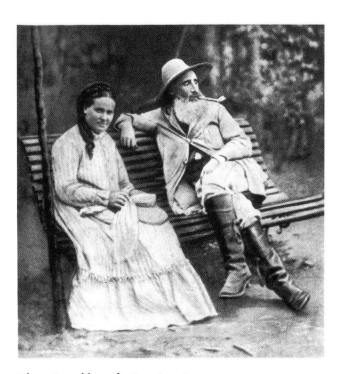

The artist and his wife, Pontoise, 1877

did Degas and Manet, the Goncourt brothers, Flaubert, and Zola—or contemplate nature with fidelity, instead of trying to beautify it or making concessions to the corrupted taste of the general public.

There can be no doubt that each of the young painters left these gatherings at the Café with a feeling of encouragement, his ideas clarified by discussions and his will power strengthened because he felt himself sustained by his comrades. The difficult and solitary hours during which works were created which as yet found no response became easier to endure after such exchanges of views, where each found himself while sensing that he was participating in a new movement. Isolated at La Varenne-Saint-Hilaire, later at Pontoise and subsequently at Louveciennes—only infrequently able to attend the reunions of his friends—Pissarro did not fail to benefit from his links with the small group. Through their meetings the painters, most of whom lived in the outskirts of Paris, were able to remain in touch with each other. Thus their convictions gained impetus and thus they gathered the energy to prepare a future which was to reserve a historic role for them.

Outside of those who were to gain celebrity as Impressionists, Pissarro was friendly with some less remarkable artists. Among them, besides Ludovic Piette, were Antoine Guillemet, pupil of Corot and Courbet and friend of Cézanne and Zola (through whom Pissarro probably became acquainted with him), Edouard Béliard, and several others. Sometimes the relationships established by discussions at the Café Guerbois were furthered even more by mutual work sessions. Monet and Renoir often put their easels in front of the same motif, and Pissarro, too, liked to paint in the company of his comrades. In 1864 he had worked with Piette; in the fall of 1867, he was invited by Guillemet to join him at La Roche-Guyon where he would find bed and board. In a letter written from Yport after a visit with Monet, Guillemet insisted: "I absolutely count on you for La Roche. Besides, you promised, didn't you? It will be marvelous for me to see again good painting and to work with a real buddy like you. I am so disgusted with the painters I meet here, all grocers and fobs. Cézanne will probably come too."

Pissarro accepted. In La Roche-Guyon he was to paint with a palette knife a small landscape of astonish-

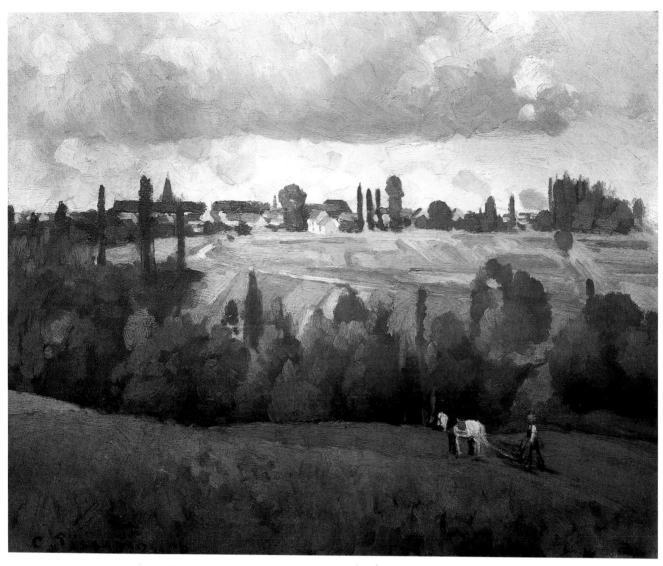

LANDSCAPE OF ENNERY NEAR PONTOISE. 1868. Oil on canvas. *Kunsthalle, Bremen*

ing synthetic daring, as well as probably a large still life executed in a similar fashion (page 51), in which he showed a firmness of design allied with a sobriety of colors which make it one of the most audacious works of his beginnings. The influence of Courbet, revealed in the concept rather than in the realization of this canvas, is the better explained by the fact that Guillemet must have spoken at length about Courbet whom he had visited at Ornans. If Cézanne really joined his two friends on this occasion, then his famous *Still Life with Black Clock*, which he was to offer to Zola, may derive its origin from those weeks spent with Pissarro and Guillemet at La Roche-Guyon.

In his landscapes of Pontoise and Louveciennes Pissarro usually showed less vigor and strength, though his draftmanship is always firm and his colorations are

sober. But instead of the palette knife, he uses brushes for an execution of hatchings and commas which delicately renders the phenomena of nature without succumbing to the minute details of his subjects. He sees his motifs broadly, establishes masses livened by vivid brush strokes, skillfully distributes accents, balances the elements of the composition and knows how to take full advantage of color schemes that—though frequently still earthy—have a tendency to become brighter in the contact with outdoor light. If, in his search, he shows less amplitude than Monet and less subtlety than Renoir, perhaps also less poetry than Sisley, he achieves, on the other hand, a sentiment of intimate communion with nature that manifests itself with soft insistence throughout his work. In the absence of facile flashiness, the application he brings to

his task is dominated by tenderness and humility. These sentiments inspire him when he contemplates and paints sites of usually modest aspects and certainly always devoid of vulgar "beauty." He favors the banks of quiet rivers, sunlit hills, green pastures and simple cottages, trees covered with snow, deserted lanes, a whole peaceful universe, near Paris, where those who work the soil live. Millet had already observed those peasants with a certain sentimentality that had not, however, prevented him from admirably seizing their gestures, but Pissarro adopted an attitude both more simple and more natural. Rather than glorifying—consciously or not—the rugged existence of the peasants, he placed them without any "pose" in their habitual surroundings, thus becoming an objective chronicler of one of the many facets of contemporary life. And notwithstanding his admiration for Courbet and the socialist views he himself held, he refused to use these subjects as a pretext for political statements. It was exclusively as a painter, a man who expresses himself through the arrangements of lines, of forms, and of colors, that Pissarro approached the motifs that the countryside around Pontoise and Louveciennes offered him with such profusion.

His life was still difficult, for his pictures did not sell easily. Père Martin, an art dealer on the Rue Laffitte, whom he met around 1868, paid 20 to 40 francs, according to size, for canvases that he sold for prices varying from 60 to 80 francs. Sisley did not obtain more and Cézanne had to be satisfied with resale prices that never went beyond 50 francs; only Monet was able to get 100 francs for his paintings from Martin. Under these circumstances and in view of the slowness with which his works found buyers, Pissarro saw himself obliged, at one time, to follow the example of Guillaumin and to paint stores in order to gain a modest sustenance. But the artist seems to have submitted to such humiliations without revolting against fate as did the impetuous Monet.

Pissarro's frugal, contemplative, and industrious life was brutally interrupted by the Franco-Prussian War. Monet left a certain number of canvases with his friend at Louveciennes before leaving for Le Havre, but soon the enemy's advance forced Pissarro to abandon his house and to take refuge with Piette at Montfoucault. He was not to remain there for long,

however, and soon joined a half-sister in London. It was in England that the artist married Julie Vellay who was to bear a third child at the end of 1871. At least he would now escape the complications that his non-conformism had created, for before his arrival at Montfoucault, for instance, Piette had had to warn him, "In order to avoid tittle-tattle . . . I must believe that you are married and you must make me believe this. It is stupid but necessary."

Life in England turned out to be even more difficult for the Pissarro family than it had been in France. It was then, out of pity for the misery of his young colleague, that Daubigny recommended him to another French refugee, Paul Durand-Ruel, who had just opened a gallery in London. The dealer purchased two of Pissarro's paintings. Thus began a relationship that was to continue even beyond the artist's death but through which Durand-Ruel—because of the interest he was soon to show for all of Pissarro's friends—came near bankruptcy before he was finally rewarded by success and fame. Although Pissarro's connections with the dealer sometimes were overshadowed by misunderstandings and resentments, it is none the less true that for many years Durand-Ruel was the only person ready to back the group of young painters and to risk his own fortune in the service of their cause.

Through Durand-Ruel, Pissarro learned that Monet also was in London. The two friends were to meet frequently from then on. Both were enthusiastic about the city, Monet working in its parks, whereas Pissarro, who lived on the outskirts, observed effects of mist, snow, and spring. Together they visited the museums and studied the works of the British landscapists. Despite the fact that they felt themselves to be closer to nature than either Turner or Constable had been, they did benefit from the acquaintance with their forerunners. Pissarro in particular was to brighten his palette considerably during his sojourn in England.

The news he received from France was not very encouraging. In February 1871 Béliard informed Pissarro that he might expect the loss of everything he had left behind at Louveciennes. A little later the wife of the owner of his house there replied to an inquiry by the artist: "You ask for information concerning your house. I can assure you the word is poorly

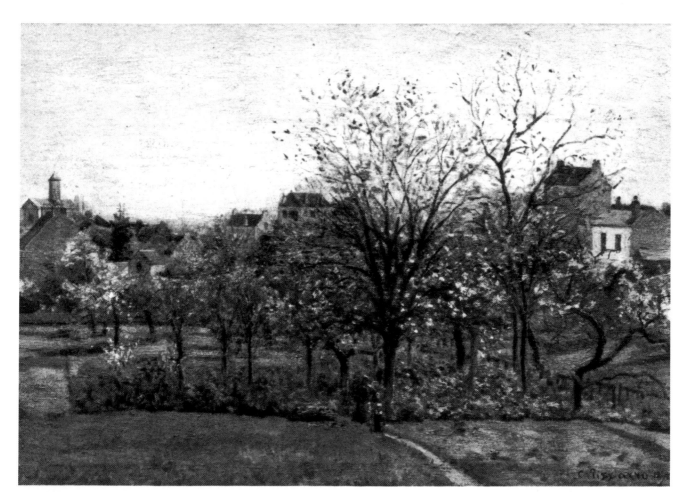

ORCHARD—SPRINGTIME. 1870. Oil on canvas. *Formerly M.A. Ryerson Collection, Chicago*

chosen: stable would be more accurate. There were two carloads of dung in it. In the small room beside the living room horses were kept; the kitchen and pantry were used as a sheepfold, the sheep being slaughtered in your garden. You may well imagine that part of the trees and flowers served for pasture. . . . The former occupants also put fire to your house. In the bedroom a beam must be replaced and repairs are necessary. . . . We have some of your furniture in our place, such as the mahogany beds, the mirrored wardrobe, the little round table, its marble broken (but all the pieces are saved), the night table, the toilet stand, a large and a small mattress, and your sideboard, but this one is very sick, one door and one side of the shelves are missing. . . . To sum it up, the Prussians have caused plenty of havoc, and certain Frenchmen too. I forgot to tell you that we have some of your pictures well taken care of, however there are a few which those gentlemen, for fear of dirtying their feet,

put on the ground in the garden; they used them as carpets. My husband has picked them up and they also are now in our house."

Subsequently Pissarro wrote from London to his friend Théodore Duret, one of the first critics to recognize his talent, that only forty of a total of fifteen hundred canvases left behind at Louveciennes had survived, but it would seem that the distance and the somber mood of the reports he was receiving caused him to exaggerate the extent of his losses. Indeed, his friends had not forgotten him and sent him long letters, yet what they had to tell was extremely depressing. As a matter of fact, Pissarro's misfortunes seemed insignificant compared to the ravages the disastrous war had caused in France. Père Martin clamored for a dictatorship, reported that during the Commune dogmeat had been sold at four francs the pound, and mentioned in a postscript that Bazille had been killed on the battlefield. Duret wrote after the

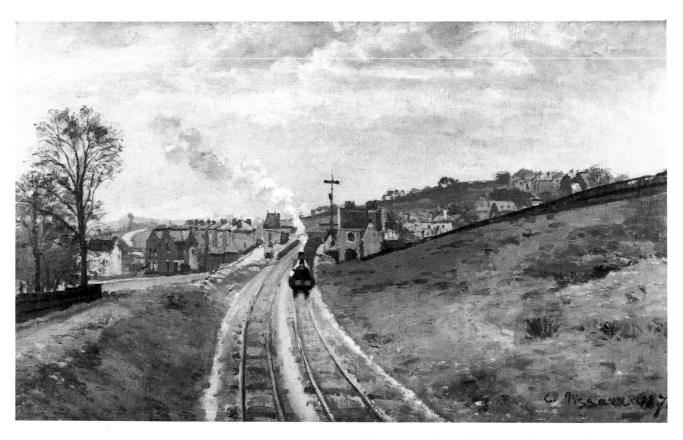

PENGE STATION, UPPER NORWOOD NEAR LONDON. 1871. Oil on canvas. *Courtauld Institute Galleries, London*

fall of the Commune: "Dread and dismay are still everywhere in Paris. Nothing like it has ever been known. . . . I have only one wish and that is to leave, to flee from Paris for a few months. . . . Paris is empty and will get still emptier. Manet, Degas, among your friends, are absent. One might think there never had been any painters and artists in Paris."

Since Duret spoke of his intention of coming to London, Pissarro hastened to inform him that, despite the bad news, he was anxious to go back to Louveciennes. "I am here for only a very short time," he replied in June. "I count on returning to France as soon as possible. Yes, my dear Duret, I shan't stay here, and it is only abroad that one feels how beautiful, great, and hospitable France is. What a difference here! One gathers only contempt, indifference, even rudeness; among colleagues there is the most egotistical jealousy and resentment. Here there is no art; everything is a question of business. As far as my private affairs, sales, are concerned, I've done nothing, except with Durand-Ruel. . . . My painting doesn't catch on, not at all; this follows me more or less everywhere."

His homesickness apparently prompted Pissarro to forget that the hostility he had met in England did not differ drastically from the way in which his pictures had been received by the French public, although it is true that enmity experienced in a foreign land is even more unbearable than that shown by one's own countrymen. By the end of June 1871 Pissarro was back in Louveciennes where his son Georges was to be born in November.

The happy feeling of being once more in France, which he considered his fatherland even though he was to remain a Danish citizen all his life, soon found its expression in the paintings he executed upon his return. They seem inspired by a contentment, confidence, and lucid enthusiasm which make it obvious that depredations and misfortunes could gain no hold on the artist who, in the contact with nature, found the strength to surmount all difficulties. The calm beauty of the landscapes he now painted, their serenity and gayer colorations did not fail to impress all his friends, while Durand-Ruel did his best—and successfully, it would appear—to defend his work. In 1872 Guillemet wrote to Pissarro after a visit to Paris:

"I have *done* the Rue Laffitte and have visited the galleries, including Durand-Ruel's. What I wanted to say is that everywhere I saw charming and really perfect things of yours and that I felt anxious to tell you this immediately. . . . Thus I saw especially at Durand-Ruel's bright and varied pictures, lively in a word, which gave me the greatest pleasure. I also saw very fine Monets and Sisleys, though perhaps penetrating nature less intimately. . . . You must be well satisfied, now that in art you have rounded the cape of tempests. You are successful in what you do and your paintings please. So much the better, and I am really happy for you."

Piette also hastened to congratulate his comrade: "You do not speak about yourself, my dear Pissarro, being as modest at the moment of victory as you were confident in your star during the days of painful struggle. Now that you are about to acquire a great name—and you certainly deserve it—money, which has such good legs when it comes to escaping the chase of us other poor runners always eagerly after its scent, money, I say, will no longer fail you. That is my hope. You will thus be able to travel while you work; why don't you come to Montfoucault?"

But Pissarro was unable to visit Piette. He had just settled in the Hermitage quarter of Pontoise where several friends, all younger than he, had come to join him. Indeed, Cézanne had finally given in to Pissarro's entreaties and moved with his little family to Pontoise; also present were Béliard and Guillaumin who, obliged to earn his livelihood by working for the Public Roads Administration, came to paint at Pissarro's side whenever he could free himself. No wonder that Pissarro, in the fall of 1872, proudly informed Guillemet: "Béliard is still with us. He is doing very serious work at Pontoise. . . . Guillaumin has just spent several days at our house; he works at painting in the daytime and at his ditchdigging in the evening, what courage! Our friend Cézanne raises our expectations and I have seen, and have at home, a painting of remarkable vigor and power. If, as I hope, he stays some time at Auvers, where he is going to live, he will astonish a lot of artists who were in too great a haste to condemn him."

Despite Cézanne's awkwardness, his indecision, and his doubts, Pissarro's confidence in his friend's genius had never faltered. During the months they spent together, Cézanne borrowed a large landscape of Louveciennes which Pissarro had painted in 1871, in order to copy it and so better to appropriate the other's technique. Frequently they worked together in the Hermitage quarter, at Valhermeil, and even, in the middle of winter, in a street of Pontoise. By the time Cézanne moved to nearby Auvers where Dr. Gachet, a friend of Pissarro's, lived, he had abandoned definitely the impetuous execution of his beginnings in favor of a patient penetration of nature which prompted him—following the example of his mentor—to "replace modeling by the study of tones."

Surrounded by companions whose progress enchanted him, Pissarro himself was working enthusiastically, the more so since success continued to reward him. In January 1873, five of his landscapes brought 270, 320, 350, 700, and 950 francs respectively at a Parisian auction sale; these prices were rather high and caused a good deal of comment. Delighted, the painter wrote his friend Duret: "The reactions from the public sale are making themselves felt as far as Pontoise. People are very surprised that a picture of mine could go for as much as 950 francs; it was even said that this is astonishing for a straight landscape."

When Duret congratulated him, Pissarro replied by speaking not only for himself but for all his comrades: "You are right, my dear Duret, we are beginning to make our breakthrough. We meet a lot of opposition from certain masters, but mustn't we expect these differences of view when we arrive—as intruders—to set up our little banner in the midst of the fray? Durand-Ruel is steadfast; we hope to advance without worrying about opinion."

That was also Monet's conviction, though for a long time he had been anxious for action that would hasten the progress which, according to him, was much too slow. Convinced that the yearly Salons did not provide sufficient opportunity for the group to manifest itself in strength, Monet began, in the spring of 1873, to discuss with his friends the project of an independent exhibition, organized at the expense of the participants and opening its doors two weeks *before* the Salon so as to emphasize that this was not a manifestation of artists rejected by the jury. Pissarro and Sisley were among the first to support this plan,

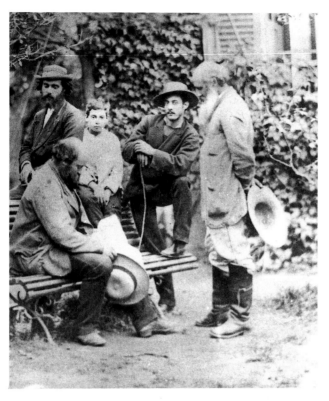

Paul Cézanne (seated) and Camille Pissarro (standing) in Pissarro's garden at Pontoise, 1877. The small boy is Lucien Pissarro

is not a shred in France. You and some other ardent, generous, and sincere spirits, you will have given a legitimate impulse. Who will follow you? The gang of incapables and blunderers. Then, as these will gain in strength, they will be the ones to abandon you. If they can manage to curry any favors with the official Salons, they will join these and become your enemies. If you add to this the responsibilities, the disgust for problems of administration, the breaches of trust committed by unscrupulous employees—for painters, like all artists, are easy to dupe—then you will be drowned in a sea of disappointments, my poor Pissarro. I would say nothing against an association restricted to people of talent, who work, are loyal, and inspired by enlightened daring, such as you and some

to which Pissarro also rallied Béliard and Guillaumin. Of the members of the Batignolles Group, only Manet refused to participate, wishing to win his combat on the battlefield of the Salon itself. But Degas and some of his friends, as well as Berthe Morisot, Renoir, and several others joined the first adherents gathered around Monet.

During the meetings that preceded the formation of the Association of Independent Painters, Pissarro read the by-laws of a corporation of bakers which he had studied at Pontoise, and participated actively in establishing the rules of the cooperative. In order completely to avoid the yoke of any jury, it was planned to admit anybody willing to pay the membership fee. Yet Piette, whom Pissarro had asked to join the organization, was very pessimistic:

"You are trying to operate a useful reform," he wrote his friend in the summer of 1873, "but it can't be done; artists are cowards. . . . Where are those who protested against the exclusion of Courbet [because of his participation in the Commune] from the exhibitions in Paris and Vienna? Should not all painters have objected massively by abstaining? Of solidarity there

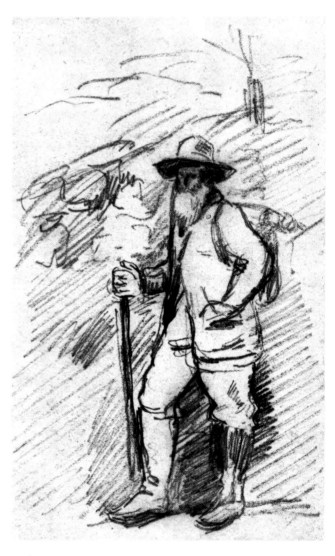

Paul Cézanne: PISSARRO ON HIS WAY TO WORK. About 1874
Pencil. *The Louvre, Paris*

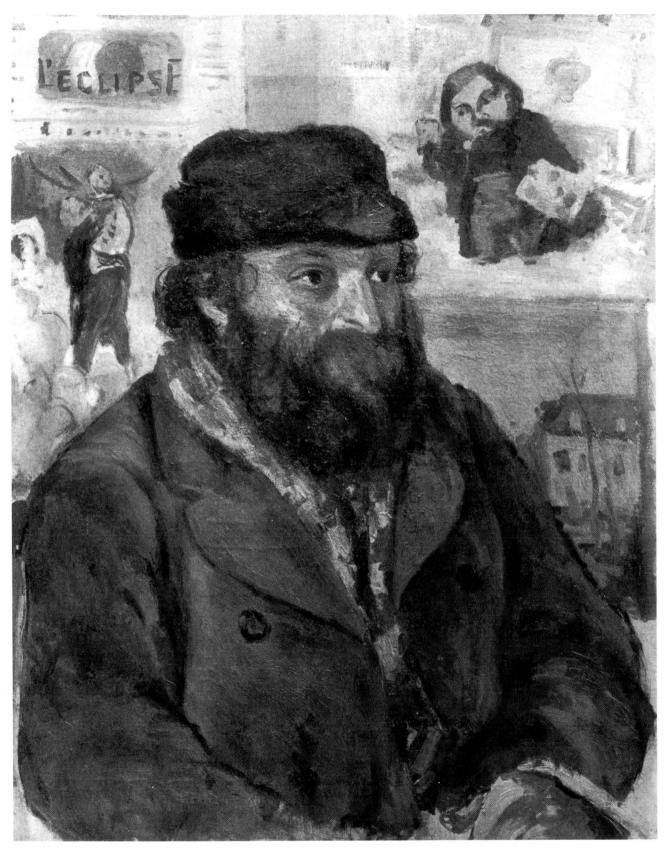

PORTRAIT OF PAUL CEZANNE. 1874. Oil on canvas. *Collection Robert von Hirsch, Basel*

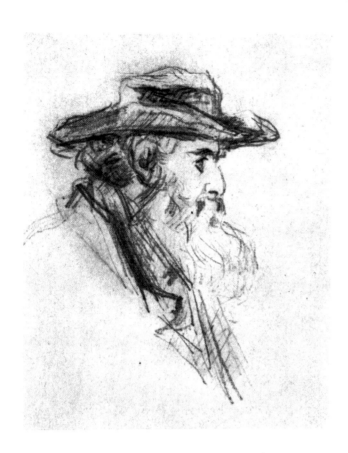

Paul Cézanne: PORTRAIT OF CAMILLE PISSARRO. About 1873
Pencil. *Private collection, New York, promised to the Louvre*

uniform group, each exhibiting a series of representative works instead of the isolated canvases they might have shown at the Salon had they been admitted to it. Just the same, Duret now adopted Manet's viewpoint and entreated Pissarro *not* to participate in Monet's venture. In February 1874 he explained to his friend:

"You still have one step to take, that is, to succeed in becoming known to the public and accepted by the dealers and art lovers. For this purpose there are only public auctions and the large exhibitions of the Salon. You possess now a group of art lovers and collectors who are devoted to you and support you. Your name is familiar to artists, critics, a specific public. But you must make one more stride and become widely known. You won't get there with exhibitions put on by special groups. The public doesn't go to such exhibitions, only the same nucleus of artists and patrons who already know you.

"The Hoschedé sale did you more good and ad-

of those around you. I would anticipate much of an association of this kind and do believe that it would be profitable and just to establish it, but I am distrustful of the mass of those idle and perfidious colleagues without moral or political convictions who only want to use others as stepping stones. It is that rabble which will be the ruin of your association and which, on the other hand, causes the destruction of France."

In order to insure a greater homogeneity of their exhibition, the adherents of the group eventually did renounce admitting participants indiscriminately and limited the show to members and to artists they invited. Not without difficulty did Pissarro—with the help of Monet—succeed in having Cézanne included.

When, at the beginning of 1874, on the occasion of the sale of Ernest Hoschedé's collection, works by Pissarro, Sisley, Monet, and Degas once more reached rather high bids, it looked as though the public was on the verge of accepting the young painters. Under these circumstances it seemed particularly opportune that they should present themselves as a more or less

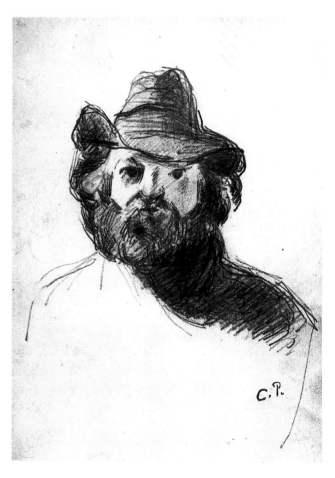

PORTRAIT OF PAUL CÉZANNE. About 1874
Pencil. *The Louvre, Paris*

vanced you further than all the special exhibitions imaginable. It brought you before a mixed and numerous audience. I urge you strongly to round that out by exhibiting this year at the Salon. Considering what the frame of mind seems to be this year, your name now being known, they won't refuse you. Besides, you can send three pictures—of the three, one or two will certainly be accepted. Among the 40,000 people who, I suppose, visit the Salon, you'll be seen by fifty dealers, patrons, critics who would never otherwise look you up and discover you. Even if you achieve only that, it will be enough. But you'll gain more, because you are now in an exceptional position in a group that is being discussed and that is beginning to be accepted, although with reservations.

"I urge you to select pictures that have a subject, something resembling a composition, pictures that are not too freshly painted, that are already a bit staid. . . . I urge you to exhibit; you must succeed in making a noise, in defying and attracting criticism, coming face to face with the big public. You won't achieve all that except at the Salon."

But if Pissarro was really, as Duret put it, at the head of a "group that is being discussed," he certainly felt no inclination to detach himself from that group in order to exploit the vein that his friend tried to make so attractive. He was bent less on pushing his own career (by choosing canvases likely to please the jury) than on participating in an act of protest and of faith, such as his comrades prepared. Pissarro therefore did not follow Duret's advice. His place was with Monet and the others, their ideas were his and so was their goal; if their initiative should prove unsuccessful, he would share their fate. After all, the exhibition of the group, which was to open on April 15, 1874, was not merely a matter of opportunism; it involved the principle of freedom of expression. Not for one minute could Pissarro consider deserting the others on this fine occasion.

Although deeply affected by the loss of his daughter Jeanne who had died late in March 1874 at the age of nine, Pissarro was ready to take his place beside Monet, Renoir, Sisley, Béliard, Guillaumin, Degas, Cézanne, Berthe Morisot, and their associates. He did so without any fanfaronade, as the simple duty of a man guided by his convictions, participating with five landscapes

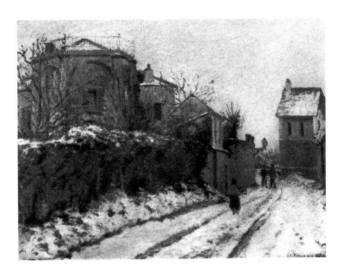

STREET IN PONTOISE, WINTER. 1873. Oil on canvas
Formerly collection Sheldon Whitehouse, New York

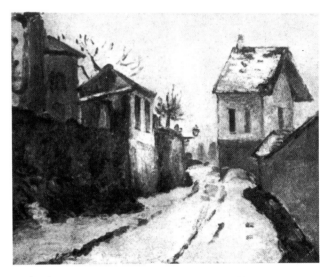

Paul Cézanne: STREET IN PONTOISE, WINTER. 1873
Oil on canvas. *Collection Bernheim-Jeune, Paris*

in the first and historic exhibition of the little group.

Pissarro earned his full share of the sallies and jests which this courageous manifestation provoked. It was this show that prompted a particularly witty reviewer to mock the *impressionist* painters, thus coining a word under which the exhibitors were to enter into History. There was a profusion of articles describing the event as an absurdity, a trick invented by a few daubers to attract the public's attention at any price, although this public, as the critics stated with satisfaction, was in no mood to be taken in by these practical jokers. Even the few critics enlightened enough to concede that the endeavors of the group deserved to be taken

27

seriously and were not without merits, became irresolute when analyzing individual works. Castagnary, for instance, who had always been favorably inclined toward new and original efforts, commented:

"On the ashes of Cabanel and Gérôme I swear that here is talent, and even much talent. These youths have a way of understanding nature which is neither boring nor banal. It is lively, sharp, light; it is delightful. What quick intelligence of the object and what amusing brushwork! True, it is summary, but how just the indications are!" Yet, when studying Pissarro's contribution, he moderated his hesitant praise:

"Pissarro," he wrote, "is sober and strong. His synthetizing eye seizes up the whole at a draught. But he makes the mistake of reproducing on the soil shadows cast by the trees that are placed outside his subject and whose existence the spectator thus must deduce, not being able to perceive them. He also has a deplorable liking for truck gardens and does not shrink from any presentation of cabbages or other domestic vegetables. Yet these defects of logic or these vulgarities of taste do not detract from his fine technical qualities. In his *Morning in June* one is forced to commend without reservations the force that grouped the various elements of the landscape and the masterly execution with which he has harmoniously balanced the volumes."

Ill-supported by the few who sympathized with their efforts, while their numerous adversaries preferred facile scoffing to serious discussions, the small phalanx of painters emerged in a rather sad state from this first test. Instead of having made any progress in their quest for recognition, they had gathered ridicule, at least in the press and in public opinion. The consequences were simple enough: buyers showed themselves reluctant. And when the time for accounting came, some of the exhibitors had not even gained the price of their annual contribution, which amounted to 61.25 francs. Whereas Sisley sold 1000 francs worth of paintings, Monet earned only 200, Renoir 180, and Pissarro but 130, less a ten per cent commission charged by the association. Degas and Berthe Morisot, among others, did not sell anything, but they at least did not have to depend on sales for their livelihood. Once exterior debts were paid, the association still found itself with a debt of 3,436 francs, which meant

that each member owed 184.50 francs to the organization. Under these circumstances the liquidation of the co-operative became an urgent matter; it was proposed to a general meeting, was voted upon, and unanimously decided.

Not having participated in the exhibition, Piette—ruined by the War and the Commune—had retired to his farm in Montfoucault and knew nothing about these events when he wrote his friend: "And you, my poor old fighter, young in spirit despite your hair turned white too early, what has become of your attempt so well begun, I mean your association and your exhibition? I want to know about the financial success since you were assured of the other. Have your receipts covered the expenses? . . . I hope, my dear Pissarro, that you are not as hard up as I am. . . . But if an inimical fortune is harassing you, too, then at least you should come here: we could make excursions in my horsedrawn buggy and will find new motifs in the surroundings." This time Pissarro was eager to accept the invitation; he went to spend the fall and winter in Mayenne where he worked, however, with little enthusiasm, although he made a valiant effort to overcome his disappointment.

Pissarro was greatly disturbed by the failure of the exhibition. In April 1874 one of his landscapes had still fetched 580 francs at an auction, but now Père Martin did not hesitate to say everywhere that Pissarro was "lost," that he had no chance of getting out of the rut if he persisted in painting so vulgarly (the word was obviously lifted from Castagnary's comments), so heavily, and with his "muddy palette." Rather than insist on the fact that he had actually counseled against the venture, Duret tried to cheer up his friend as best he could:

"After quite a long time," he wrote in June, "you have succeeded in acquiring a public of select and tasteful art lovers, but they are not the rich patrons who pay big prices. In this small world, you will find buyers in the 300-, 400-, 600-franc class. I am afraid that before getting to where you will readily sell for 1,500 and 2,000, you will need to wait many years. Corot had to reach seventy-five to have his pictures get beyond the 1,000-franc note. . . . The public doesn't like, doesn't understand good painting; the medal is given to Gérôme, Corot is left behind. People

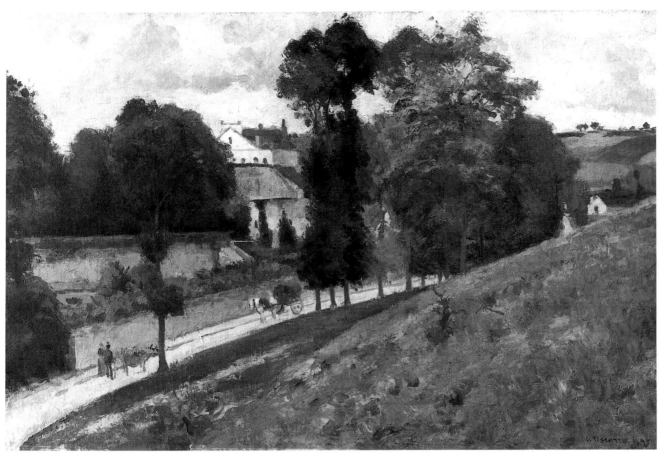

THE HERMITAGE, PONTOISE—ROAD FROM SAINT-ANTOINE. 1875. Oil on canvas. *Formerly Collection A. Cassirer, Berlin*

who know what it's all about and who defy ridicule and disdain are few, and very few of them are millionaires. Which doesn't mean that you should be discouraged. Everything is achieved in the end, even fame and fortune; in the meantime the judgment of connoisseurs and friends compensates you for the neglect of the stupid."

Yet it was not easy to wait for better days when one had to provide for a family and felt nothing but scorn everywhere. Moreover, the conditions of daily life were becoming increasingly difficult. France was in the throes of an economic depression, industrial production declined, and Durand-Ruel's affairs were sorely affected by the crisis at the very moment when the painters needed his help more than ever. "Everything is going up here in a frightening manner," one of Pissarro's aunts wrote to a nephew in Saint Thomas, "beginning with taxes on rents, which have nearly doubled, and on food in general. The new taxes imposed since the war have produced a rise in price for all commodities. To give you an idea: coffee for

which one used to pay 2 francs a pound is 3 francs 20 centimes; wine has gone from 80 centimes to 1 franc a liter; sugar from 60 to 80 centimes; meat has gone sky high; cheese, butter, eggs have gone up in proportion. By means of the greatest economy, one doesn't die, but fares badly. Business is at a standstill and our young people are sad."

Under these circumstances Pissarro finally reached a point where he began to ask himself whether his paintings were not really worthless. "Your letters are truly distressing," Guillaumin wrote to him at Montfoucault, "even more than your pictures which you say are so gloomy. What is it that always makes you doubt yourself? This is an affliction of which you should get rid. I know very well that times are hard and that it is difficult to look at things gaily, yet it is not on the eve of the day where all will turn better that you should give in to despair. Don't worry, it will not be long until you will occupy the place you deserve. . . . I do not at all understand the disdain with which you speak of your canvases; I can assure you

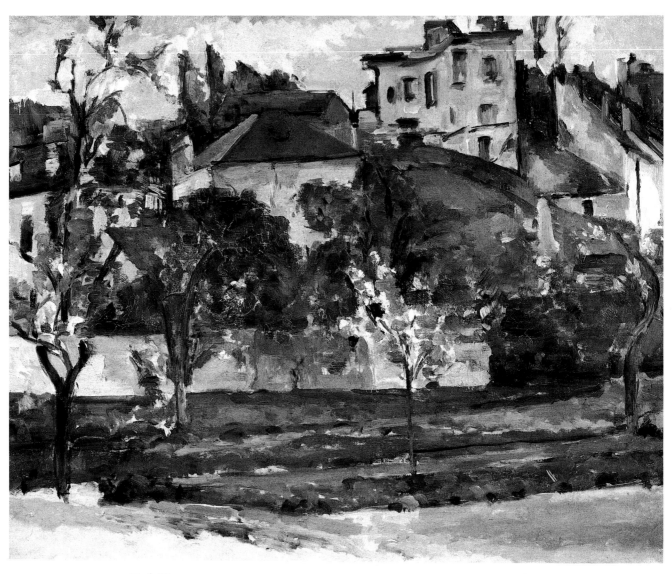

Paul Cézanne: ORCHARD WITH FLOWERING FRUIT TREES, SPRINGTIME, PONTOISE. 1877
Oil on canvas. *Collection Mrs. Alexander Albert, San Francisco.* Compare with Pissarro's painting, page 107

that they are very fine and you are wrong to speak of them as badly as you do. That is an unfortunate frame of mind which can only lead to discouragement, and that, my dear Pissarro, is not right. The utmost anarchy reigns in the opposite camp and the day is near where our enemies will tumble."

Although quite depressed himself, Guillaumin, in a second letter, again tried to bolster his friend's morale: "I am very anxious to see you and above all to talk to you. I feel that a few moments spent with you would cheer me up. Tonight . . . I saw one of your pictures which is a truly beautiful thing. You say that you are not doing anything worthwhile. I don't believe it after what I saw. I can understand that you are worrying and do not have all your heart in your work; that

is probably what hinders your judgment of what you are doing. Try not to let yourself grow disheartened. Better days are ahead. . . ."

Pissarro reacted to adversity in a characteristic manner: he participated in the formation of a new group of artists, L'Union, for which he obtained Cézanne's and Guillaumin's adherence. All three resigned, however, when they discovered that the main activity of the president consisted of intrigues against Monet and his friends. Monet himself, unable to assemble a new Impressionist exhibition in 1875, decided to organize in March a public auction in which Renoir, Sisley, and Berthe Morisot participated. The result was disastrous. The police had to step in to prevent altercations from turning into real

fistfights but could not restrain the public from greeting each bid with derisive howls. The painters were forced to buy back a number of their own works; the average price was 163 francs (ten canvases by Renoir did not even reach the 100-francs mark).

"I have had some details about the Monet sale," Piette wrote to Pissarro. "Père Martin pretends that if they tried it again with pictures chosen among their most carefully executed ones, they would inevitably be successful. But until then their works are depreciated. The collector who used to pay good prices for them will now *bargain*. You are wise, Pissarro, to have kept away from these battles which tear one's heart to pieces and punch a hole into one's pocketbook—for the benefit of the auctioneers!"

The disfavor that the works of his friends had met could not fail to extend itself also to Pissarro's paintings; his existence became just as precarious as that of the others. Fortunately a few new supporters began to make their appearance: first Gustave Caillebotte, a wealthy painter who, after befriending Monet, soon started buying canvases by all the Impressionists; then the modest customs inspector, Victor Chocquet, interested mostly in Renoir and Cézanne; the opera singer Jean-Baptiste Faure, who was soon being accused of acquiring Impressionist pictures in order to make himself conspicuous and gain notoriety; Zola's publisher, Charpentier; the Rumanian physician, Georges de Bellio; and several others. Henri Rouart, a friend of Degas, made a few purchases, while Duret continued to spread the gospel of his friends.

In 1876, assisted by Caillebotte, Monet took up the project of a second group show. Pissarro was ready with a dozen pictures, but this time Cézanne was among those who excused themselves because he wished to exhibit at the Salon (where the jury rejected his entries), and Guillaumin could not participate, not having anything prepared. The second exhibition did not have any more success than the first one. Pissarro was once more greatly disconcerted and voiced his feelings in a letter to Cézanne.

"If I dared," Cézanne replied during the summer of that year, "I should say that your letter bears the mark of sadness. Pictorial business does not go well; I am much afraid that you are rather gloomily influenced by this but am convinced that it is only a passing

thing." However, by September the situation was still unchanged and Manet's brother told Berthe Morisot: "The entire clan of painters is in distress. The dealers are overstocked. . . . Let's hope that the buyers will return, but it's true that the moment is not favorable."

Despite continuous worries the year 1876 was to be a particularly fecund one for Pissarro as well as for his comrades. Working in Pontoise and, during the fall once more at Piette's in Montfoucault, Pissarro, after having executed a series of paintings with the palette knife (pages 77 and 79), returned to ordinary brushes, which he manipulated with masterly vigor (page 81). The following year seemed to start under more favorable auspices. In January 1877 Caillebotte purchased a large landscape by Pissarro and simultaneously announced that a new group show would be organized at any cost. During the spring Cézanne again came to spend several weeks with Pissarro in Pontoise and the two friends set out anew to work side by side, finding both confidence and courage in their close companionship. Pissarro even succeeded in obtaining Cézanne's participation in the third group exhibition of the Impressionists, in which Piette, too, finally consented to participate. Yet a letter which he sent Pissarro shortly before the opening indicates that petty jealousies and resentments were beginning to divide the group. Having just held a one-man show in Paris, Piette bitterly complained to his old friend:

"The gentlemen of our association have not appeared (except for Cézanne and Guillaumin). If you had been here I am sure you would have shown up. Why? Because, independent even of your friendship, a feeling of solidarity would have prompted you to do so. Since we wish to fight against a common enemy, we should enter into a sincere pact. You are doing this, while Renoir and Monet only see in the annual association . . . a means to use the others as rungs of a stepladder. Their talent, which obviously is very great, has turned them into egotists. . . .

"And on Monday we shall go to *our* Salon; since we are paying for it, this word can well be used. I rather fear that it will be difficult to obtain anything but dark corners and that all the good walls will be taken over by Renoir and Monet. . . . In my opinion the places of honor should go to capital works by

Paul Gauguin: PORTRAIT OF CAMILLE PISSARRO. 1880
Pencil. *Collection Fru Urban Gad, Copenhagen*

Renoir, Monet, Pissarro, but I do not think that all the choice spots should be occupied by Renoir and Monet; they should also hang some of their own paintings in the darker rooms. In this fashion there would be well-lit spaces for everybody.... But it won't be easy to make them admit this."

If Piette could speak so openly about his misgivings, it was because he knew that Pissarro was always ready to defend just causes. Far from claiming the advantages to which his place in the group, his talent, and his age entitled him, Pissarro constantly subordinated his interests to those of the community. This attitude, coupled with his understanding, as well as the wisdom and warmth he brought to all his friendships, not only were responsible for the fact that others readily confided in him, they also lent a particular weight to his levelheaded advice.

There were fewer participants in the third Impressionist group show than there had been in the previous exhibitions, a circumstance that allowed each associate to send in a greater number of works. Monet submitted no less than thirty-five canvases, Degas twenty-five, Renoir twenty-one, and Pissarro twenty-two, which he presented in white frames (an innovation that was not to the liking of Durand-Ruel). As a member of the hanging committee—together with Caillebotte, Monet, and Renoir—Pissarro seems to have seen to it that the works were well distributed and that Piette's apprehensions were thus quieted. But in spite of the fact that the group this time presented a more complete and more homogeneous exhibition than ever, public reaction was scarcely more favorable than before. Besides a few approving comments—which always produce less good will than the harm caused by vilifying reviews—there was again the synchronized concert of abusive critics, whose writings more or less resembled the opinion that Paul Mantz expressed in the influential *Temps* when he said of the Impressionists:

"They keep their eyes closed, their hand is heavy, and they show a superb disdain for execution. There is no need to discuss these visionary spirits who imagine that their carelessness might be taken for grace and their impotence for candor.... Whatever they may do, the outlook for the future remains reassuring. There is no reason to fear that ignorance will ever become a virtue."

It goes without saying that the readers of Mantz and of his colleagues did not exactly rush to the public sale organized at the closing of the exhibition by Renoir, Sisley, Caillebotte, and this time also Pissarro. If Monet preferred to abstain, Pissarro was too hard pressed by problems of all kinds not to try his chance. Although the public was less noisy than during the first auction, the bids were hardly higher. The average price did not exceed 169 francs (only seven francs more than in 1877). Pissarro saw his canvases knocked down for 106, 130, 200, and 230 francs respectively. A small painting by Renoir brought only 47 francs.

At that time an industrial worker earned about five francs a day, an office employee about 100 francs a month. On the other hand, a carpenter, for instance, with a wife and two children, had to spend 1,000

francs a year for food and fuel, plus 150 to 200 francs for rent. While the Impressionists painted, on the average, one picture per week (forty-three paintings by Pissarro are recorded for 1876, fifty-three for 1877, forty for 1878, though only thirty-four for the following year), their income was so irregular that frequently the money earned in a transaction was insufficient to settle the most urgent debts and to obtain extension of further credit. In the country everyday expenses were, of course, lower than in Paris, but the Pissarro household by then comprised three children and the artist had to be satisfied with 50 francs for canvases of about 20 by 25 inches, and with 100 francs for those approximately 25 by 30. As a result he found himself in such difficulties that he was delighted to meet Eugène Murer, a pastrycook and childhood friend of Guillaumin, in whose house the painters soon began to meet once a week and who frequently exchanged meals for their pictures. Struck by the misery of his new acquaintances, Murer, in the

fall of 1877, organized a lottery in his neighborhood for the benefit of Pissarro and Sisley.

It was also around 1877 that Pissarro met, in the home of the collector Gustave Arosa, his host's godson, a young bank employee, Paul Gauguin. The latter, whose shrewd business sense had permitted him to achieve comfortable circumstances, was devoured by a passion for art. Not only had he begun to assemble a group of Impressionist works, but he had also started to paint and even had sent a landscape to the Salon of 1876. Enchanted to meet an artist he admired, Gauguin immediately asked Pissarro for advice; he also purchased several of his canvases.

Neither Murer nor Gauguin, however, were able to pull Pissarro out of his chronic predicament. A brochure on the Impressionists which Duret published in the spring of 1878, in which he reserved a highly complimentary chapter for his friend, had no practical repercussions either, the less so as several public auctions had again witnessed ridiculously low prices

THE ROAD TO PONTOISE IN OSNY. 1883
Oil on canvas. *Collection Mr. and Mrs. Jacques Gerard, New York*

Paul Gauguin: THE ROAD TO PONTOISE IN OSNY. 1883
Oil on canvas. *Whereabouts unknown*

33

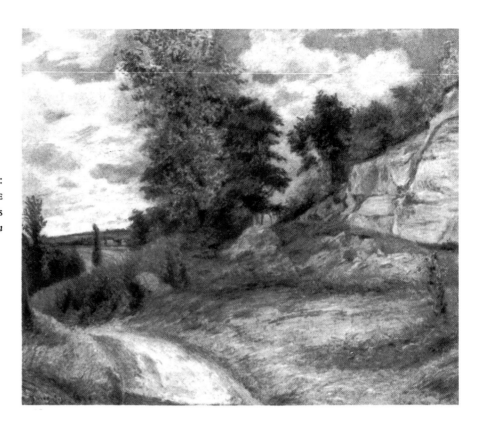

Paul Gauguin:
THE QUARRY OF LE CHOU NEAR PONTOISE
1882. Oil on canvas
Private collection, London

for Pissarro's paintings. During the entire year of 1878 the artist had to struggle against inextricable impediments, let alone the death of Piette in whom he lost a devoted friend. (When his fourth child was born in the fall of 1878, the painter named him Ludovic-Rodolphe in honor of the deceased.) Now prevented from returning to Montfoucault, Pissarro spent the entire year at Pontoise. However, he decided to rent a small room in Montmartre so as to be able to show his pictures to the few collectors interested in them; this was necessary because no subsidies from hard pressed Durand-Ruel were forthcoming. "I'll do anything within my power," the painter explained to Duret, "in order to make some money, and I'll even renew business relations with Père Martin, if the opportunity should come up. But you must realize that it is very hard for me. . . ."

His wife's new pregnancy was not an easy one; after so many years of privations she now abandoned herself completely to discouragement. "I am going through a frightful crisis," Pissarro wrote to Murer, "without seeing any way of getting out of it—things are very bad." All his letters of that year reveal a profound dejection.

Always maintaining a rigid schedule of work, Pis-

sarro used to leave every morning for his motif, yet it became increasingly difficult for him to muster, in front of nature, the complete detachment that creative efforts demand. How could he forget his worries when doubts held him in their grip and when he knew that upon returning home he would find a spouse so overwhelmed by suffering and bitterness that she began accusing him of egotism? Notwithstanding his persistence, he did produce less that year than previously, and he confided to Murer, "My work is done without gaiety as a result of the idea that I shall have to give up art and try to do something else, if it is possible for me to begin over again. Depressing."

Approaching fifty, Pissarro had to admit sadly that nowhere was there any promise for an improvement of the situation. "Soon I shall be old," he wrote Duret, "my eyesight is declining, and I shall be as advanced as twenty years ago." Yet despite everything, Pissarro did not regret for a single instant having remained faithful to his convictions, steadfastly refusing any compromise. "What I have suffered is beyond words," he told Murer, "what I suffer at the actual moment is terrible, much more than when I was young—full of enthusiasm and ardor—convinced as I am now of being lost for the future. Nevertheless, it seems to me

that I should not hesitate, if I had to start over again, to follow the same path." Consequently, as soon as there was a question of organizing a fourth exhibition of the group, in 1879, Pissarro was ready to participate, whereas Renoir and Sisley, worn out by the battle, decided to abstain and to send their paintings to the Salon instead, because, as Sisley explained, "The moment is still far when we shall be able to do without the prestige attached to the official exhibitions." Cézanne, too, submitted once more to the judgment of the jury (and Monet was to follow their example in 1880). It was then that Pissarro presented a new recruit to the group, Paul Gauguin, who had begun to paint at his side.

The monotony of daily misery, of deceived hopes, of arduous work continued. Moreover, Pissarro once again was dissatisfied with his work and complained to Caillebotte about his execution, which he considered too rough. But not for a moment did he interrupt his efforts, so that, during the summer of 1879, Caillebotte could write to him, "I learn with pleasure that you are keeping busy despite that technique which you mentioned to me." Indeed, what else could

Pissarro do? At last, in 1880, the general situation began to improve and Durand-Ruel could once more buy the works of the various painters. Soon, Pissarro was able to tell Duret, "I am not rolling in money; I am enjoying the results of moderate but steady sales. The only thing I dread is a repetition of the past."

The fifth exhibition of the Impressionists, to be held in 1880, assembled only a few of the old members of the group—Pissarro, Degas, Berthe Morisot, and Guillaumin—the others preferring to try their chances at the Salon. But it was in 1881, at the time when conditions had definitely improved and become stabilized, that a crisis was to develop openly among the remaining members of the association. Caillebotte would not forgive Degas for having called his friends Monet and Renoir "renegades" on account of their participation in the Salon. "If there is anybody in the world," he wrote Pissarro, "who has the right not to forgive Renoir, Monet, Sisley, and Cézanne, it is you, because you have experienced the same practical demands as they and you haven't weakened. But you are . . . less complicated and more just than Degas. . . ."

Despite his tact, Pissarro was unable to obtain a rec-

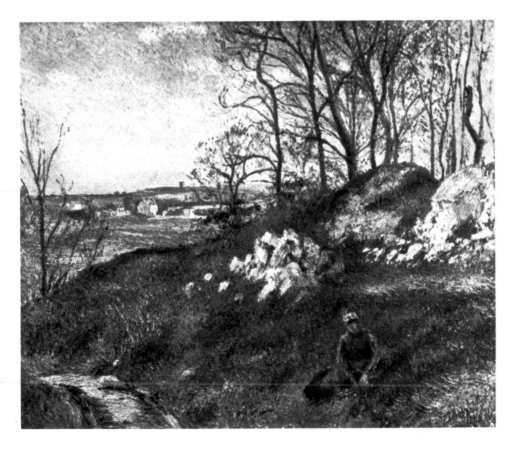

THE QUARRY OF LE CHOU NEAR PONTOISE.
1882. Oil on canvas
Collection M. P. Voute, Amsterdam

35

Pissarro's house (left foreground) at Eragny

onciliation between Degas and Caillebotte, nor could he prevent the latter from abandoning the association. The show of 1881, the sixth of the group, thus saw even fewer participants than the preceding one. Yet, as though he wished to show that he had no hard feelings for his comrades who had deserted the Impressionist exhibitions in favor of the Salon, Pissarro spent the summer with Cézanne at Pontoise, once more working in close communion with him. His customary frankness later prompted Pissarro to say of those times during which they had been so intimately associated, that Cézanne "has exposed himself to my influence as I did to his. . . . What is strange, is the similarity of some of his landscapes of Auvers and Pontoise with mine. To be sure, we were always together! But what cannot be denied is that each of us kept the only thing that counts, the unique *sensation.*"

During this summer, whenever he could escape from his office, Gauguin came to join the two friends, avidly drinking in their words, studying their paintings, and trying to perfect his artistic expression in their company. Estimating that Pissarro's benevolence authorized him to do so, Gauguin, newcomer that he was, took an active part in the organization of the seventh group show, in 1882. But there were again arguments with Degas as a result of which Gauguin, always impetuous, wrote to his *cher professeur:* "Two more years and you will be left alone in the midst of these schemers of the worst kind. All your efforts will

be destroyed, and Durand-Ruel, too, on top of this. In spite of all my good will, I cannot continue to serve as buffoon. . . . Please accept my resignation. From now on I shall remain in my corner."

In view of these quarrels, Durand-Ruel finally decided to take matters into his hands. Pissarro eventually agreed to drop Degas—center of all discord—whereupon Monet, Renoir, Sisley, Caillebotte, and Gauguin rejoined the association. Cézanne, however, persisted in his isolation. As the only member of the group who had never faltered, Pissarro even tried to obtain Manet's participation, but without success. Nevertheless, the exhibition of 1882 turned out to be the most homogeneous the Impressionists had ever organized. This time the critics were less aggressive and a few new collectors appeared. Yet, in spite of all this, things were not to go smoothly; the prosperity that had begun in 1880 was succeeded two years later by another depression which seriously affected Durand-Ruel; more difficulties for the painters began to loom. The new crisis also deprived Gauguin of his job, whereupon he decided henceforth to paint "every day." He now asked Pissarro to assist him in his attempt to earn a livelihood with his pictures, yet his mentor, once more exposed to constant worries, could not provide much help.

Toward the end of 1882 Pissarro left Pontoise for the nearby village of Osny where Gauguin again came to paint at his side. Despite the fervent admiration the younger man expressed for his work, Pissarro himself was deeply troubled by the evolution of his style and of his technique, which had not ceased to preoccupy him since he had first discussed it with Caillebotte in 1879. The comments of certain critics did nothing to reassure him; especially opinions such as those expressed by Charles Ephrussi, who had said in 1880:

"Pissarro paints uneasily with vivid colors; under his brushes spring and flowers become gloomy, the air turns heavy. His execution is pasty, woolly, tormented; his figures, of a melancholy character, are treated with the same procedure as the trees, the grass, the walls, and the houses. Yet an air of a certain largess and a certain will power in the rendition of well-composed landscapes makes up for this heaviness."

But the artist himself knew that the problem was not to "make up" through will power for the deficiencies that bothered him. And Gauguin could not mollify

him when he replied to a particularly discouraged outburst of Pissarro: "I received your rather extraordinary letter this morning. One would say that the fog in this moment influences your morale. You seem to be down in the dumps. . . . Just the same, I have no qualms concerning you. I know very well that it is always long and difficult to complete something, no matter which way one tackles the problem, but you generally have the necessary tenacity for obtaining a good result."

Since he was so little satisfied with his work, Pissarro learned without enthusiasm that Durand-Ruel—who by now had abandoned all hope of reviving the Impressionist group—was planning a series of one-man shows for the spring of 1883. After Monet and Renoir, Pissarro's turn was to come in May. "I shall appear sad,

tame, and lusterless after such *éclat*," he wrote his eldest son, Lucien, who had left for London to prepare for the artistic career of which he dreamed. Pissarro did not display more confidence following the opening of his exhibition: "Am I happy? Gracious, no. . . . I have received many compliments, but I do not compliment myself. Aside from two or three things, it's weak. Let's not talk about it anymore."

It was not until 1885 that Pissarro finally shook off this downcast frame of mind, after he met in Guillaumin's studio young Paul Signac who was the same age as his own son Lucien. Signac told him about the endeavors of his friend Georges Seurat, who was engaged in developing a scientific method to guide the artist's sensations and thus buttress the instinctive vision of nature by the strict observation of optical laws. In

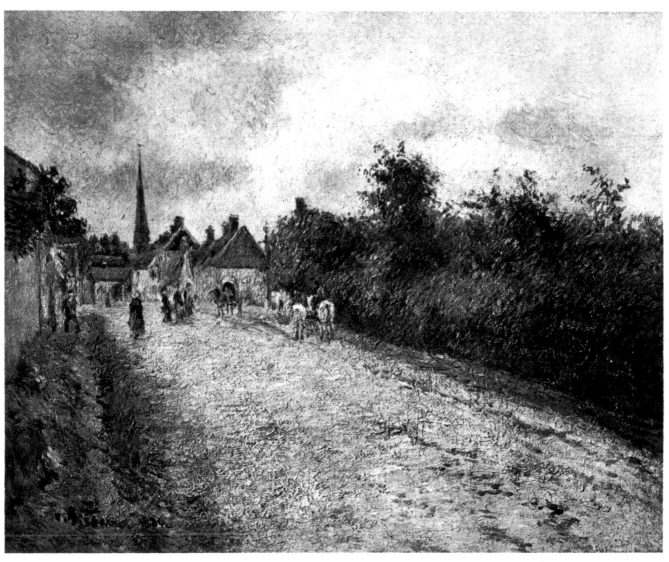

ENTRANCE TO THE VILLAGE OF ERAGNY. 1884. Oil on canvas. *Private collection, New York*

October of the same year Pissarro met Seurat himself who explained at length his theories. Having been dissatisfied with his execution for several years, and feeling that he had reached an impasse, Pissarro was particularly receptive to Seurat's innovations. He therefore did not hesitate to embrace these while at the same time offering his new friends the benefit of his experience which they, in turn, gladly welcomed. Pissarro's adoption of their views enchanted Seurat and Signac. "How much misery and trouble your courageous conduct will bring you!" Signac now wrote to Pissarro. "For us, the young, it is a great good fortune and a truly great support to be able to battle under your command."

But Pissarro had no intention of placing himself at the head of a new movement. In a letter to Durand-Ruel (who had left for the United States, there to try his luck) he explained a little later the nature of the revolutionary concepts shared by the small group gathered around Seurat, which his son Lucien had also joined. Their purpose, he said, was "to seek a modern synthesis by methods based on science . . . to substitute optical mixture for the mixture of pigments, which means to decompose tones into their constituent elements, because optical mixture stirs up luminosities more intense than those created by mixed pigments. As far as execution is concerned, we regard it as of little importance; art, as we see it, does not reside in the execution: originality depends only on the character of the drawing and the vision peculiar to each artist." And with his customary loyalty Pissarro insisted, "It is Seurat, an artist of great merit, who was the first

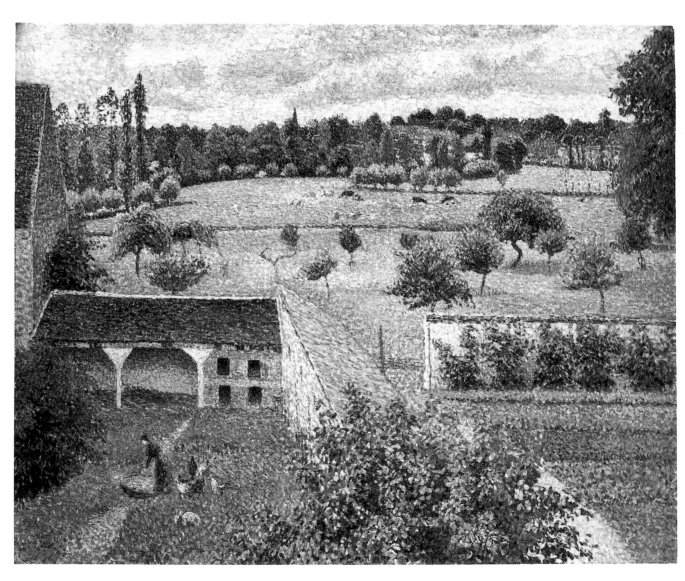

VIEW FROM THE ARTIST'S WINDOW, ERAGNY. 1888. Oil on canvas. *Ashmolean Museum, Oxford*

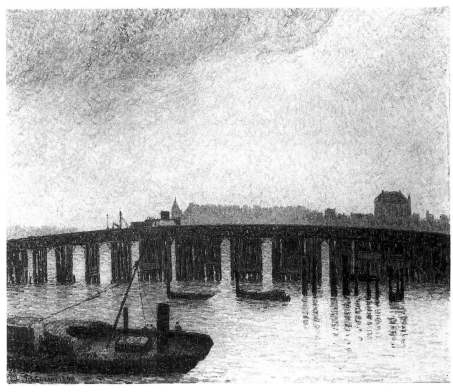

OLD CHELSEA BRIDGE, LONDON. 1890
Oil on canvas. *Private collection, New York*

to conceive the idea and to apply the scientific theory after having made thorough studies. I have merely followed his lead. . . ."

Seurat's system demanded a meticulous technique for which he adopted an execution of small dots which permitted the juxtaposition of minute though distinct particles of pigment. These dots corresponded to the various elements—light, shadow, local color, and interaction of colors—the mixture of which was to be achieved optically, that is, in the eye of the observer. With great patience Pissarro submitted to the rigors of this procedure, which prevented him from working out of doors (pages 110-111).

When, in 1886, quite unexpectedly and after an interval of four years, the question arose of organizing an eighth exhibition of the Impressionist group, Pissarro insisted that Seurat, Signac, and his son Lucien be allowed to participate. After long and painful discussions, during which he was opposed not only by Renoir but also by Gauguin, Pissarro's conditions were accepted and the *pointillistes* were able to display their paintings in a separate room. The show aroused a good deal of curiosity, although Pissarro's efforts met with little comprehension. Some saw in him the chief of a small gang of eccentrics, others accused him of slavishly following the ridiculous innovations of that mystifier, Seurat. Durand-Ruel simply refused to buy the new

pointilliste canvases by Pissarro; collectors showed the same resistance.

Signac had been right; Pissarro's radical change of style engendered a hostility that immediately affected his livelihood. He was now fifty-five, having to provide for six children, the last two born in 1881 and 1884. Once more the procession of worries and debts, of vain appeals, of disdain and scoffing. This time the artist's wife could not take it any more. At her urging, Lucien had to seek employment in Paris. She also began approaching various friends but collected only empty condolences. Finally she abandoned all hope. In the fall of 1887, while her husband was in Paris running from one collector and one dealer to another, she wrote to her first-born son:

"Your poor father is really an innocent; he doesn't understand the difficulties of living. He knows that I owe 3,000 francs and he sends me 300, and tells me to wait! Always the same joke. I don't mind waiting, but meanwhile one must eat. I have no money and nobody will give me credit. I paid off a little of the debts here and there, but it is so little that they don't want to give me any more credit. What are we to do? We are eight at home to be fed every day. When dinner time comes, I cannot say to them 'wait'—this stupid word your father repeats and repeats. I have used up anything I had put aside. I am at the end of my tether and,

39

Camille Pissarro in his studio at Eragny, about 1897

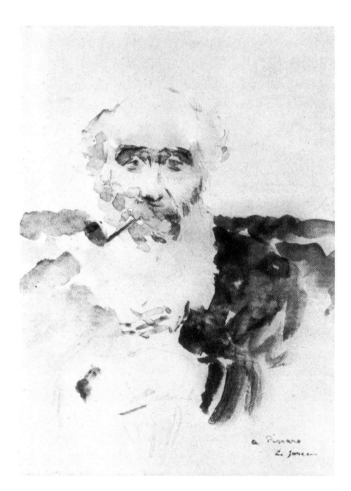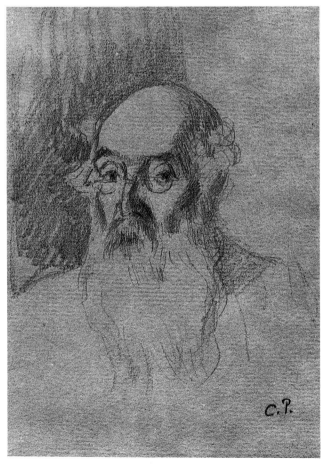

Jean-Louis Forain: PORTRAIT OF CAMILLE PISSARRO. About 1897?
Watercolor. *Collection Bonin-Pissarro, Paris*

SELF-PORTRAIT. About 1898. Pencil
Formerly collection John S. Newberry, Jr., New York

what is worse, have no courage left. I had decided to send the three boys to Paris and then to take the two little ones for a walk by the river. You can imagine the rest. Everyone would have thought it an accident. But when I was ready to go, I lacked the courage. Why am I such a coward at the last moment? My poor son, I feared to cause you all grief, and I was afraid of your remorse. Your dear father wrote me a letter which is a masterpiece of selfishness. The poor dear man says that he has reached the top of his profession and doesn't want to prejudice his reputation by having an auction sale or by pawning his pictures. Not to prejudice his reputation! Poor dear, what repentance for him if he should lose his wife and his two little ones! To uphold his reputation! I think he doesn't know what he is saying. My poor Lucien, I am terribly unhappy. Good-by. Shall I see you again, alas?"

If Pissarro finally did abandon Seurat's "divisionism," it was neither to appease his wife nor to save his reputation, nor was it in order to escape the disastrous consequences of his act of independence. He did so exclusively because he realized that he had made a mistake in adopting theories that were completely in conflict with his nature. Toward 1890 his recent paintings ceased to satisfy him, and once this had happened, no scientific reasoning could persuade him to follow a path that seemed to hamper rather than to enhance his evolution. As soon as he had reached this conclusion, he explained his views to his young friends, and eventually told one of Seurat's disciples:

"I believe it is my duty to write you frankly and tell you how I regard the experiment I made with systematic divisionism by following our friend Seurat. Having tried this theory for four years and having then abandoned it, not without painful and obstinate efforts to regain what I had lost and not to lose what I had learned, I can no longer consider myself one of the neo-impressionists. . . . Having found after many attempts (I speak for myself) that it was impossible to be true to my sensations and consequently to render life and movement, impossible to be faithful to the effects, so random and so admirable, of nature, impossible to give an individual character to my drawing, I had to give up."

The renouncement was sorrowful but turned out to be highly advantageous, since Pissarro's execution now became more subtle, his color scheme more refined, his drawing firmer. Thus he emerged enriched from his trials and was able to benefit more fully from the liberty of expression at last regained. So it was that Pissarro approached old age with an increased mastery.

It was not long after he broke with Seurat, shortly

41

GIRL WASHING HER FEET IN A BROOK. 1895. Oil on canvas. *Collection Nathan Cummings, Chicago*

before the latter's death, that Pissarro also began to disagree with Gauguin, whose efforts to promote himself as the chief of a new symbolist movement greatly displeased him. As the old revolutionary he was, Pissarro had only contempt for Gauguin's growing mysticism and explained to Lucien: "The frightened bourgeoisie, surprised by the immense clamor of the disinherited masses, by the tremendous demands of the lower classes, feels that it is necessary to bring the people back to their superstitious beliefs. Hence the bustling of religious symbolists, religious socialists, idealistic art, occultism, Buddhism, etc., etc. That fellow Gauguin has sensed this tendency.... May this movement be only a death rattle, the last. The Impressionists have the true position; they stand for a healthy art based on sensation, and that is an honest stand."

When Gauguin's wife recommended, from Denmark, a young painter to Pissarro (who never accepted pupils but was always ready to give benevolent advice), the artist replied somewhat sadly, "I see Gauguin very seldom. He now frequents a different milieu and only through others do I occasionally hear about him. I learned from the papers that he held a rather successful auction and that he intends to settle in Tahiti." The paintings that Gauguin brought back from the South Sea island in 1893 did not satisfy his former mentor, so that their rift became even more accentuated.

Thanks to the success he had met in America, Durand-Ruel was once more in a position to offer the Im-

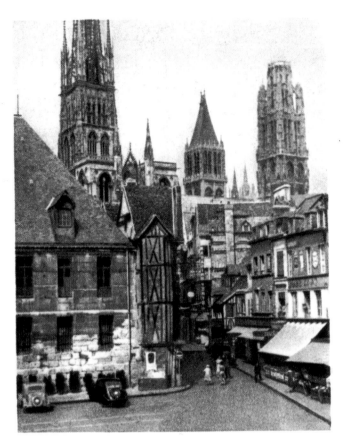

Rue de l'Epicerie, Rouen, before its destruction
in World War II. *Photograph by the author*
Compare with page 153

pressionists steady support; Pissarro henceforth experienced a peace of mind that allowed him to go about his work with renewed enthusiasm. In 1884 he had left Osny and settled in a large house surrounded by a big garden in Eragny-sur-Epte, near Gisors. There Theo van Gogh asked him to accept as a boarder his brother Vincent, whom Pissarro had met during the Dutchman's sojourn in Paris. According to the recollections of his son Lucien, the old master had been impressed with the dark paintings Vincent van Gogh had shown him of his Dutch period and had "foreseen the power of this artist. He thereupon had explained to him the search for light and color. It had not taken Vincent long to understand and to follow this direction in his own way." But when it came to putting up van Gogh upon his release from the asylum of Saint-Rémy, Madame Pissarro objected to his presence in a house filled with small children. Vincent eventually went to Auvers where Dr. Gachet consented to look after him.

In 1889 Pissarro began to suffer from a chronic eye infection that often prevented him from painting outdoors. He had a special studio built in his garden in Eragny and also frequently worked from behind windows. In order to vary his subjects, he now began to travel a good deal. Already in 1883 he had been working in Rouen; he returned there for long and productive stays in 1896 and 1898. He also undertook several trips to England where Lucien had settled permanently. In the extensive correspondence that he exchanged with his eldest son, Pissarro encouraged him, gave him advice, and imparted to him the essential tenets of his own philosophy. At the same time he followed with tenderness and pride the evolution of his other children, all of whom showed artistic inclinations. But in 1897 he experienced a cruel blow when his son Félix died in London at the age of twenty-three (see pages 102–103).

After his series of Rouen streets and the harbor, Pissarro undertook several series of Paris views, devoted, among others, to the Boulevard Montmartre, the Place du Théâtre Français, and the Avenue de l'Opéra. Having executed these from various hotel rooms, in 1899 he rented an apartment on the Rue de Rivoli from which he painted the Tuileries gardens. The following year he settled in one of the old houses on the Pont Neuf for an exploration of Seine vistas, of the façade of the Louvre, and of the Île de la Cité. He was now frequently invited to participate in exhibitions in various European countries and also in the United States, notably the Pittsburgh International. Thanks to the Caillebotte bequest, several of his paintings were hung

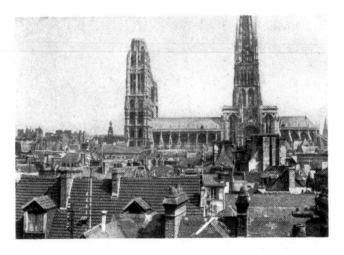

Rooftops and the Cathedral, Rouen. *Photograph by the author*
Compare with page 145

43

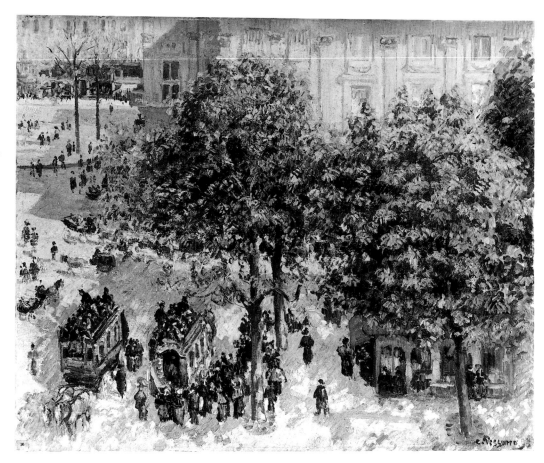

PLACE DU THEATRE FRANÇAIS,
PARIS, SPRINGTIME. 1898
Oil on canvas
Hermitage Museum, Leningrad

PLACE DU VERT GALANT,
PONT NEUF, SUNNY MORNING. 1902
Oil on canvas
Private collection, France

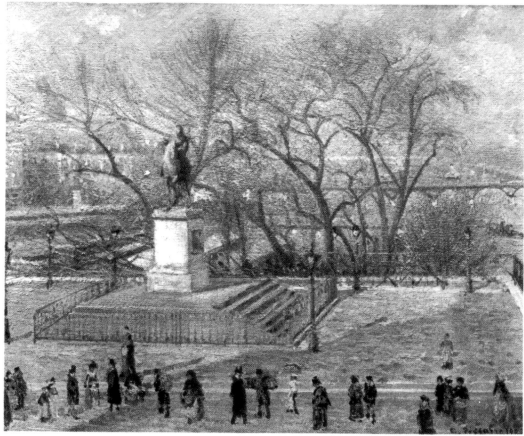

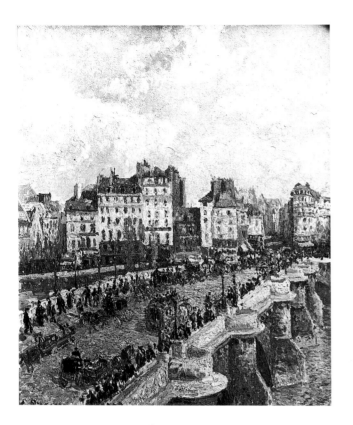

PONT NEUF, PARIS. 1902. Oil on canvas
Museum of Fine Arts, Budapest

Pont Neuf, Paris
Photograph by the artist's son Ludovic-Rodolphe Pissarro

in the Luxembourg Museum (prior to their then still problematic entry into the Louvre). But despite the efforts of his friend, the novelist Octave Mirbeau, the French government refused to acquire one of his paintings and even bargained pettily after purchasing several etchings, although these were very modestly priced.

Slowly Pissarro's fame began to spread, although his work did not attract as wide an audience as Monet's. Nevertheless, he was now respected and enjoyed a comfortable life. He was able to reimburse Monet, who had lent him the money for the purchase of the house the Pissarros occupied at Eragny. His paintings began to reach high prices at auctions and a new generation of writers and painters now surrounded the old man with testimonials of their admiration. Thus he could continue his work with confidence. The freshness of his vision permitted him to realize until the very end a succession of masterpieces.

In 1901 he undertook a new series in Dieppe and returned there again the following year. He spent the summer of 1903 in Le Havre before returning to Paris where he planned to occupy a new apartment on the Boulevard Morland. But an abcess of the prostate struck him at the very moment he was to move. A stanch believer in homeopathy, Pissarro submitted to a physician who tried to save him without operation. Blood poisoning caused his death on November 13, 1903, in his seventy-fourth year.

Pissarro never learned of the two most touching tributes of which he was the subject. On his island in the Pacific, Gauguin—though his old friend had quarreled with him about his Tahitian paintings—had written in 1902: "If we observe the totality of Pissarro's work, we find there, despite fluctuations, not only an extreme artistic will, never belied, but also an essentially intuitive, purebred art.... He looked at everybody, you say! Why not? Everyone looked at him, too, but denied him. He was one of my masters and I do not deny him."

And in 1906 when Cézanne was invited, shortly before his death, to exhibit in Aix with an association of local painters, the sixty-seven-year-old artist, venerated by the young generation as the pathfinder for the moderns, remembered an old debt of gratitude and had himself listed in the catalogue as: *Paul Cézanne, pupil of Pissarro.*

45

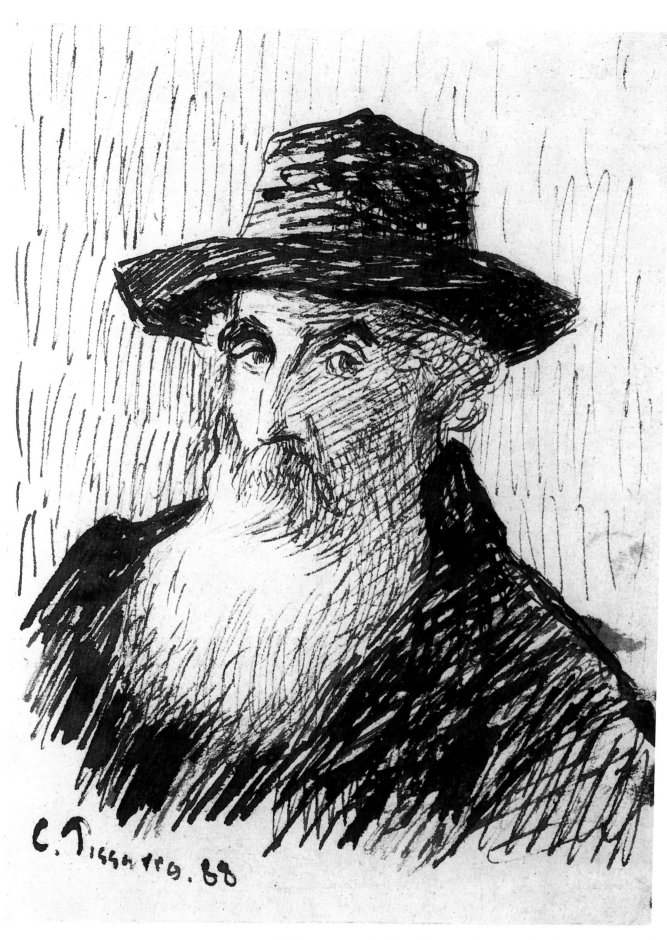

SELF-PORTRAIT. 1888. Pen and ink. *New York Public Library* (*Avery Collection*)

COLORPLATES

Painted 1867

QUAY AND BRIDGE AT PONTOISE

Oil on canvas, 15 × 18¹/₄″

The Tel Aviv Museum (Bequest of Mrs. Lilli Schocken)

Having grown up on an idyllic and tropical island, Pissarro does not seem to have been completely at ease in Paris where he had spent a few school years and to which he returned at the age of twenty-five to become a painter. He left the city whenever possible, often working on the banks of the broad Marne River or of the meandering Seine. Around 1866 he began to set up his easel in and around Pontoise, a sleepy little town not far from Paris, nestled between softly undulating hills and an ancient bridge over the Oise River, a tributary of the Seine.

In quest of outdoor effects, the painters of the Barbizon school had already taken their sketch pads or small canvases to the meadows, forests, and valleys around Fontainebleau. Occasionally they were also attracted by man-made landscapes, by views of cities or their more or less animated streets, such as Corot and Jongkind had sometimes painted. Under their influence, Pissarro chose similar subjects, though he approached them less in the poetic vein of Corot or the frequently nervous and almost stenographic style of Jongkind; instead, he showed himself more attracted by the forceful brushwork, the more pronounced and earthier colors, the stronger contrasts favored by Courbet.

Pissarro's early street scenes, which he actually painted out of doors (whereas his predecessors worked mostly in their studios from the studies they had made on the spot), depict aspects of an almost rural life, rendered quite unpretentiously and without too much care for minute detail. Broad brush strokes and a comparatively heavy impasto achieve a strong statement akin to Courbet's paintings, while an undefinable mood of peace and harmony echoes the example of Corot. Yet behind the combination of their influence appears the promise of an original approach.

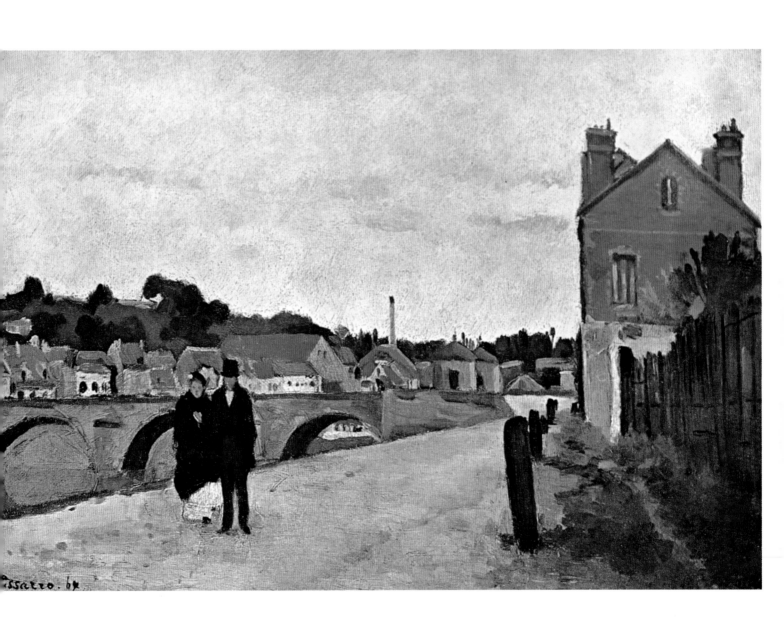

Painted 1867

STILL LIFE

Oil on canvas, 32×39¹/₂"

The Toledo Museum of Art (Gift of Edmund Drummond Libbey, 1949)

This large composition was possibly one of the boldest still lifes ever painted up to the day Camille Pissarro signed and dated it in 1867. Whereas Manet, in his superb still lifes, remained more or less consciously within the folds of the great French tradition (particularly of Chardin), and whereas Courbet—to whom the colors and the execution of this canvas actually owe a great deal—was relatively timorous in his still lifes as compared with his landscapes and figure paintings, Pissarro here seems to have ventured suddenly into a style of incredible forcefulness and originality.

A few objects of everyday life are assembled in a classic arrangement in which verticals and horizontals are masterfully balanced. Two diagonals—the loaf of bread and the knife in the ceramic dish—create an illusion of space, extending as they do toward the spectator; the knife, especially, discreetly provides this illusion, a device that has been traditionally used for this very purpose. The neutral tones of the setting are relieved by the colorful accents of the dish and the three yellow apples that are almost in the center of the composition. The large expanse of the background is broken by the two ladles hanging on the wall, their downward thrust met at the right by the upward curve of the decanter, the wineglass between them serving as a link. This expanse is opposed by the various objects on the white tablecloth, painted with lively and smaller brush strokes that further accentuate the contrast.

The only artist who, a little later, would apply a similar technique and color scheme to still lifes was Paul Cézanne, whom Pissarro had met as early as 1861. In all likelihood it was under Pissarro's guidance that Cézanne began to observe nature more closely instead of following the baroque flights of his youthful fancy. A painting of such stark realism, inner strength, monumental simplification, and sureness as this still life cannot have failed to impress Cézanne and to lead him on to a series of equally bold yet surprisingly restrained compositions.

Only very few of Pissarro's works were painted in this vein, with broad brush strokes and the use of a palette knife; only few show such an earthy and yet glowing coloration or such deftly modeled volumes. In a word, this still life strikes a new note in the artist's evolution, but it was to remain a fairly unique endeavor, as if, in spite of the fact that he had been so successful in this daring canvas, he did not feel tempted to pursue further a road that might have led him away from the intimate contact with nature toward which he had been so persistently inclined until then. PISSARRO CATALOGUE NO. 50

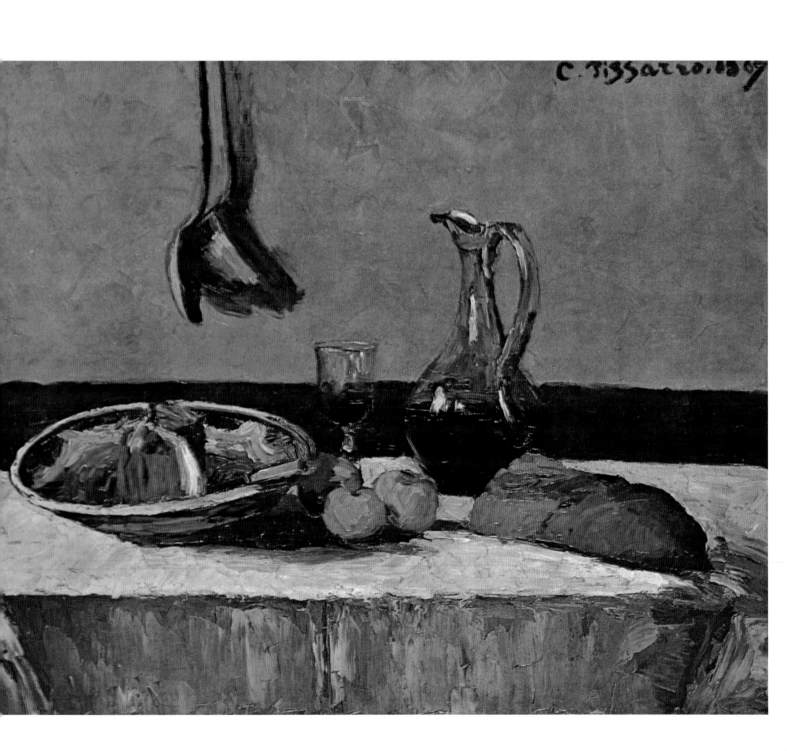

Painted 1867

THE COTE DU JALLAIS NEAR PONTOISE

Oil on canvas, 34¹/₄ × 45¹/₄″

The Metropolitan Museum of Art, New York (Bequest of William Church Osborn, 1951)

Painted somewhat less vigorously than his powerful still life of the same year (page 51), this view of a few houses hidden in a valley outside Pontoise nevertheless combines a robust approach with the charm of a peaceful vista. The solidity achieved here despite a more delicate execution and a wider range of colors shows how the observation of nature tempered Pissarro's new-found boldness. The dark, diagonal mass of a verdure-covered mount on the right sets off the horizontal hilltop in the distance with its neatly outlined fields whose curves are echoed in the opposite direction by the bend of the path in the foreground. Isolated verticals here and there and the blocks of some buildings interrupt the softness of the undulating site and the clusters of trees. An overcast sky does not prevent the sun from shedding a diffuse light over the scene.

Thanks to the intervention of Daubigny, this landscape was accepted by the Salon jury of 1868. It earned Pissarro some acclaim in spite of the fact that the picture was hung far too high. Zola seized the opportunity to express an admiration he shared with his friend Cézanne, calling Pissarro "one of the three or four painters of our time. He possesses solidity and broadness of execution, he paints generously, following the traditions, like the masters. Only rarely have I encountered a more profound science. A beautiful picture by this artist is the act of an honest man. I cannot better define his talent."

Yet the most penetrating definition of Pissarro's talent was to come from a fellow artist turned art critic for the occasion. Odilon Redon singled out Pissarro for particular praise: "For several years we have already noticed this intense and austere personality, who made us think somewhat of the picturesque roughness of the Spaniards. [His paintings] are things strongly seen, which do not lack character. The color is somewhat dull, but it is simple, large, and well felt. What a singular talent, which seems to brutalize nature! He treats it with a technique that in appearance is very rudimentary, but this denotes, above all, sincerity. M. Pissarro sees things simply; as a colorist he makes sacrifices that allow him to express more vividly the general impression, and this impression is always strong because it is simple. We are certain that public opinion will not delay pronouncing itself in favor of this genuine personality who, for a long time already, pursues its goal with an impassive conviction and all the signs of what is called an original temperament." PISSARRO CATALOGUE NO. 55

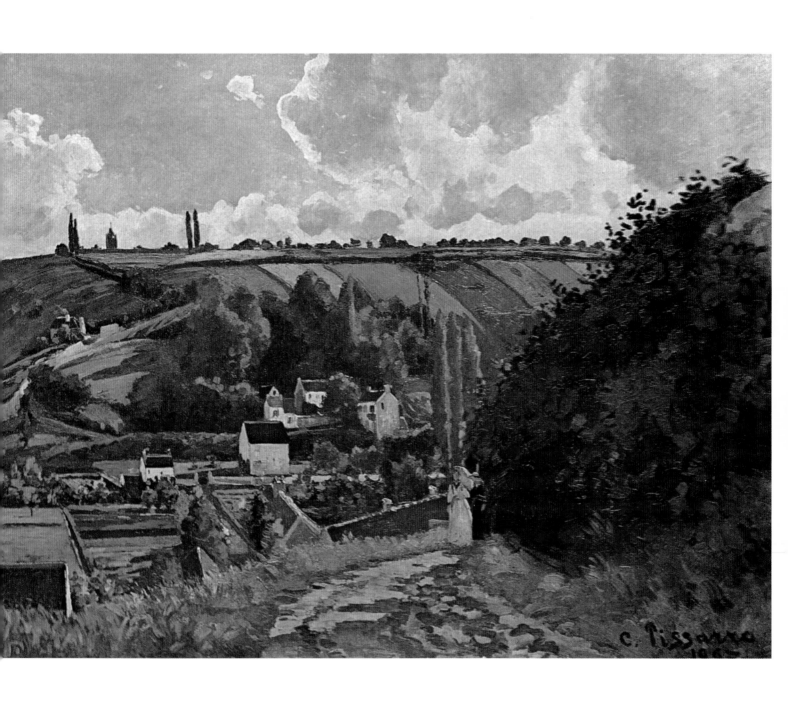

Painted 1870

LOUVECIENNES, THE ROAD TO VERSAILLES

Oil on canvas, 40¹/₈×32¹/₂″

Emil G. Bührle Collection, Zurich

The scene is the small garden in front of the artist's house in Louveciennes, on the road that leads from Saint-Germain to Versailles. At the left appear Pissarro's wife and their second child, five-year-old Jeanne-Rachel. The mother speaks with another woman, doubtless a neighbor, who stands on the other side of a wooden fence. The pictorial accent is on the straight and somewhat rigid figure of Madame Pissarro in her dark dress, an accent established with immediacy since there is not one single object between her and the beholder; the strong diagonal of the fence and its flower bed actually leads to this figure, at the same time separating it from the second vertical, that of the single tree a little to the right of the center. The blue sky, against which the foliage is set, occupies the upper right corner; its limpid surface balances the somber masses of the lower left portion. The colors are once more opaque, the forms are stable, the mood is somewhat solemn, that of a quiet summer day in the provinces without any suggestion of movement or animation.

The deliberately unassuming character of many of Pissarro's subjects led the critic Théodore Duret, who subsequently was to become the first ardent supporter of the Impressionists, to state in 1870 that for Pissarro "a landscape must be the exact reproduction of a natural scene and the portrait of a really existing spot of the universe." Yet he added, unaccustomed as he was to this novel approach, "We cannot refrain from observing that by following too strictly this theory, he frequently selects insignificant sites where nature itself does not present a composition, so that he produces a landscape without painting a picture."

This large canvas was executed shortly before the outbreak of the Franco-Prussian War, which drove the artist from his home and eventually prompted him to seek refuge with his family in England. There, in February 1871, he received a letter from a friend who told him: "... I have no news of your house at Louveciennes! Your blankets, suits, shoes, underwear, you may go into mourning for—believe me—and your sketches, since they are generally admired, I like to think will be ornaments in Prussian drawing rooms. The nearness of the forest will no doubt have saved your furniture." Pissarro's house was indeed occupied by enemy troops who, however, did not admire his paintings. A great many of his works, as well as paintings Monet had put there for safekeeping, were either destroyed or badly damaged by the occupants.

PISSARRO CATALOGUE NO. 96

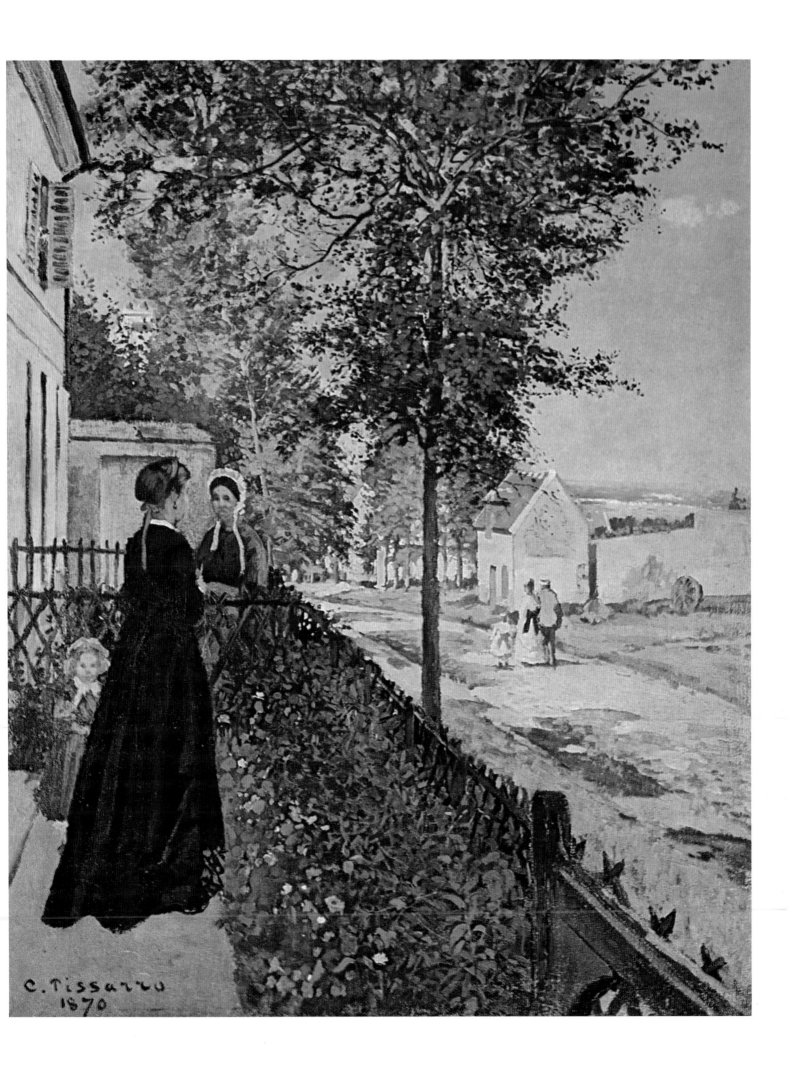

C. Pissarro
1870

Painted 1871

THE ROAD TO ROCQUENCOURT

Oil on canvas, 29¹/₄×30"

Private collection, New York

During his exile in London, Pissarro ran into Daubigny who introduced him to the young Parisian art dealer, Paul Durand-Ruel, another refugee from war-torn France. Durand-Ruel not only bought two of the painter's canvases but also told him of Monet's presence in London. The two friends soon began working in the city and its lovely vicinity, and also visited the museums together. They were interested chiefly in the British landscape painters who, as Pissarro later said, "shared in our aim with regard to plein-air, light, and fugitive effects." Pissarro freely admitted that the watercolors and paintings of Turner and Constable had an influence on the two Frenchmen, yet he specified that these painters, "while they taught us something, showed us in their works that they had no understanding of the *analysis of shadow*, which in Turner's painting is simply used as an effect, a mere absence of light. As far as tone division is concerned, Turner proved the value of this as a method among methods, although he did not apply it correctly and naturally." (Monet went even further in his criticism when he subsequently stated that Turner's work was antipathetic to him because of the exuberant romanticism of his fancy.)

These reservations notwithstanding, Pissarro returned to France in June 1871 with a palette that had become definitely brighter and more subtle. One of the first paintings he executed after his arrival in Louveciennes, this *Road to Rocquencourt*, is a hymn to homecoming, despite the sad condition in which he found his house.

A broad road occupies the entire width of the foreground; it appears to rise softly toward the horizon and there suddenly stops—having reached its gentle peak, it obviously descends again. A few trees on the right are silhouetted against a clear blue sky animated by pale summer clouds and cast thin and long shadows across the road on whose opposite side they touch a string of low houses. The sun-drenched landscape radiates with cheerfulness. The emotional content here is stronger than the lyricism of Pissarro's earlier work because its quiet but glowing confidence attains serenity.　　PISSARRO CATALOGUE NO. 118

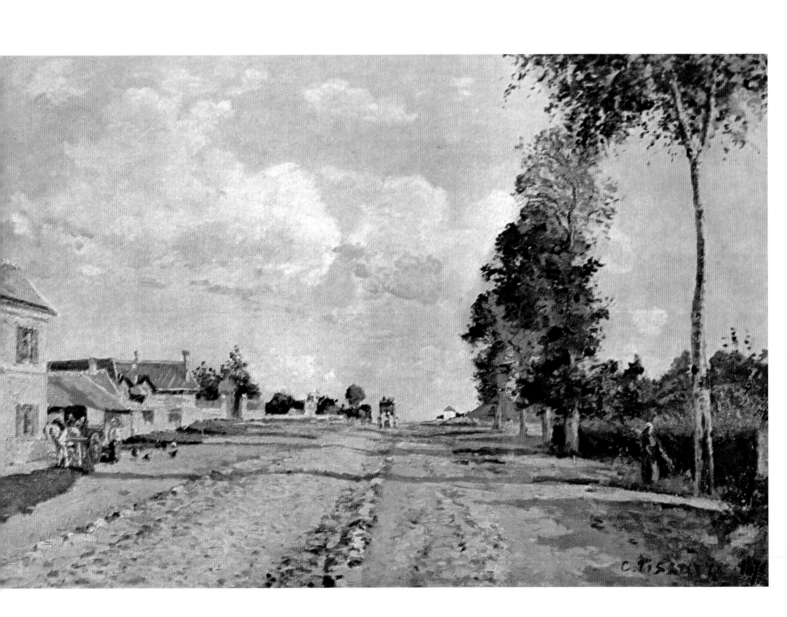

Painted 1872

SNOW AT LOUVECIENNES

Oil on canvas, 18¹/₈ × 21³/₄″

Museum Folkwang, Essen

The analysis of shadow, which had preoccupied the artist in England, was an important feature among the innovations of Pissarro and his friends. In this connection, snow scenes held a particular attraction for them because they offered an excellent opportunity for the study of reflections and of surfaces barred from direct light. There could be no question that a shadow cast on snow was not, as academic tradition had it, of a bituminous character, but that, instead of the original white, there appeared in the shaded regions colors postulated by the atmosphere as well as by the object that hid the sun. It thus became clear that surroundings exposed to the sun influence the coloration of the area remaining in the shade.

As Renoir was to explain toward the end of his life: "White does not exist in nature. . . . You have a sky above the snow. The sky is blue. That blue must show up in the snow. In the morning there is green and yellow in the sky. These colors also must show up in the snow when your picture is painted in the morning. If it is done in the evening, red and yellow would have to appear in the snow. And the shadows . . . a tree, for example, has the *same* local color on the side where the sun shines as on the side where the shadow is. . . . The color of the object is the same, only with a veil thrown over it. Sometimes that veil is thin, sometimes thick, but always it remains a veil. . . . No shadow is black. It always has a color. Nature knows only colors. . . . White and black are not colors."

Thus, shadows could obviously play a unifying role in a composition rather than brutally divide it into zones of light and darkness, And that is how Pissarro used them in the snow scene painted in Louveciennes, where bluish tints dominate the entire landscape. The bluish-green coloration of the uniform sky is mirrored throughout the strongly established foreground, the firm middle ground, and the hazier distance. The winter sun, somewhere low on the horizon to the right, is suggested by diagonal shadows and a few scattered highlights. The dark accents of tree trunks and naked branches draw a web of somber arabesques against the prevailing bluish tonality. Since the sun stands behind them, these trees are all in the shade, yet they are by no means black; their dull, brownish tints seem to benefit from reflections cast by the snow. Thus is re-created, with a reduced scale of colors, an intimate interplay between light and shadow, between solid forms and snow-covered soil, between sky and ground.

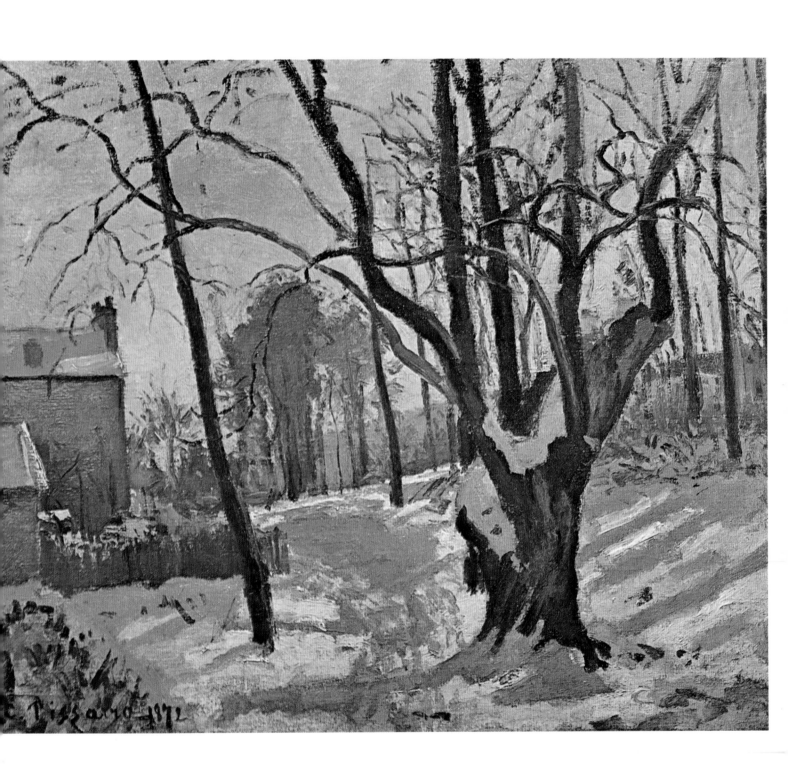

Painted 1872

ENTRANCE TO THE VILLAGE OF VOISINS

Oil on canvas, 18¹/₈ × 21⁵/₈"

Musée d'Orsay, Paris

Discussing shadows, Manet, before he himself started working out of doors, liked to maintain that, for him, "light appeared with such a unity that a single tone was sufficient to convey it and that it was preferable, even though apparently crude, to move abruptly from light to shade rather than to accumulate things the eye doesn't see, which not only weaken the strength of the light but enfeeble the color scheme of the shadows, which it is important to concentrate on." But the landscapists among Manet's friends had learned from experience that nature cannot be brutally divided into lighted and shaded areas. Although their observations helped them reduce the traditionally blackish tones of shadows, the landscape painters of the new school usually chose subjects in which the importance of shadows was reduced as much as possible. Thus, Pissarro preferred the stillness of spring or autumn days in the country to scenes of dawn or dusk.

In this painting, a road again constitutes the central feature. The line of the horizon being kept low, the sky occupies almost two thirds of the composition. A few tall trees on either side of the road reach high into the blue expanse. Their symmetry is relieved by a group of white buildings to the left, while only rooftops appear behind a low wall to the right. The invisible sun, evidently declining on the left, causes the trees to cast long shadows that cross the road in a slight diagonal, thus also preventing too symmetrical an effect.

There are none of the abrupt contrasts mentioned by Manet; on the contrary, the light is evenly distributed. The colors are soft, the brush stroke is small, delicate, but without hesitation, firmly establishing each form though smoothly blending the various elements so that none dominates at the expense of any other. Through a miracle of subtlety, an atmosphere of spring, warm sunshine, and peacefulness is achieved without suppressing the identity of houses or trees, of roofs, walls, or chimneys, all equally bathed in the light, all gently occupying their immutable place. PISSARRO CATALOGUE NO. 141

60

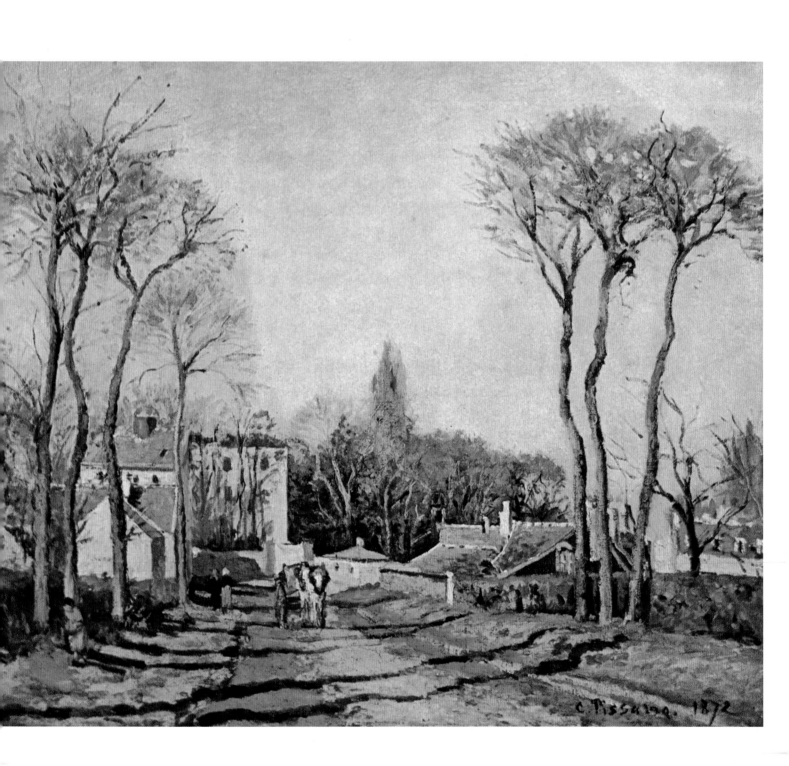

Painted 1872

CHESTNUT TREES AT LOUVECIENNES

Oil on canvas, 16¹/₈ × 21¹/₄″

Collection Mr. and Mrs. Alex M. Lewyt, New York

Courbet once jokingly said that it was his donkey who selected the sites of his landscape paintings; wherever the animal stopped on their outings, the painter would put up his easel and begin to work. Despite this obvious exaggeration, it is certainly true that the French landscapists of the second half of the nineteenth century approached their motifs much more casually than their predecessors had done. Not only did they discover beauty or picturesqueness in vistas that had until then been considered "unattractive," they actually shied away from anything that might appear too conventional, too pretty, or too cleverly arranged. This, however, does not mean that they chose their subjects with indifference or without regard for their harmonious qualities.

Duret's earlier criticism notwithstanding (see page 54), Pissarro's landscapes distinguish themselves precisely by the charm of their uncontrived composition. Never permitting himself to alter the features presented by nature, he had a particular gift for selecting motifs that presented pictorial attractions and structural elements of significant beauty which thus offered him ample opportunities for artistic exploration. Instinctively rather than methodically balancing shapes, opposing smooth planes to more detailed surfaces, harmonizing colors or contrasting them, establishing accents, shifting the focus from foreground to distance as the subject demanded, favoring nearly symmetrical aspects or, on the contrary, emphasizing either left or right, concentrating on a large expanse of sky, or else crowding the composition to the extent that the sky is scarcely visible, he always managed to create, through his composition as well as through its treatment, the particular mood he wished to evoke, a mood intimately linked to the seasons and the time of day.

In this group of bare trees observed in springtime, the peculiar diagonal of a battered trunk forcefully interrupts the verticals and the gnarled curves of the other trees as well as the faint horizontal of the aqueduct of Louveciennes in the distance. Strong lines of shadows animate the ground and contribute to its weightiness, so distinct from the cloudless sky. These shadows and the diverging lines of the two central trees thus break any threat of monotony in so unassuming a landscape; quite the opposite, they enhance it with a startling element of the unexpected. PISSARRO CATALOGUE NO. 148

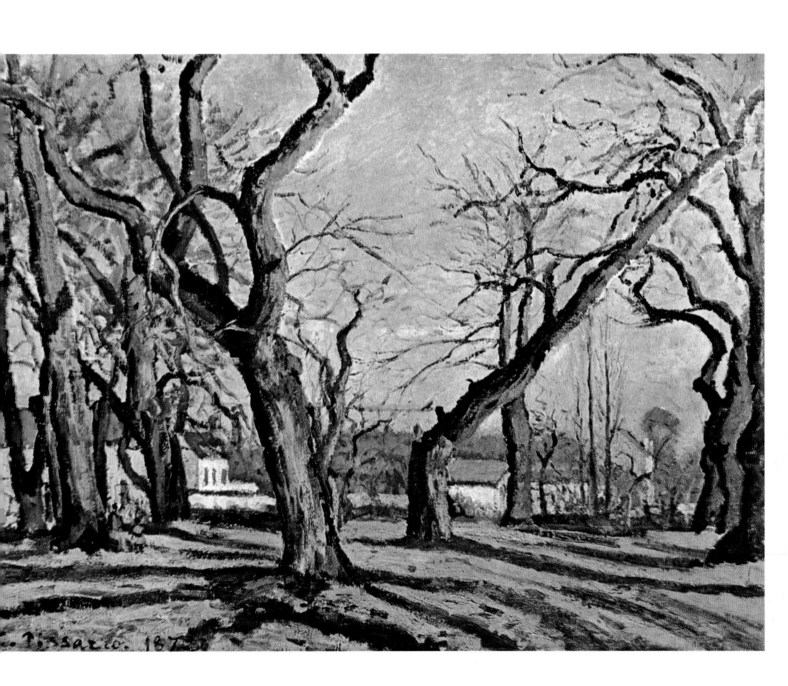

Painted about 1872

PORTRAIT OF MINETTE

Oil on canvas, 18¹/₈×14"

Wadsworth Atheneum, Hartford, Connecticut

A little girl stands aimlessly, idle, in a room. She does not wear her best clothes, or, if she does, they are hidden under the blue smock that French children used to put on for school. The room—at least what appears of it—is empty except for a partly folded extension table with various objects on it and a single bottle in a recess behind it. The walls form a corner in back of the girl; the left-hand one is covered with a diamond-patterned wallpaper above a dark green lower section, whereas the one at the right is uniformly brownish. A somber border at the base of this wall extends from the right to the child's skirt but does not continue all the way into the corner, a device doubtless designed to strengthen the effect of the straight vertical line of this corner while simultaneously establishing an uncluttered backdrop at the left, the opposite side of the composition already being occupied by the table with its small still life. Parallel to the baseboard and to the table top is the dark shelf of the recess, to which the lone bottle adds another vertical accent. There are, thus, a number of diagonals and perpendiculars that define with precision the space in which the child stands and at the same time enliven the background, providing it with a "lived-in" atmosphere. Yet the numerous oft repeated lines are arranged so as not to interfere with the figure itself. Not until Vuillard began to tackle related subjects some three decades later did a modern artist attempt to blend a figure with an "ordinary" setting without sacrificing one or the other.

The model is Jeanne-Rachel, the painter's daughter, who was nicknamed Minette. PISSARRO CATALOGUE NO. 197

64

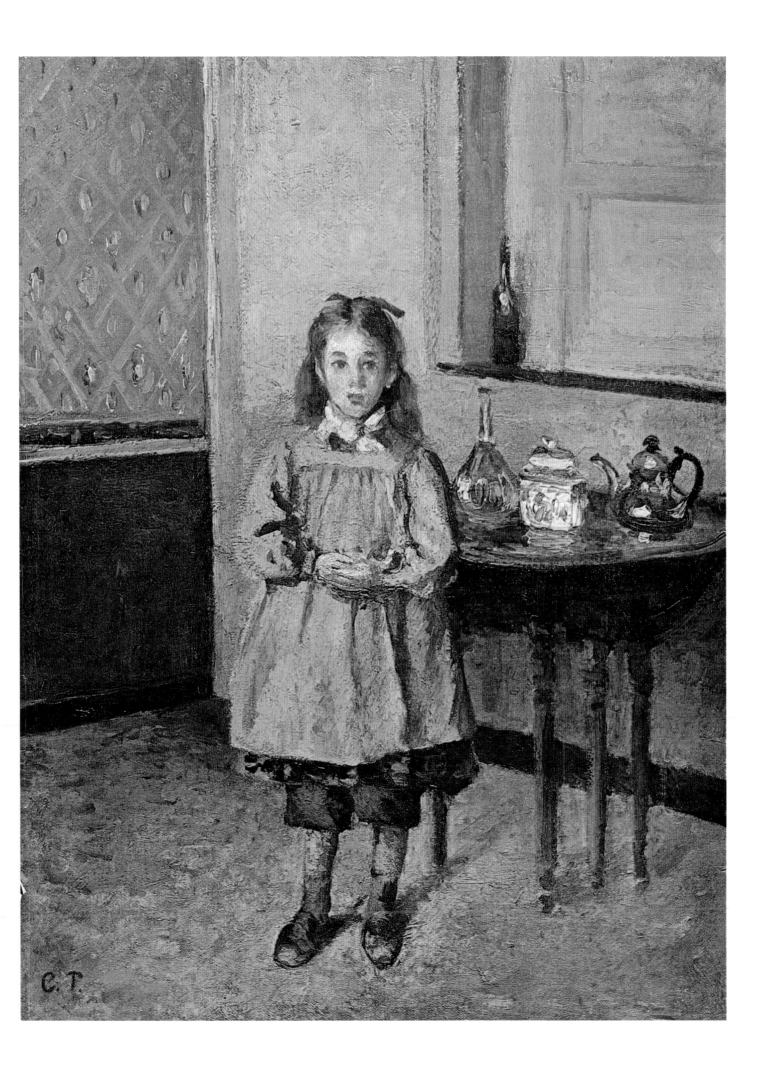

THE ARTIST'S DAUGHTER

Oil on canvas, 28¹/₂ × 23¹/₂"

Yale University Art Gallery, New Haven. John Hay Whitney, B. A. 1926, Collection

Pissarro painted only a few portraits and these were exclusively of members of his own family, close friends, and some peasants he knew well. Among these rare likenesses, this portrait of his little daughter Jeanne stands out, for it is the first "close-up" he did. The child was seven years old when he painted her, combining softness of color with a tenderness that makes one think of his former master, Corot. Muted yellows and pinks of varying shades are enlivened by the pale-blue ribbon in the straw hat and the outspoken tones of the flowers in the sitter's lap. An ornamental border on the wall serves to underline the uniformity of the background against which the figure is set in a natural pose, the small face with the large and questioning eyes directed straight at the beholder. There is a hint of sadness in the eyes of the girl, as if Pissarro had a foreboding that the child was to die only two years later.

Madame Pissarro bore her husband seven children, whom they raised with a devotion not always rendered easy by continuous material worries. The eldest, Lucien, was born in 1863 (he died in 1944 in England, to which he had immigrated in the eighties). Jeanne-Rachel, born two years later, died in Pontoise in 1874. A second son, Georges, was born in 1871, after the return of his parents to Louveciennes (he died in 1960). A third son, Félix-Camille, was born in 1874, three months after the death of little Jeanne. His life span was short; he died in London in 1897, at the age of twenty-three. A fourth son, Ludovic-Rodolphe, was born in 1878 (he died in Paris in 1952). Another daughter was born three years later and named Jeanne after her sister (she died in Paris in 1948). A last son—the only surviving child—Paul Emile, was born in 1884. All of them, at one time or another, sat for their father, who was delighted to see them attracted by the arts and who stimulated their early attempts at self expression. Without exception, Pissarro's sons chose to become painters. PISSARRO CATALOGUE NO. 193

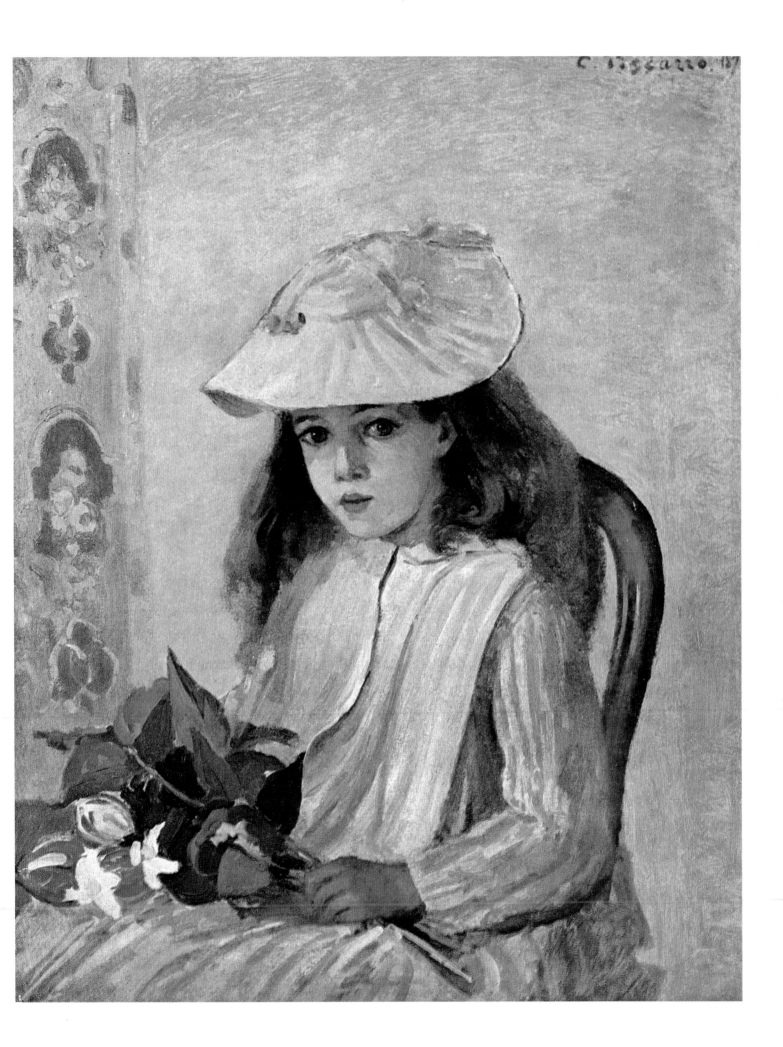

Painted about 1873

BOUQUET OF FLOWERS

Oil on canvas, 21⁵/₈×18¹/₈"

High Museum, Atlanta. Gift of the Forward Art Foundation in memory of its first President,
Mrs. Robert W. Chambers

On rainy days, when they could not paint out of doors, Pissarro and his friends worked in their studios, doing mostly portraits, nudes, or still lifes. On these occasions Pissarro seems to have particularly favored flowers. (Unlike Renoir, the only member of the group who continued to live in Paris, he was not able to secure models for studies of nudes.)

The artist's wife was extremely fond of flowers. In the early days of their life together she had even worked for a florist to earn whatever she could. Later, she always grew masses of flowers in her gardens; among them, her greatest pride were pink peonies. No wonder then that she often gathered bouquets for the still lifes of her husband and that these, as is the case here, would feature peonies of various shades, but especially pink.

The blossoms assembled in this small white porcelain vase were arranged with considerable care. The artist apparently sought for the most delicate nuances rather than for bright and dominant tones. Subtle gradations, pinks and whites interspersed with green leaves, set against a uniformly bluish background, transform this bunch of common flowers into a lovely and intimate poem. Not as flamboyant as Renoir's sparkling bouquets, nor as solid as Cézanne's fruits, this still life has a gentle charm only seldom equaled by Pissarro himself.

PISSARRO CATALOGUE NO. 198

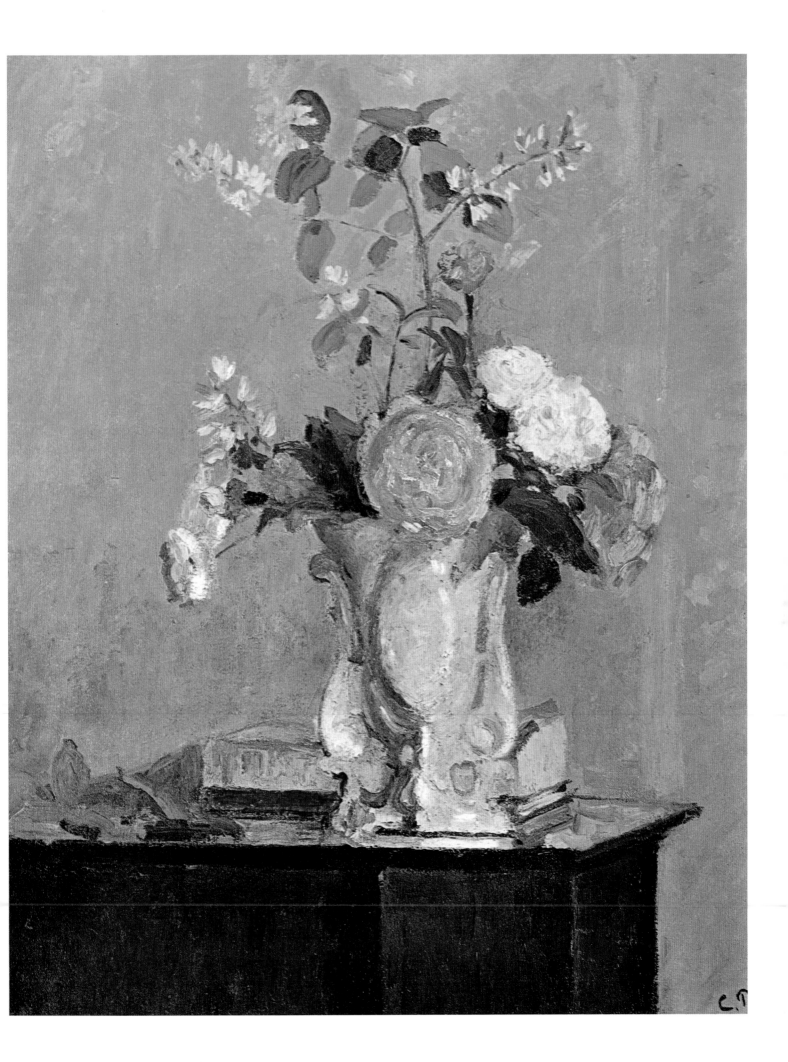

Painted 1873

SELF-PORTRAIT

Oil on canvas, 21⁵/₈ × 18¹/₈″

Musée d'Orsay, Paris

Among the small number of portraits by Pissarro, there are few of the artist himself. This self-portrait is the earliest of the four that are known (there may have been others among the canvases destroyed by the Prussians in 1870). The painter is forty-three years old here; his head is already balding and his ample beard has begun to gray, giving him a somewhat older appearance. His expression is grave yet mild. After difficult years, things seemed to be brightening a little; early in 1873 some of his canvases had brought surprisingly high prices at a Paris auction, and his dealer, Durand-Ruel, was steadfastly promoting the works of Pissarro and his friends.

"Pissarro looked like Abraham," George Moore later recalled. There was, indeed, a biblical dignity about him which is reflected even in this portrait, though it has obviously been done without any self-conscious "posing" on the part of the painter. With great honesty and simplicity, he has scrutinized his features—those of a modest, wise, and warm human being.

This patriarchal figure was a familiar sight in the various cafés where his friends used to gather, although living outside Paris and often unable to raise the fare for the short trip, he did not appear there as frequently as he may have wished, in order to participate in the revitalizing exchange of views that he must have missed in his rural isolation. When, the very year in which this portrait was painted, Monet and his companions decided to break completely with the whimsical Salon juries and to organize an exhibition of their own, Pissarro joined them as a matter of course; he also insisted that his friend Cézanne—who was then working with him in Pontoise and nearby Auvers-sur-Oise—be invited. It was at this first group show, held in the spring of 1874, that a mocking reviewer invented the word "impressionist" to designate these artists who, in his opinion, pursued a ridiculous attempt of re-creating on their canvases their impressions of nature. The new, derisive term was courageously adopted by the painters—with the exception of Degas—and actually used for some of their subsequent showings. Camille Pissarro was to be the only member of the group who participated in all eight exhibitions of the Impressionists, held between 1874 and 1886, and this in spite of the fact that these manifestations earned him more ridicule than fame, so that his modest success at the auction of 1873 was soon followed by complete public indifference. PISSARRO CATALOGUE NO. 200

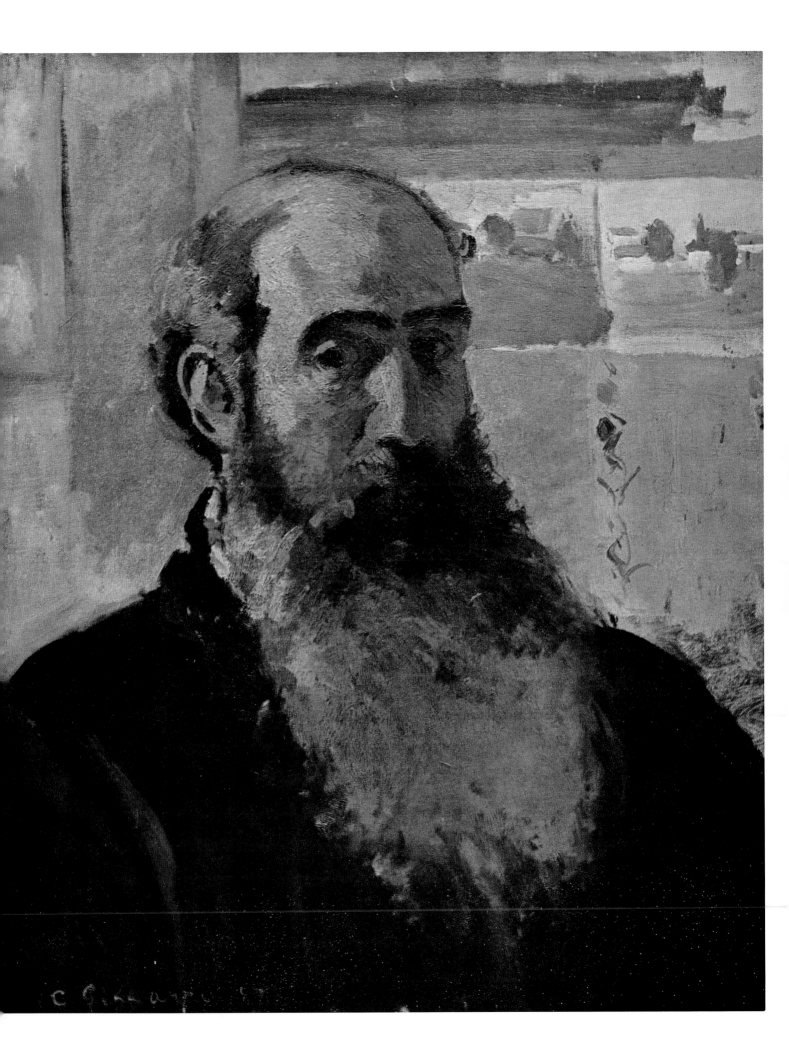

Painted 1873

THE OISE NEAR PONTOISE

Oil on canvas, 18×21³/₄″

Sterling and Francine Clark Art Institute, Williamstown, Massachusetts

It took courage to select a motif where smokestacks "marred" an idyllic site on the banks of a quiet river. These symbols of industrialization were considered unworthy of an artist's attention. And yet Pissarro used to full advantage their straight verticals rising toward a covered sky with whose clouds some of the white smoke confounds itself. The vividly painted vegetation on the slope in the foreground is contrasted by the limpid quality of the water with its reflections and by the more even execution of the structures and trees on the distant bank. The sky, however, seems to echo the vibrant brush strokes of the slope, so that the clusters of buildings and trees in the middle ground appear to be wedged in between these livelier areas; this different treatment produces an impression of both animation and calm.

In those crucial years of the early seventies, Pissarro was developing a style that, for all its poetic values, showed firmness of form and expression. Duret, who by now had come to understand more fully the goal his landscapist friends were pursuing (see page 54), wrote to Pissarro in 1873: "You haven't Sisley's decorative feeling nor Monet's fanciful eye, but you have what they have not, an intimate and profound feeling for nature and a power of brush, with the result that a beautiful picture by you is something absolutely definitive. If I had a piece of advice to give you, I should say: Don't think of Monet or of Sisley, don't pay attention to what they are doing, go on your own, your path of rural nature. You'll be going along a new road, as far and as high as any master!"

It seems doubtful whether Pissarro really needed such an admonition, for in spite of his genuine respect for Sisley and especially for Monet (whom he valiantly defended when he thought that Duret did not sufficiently appreciate his genius), he did not have any inclination to imitate them. In an art that is based essentially on the immediate expression of the painter's sensations, the artist is *alone* in front of his motif. Unless he is merely an imitator—which Pissarro certainly was not— the act of creation is the result of that indescribable process in which his observation of nature directly commands his hand, in which his brush follows the dictate of his eyes. (On this subject see page 84 for Lucien Pissarro's explanation.)

PISSARRO CATALOGUE NO. 218

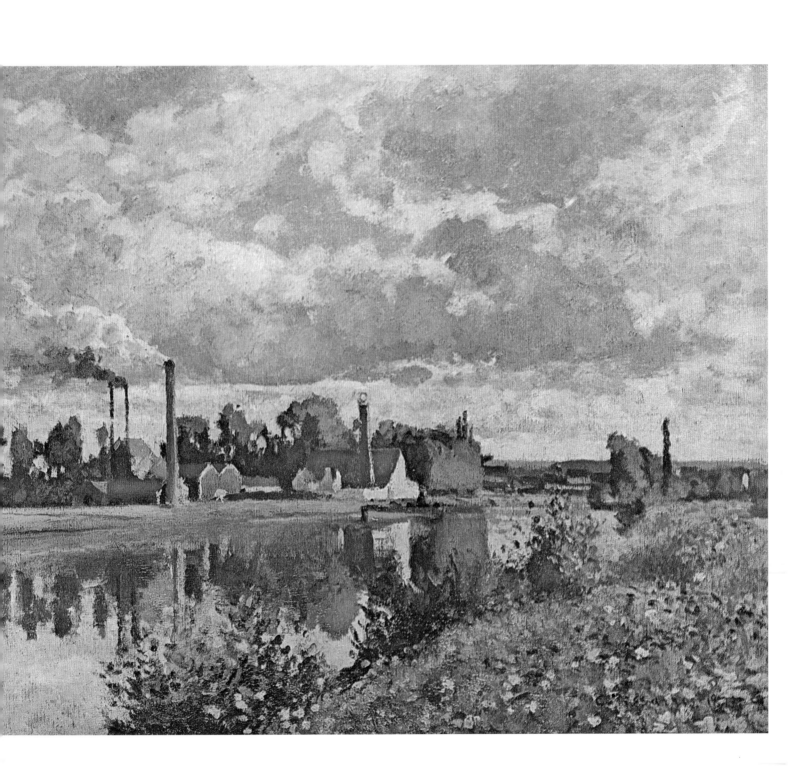

Painted 1873

THE HAYSTACK, PONTOISE

Oil on canvas, 18¹/₈ × 21⁵/₈″

Collection Durand-Ruel, Paris

Lionello Venturi has called this painting one of Pissarro's "most accomplished masterpieces. The mass of the haystack is almost conical, but this 'almost' allows the geometrical form to absorb the pictorial value. This mass pushes the plain into the far distance and consequently presents a strongly accentuated monumental character. The color is particularly precious and varied. The sky shows nuances of pink, white, purple, and blue. The plain is divided into white, yellow, green, and rose areas. The variety of colors invades everything, and yet each color has its function in the over-all light. Since the light manifests itself only in the colors, without any chiaroscuro, its smiling presence is felt everywhere, even in the penumbra, as if this painting were a feast of nature."

In contrast to a similar subject, painted a few years later in the rich meadows around Montfoucault (see page 81), the colors are soft, their luminosity is subdued, yet their pastel-like tints, interrupted by no harsh contrasts, and their subtle interplay create a vision of incredible calm and sunshine. The monumentality that Millet used to confer upon his figures of peasants in the fields has here been invested in the fields themselves and in the central haystack. Thus, without any literary or sentimental connotations, a simple landscape, masterfully composed and painted, becomes a symbol of man's toil and hopes, a glorification of the eternal miracle of harvesting. PISSARRO CATALOGUE NO. 223

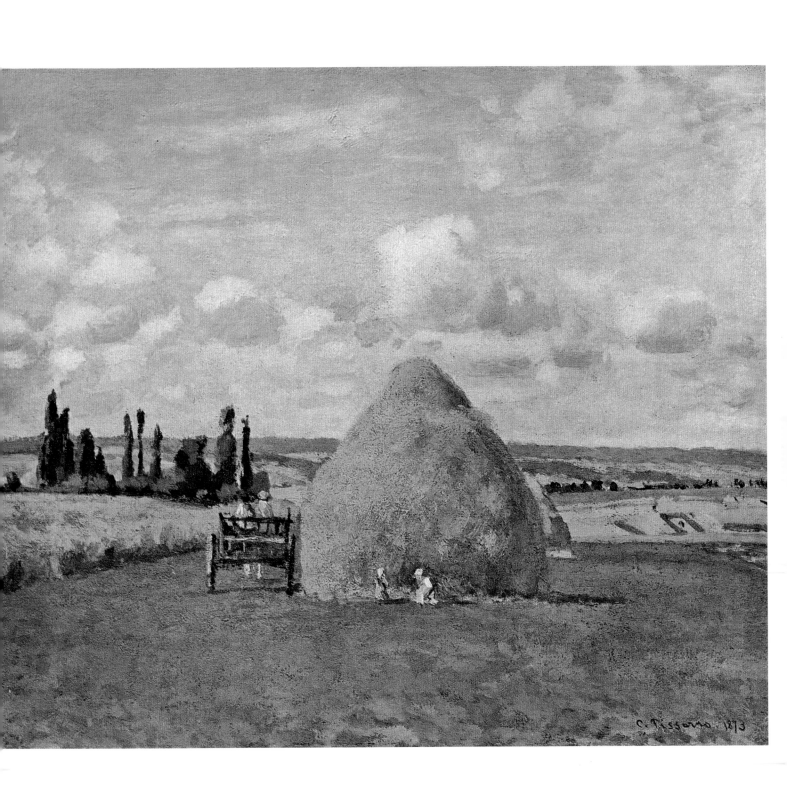

Painted about 1874

QUARRY NEAR PONTOISE

Oil on canvas, 22⁷/₈ × 28³/₈″

Kunstmuseum, Basel (R. Staechelin Foundation)

In the middle seventies Pissarro reverted temporarily to the palette knife so dear to Courbet which he himself had occasionally employed in earlier years (see page 51). Foregoing the technique of small commas or loose strokes applied with a brush, which can either fuse or oppose the tiny particles of color applied to the canvas, the artist used a flexible spatula with which the pigment is generally spread on larger areas and with less attention to detail. This little instrument flattens the pigment but often leaves uneven edges, so that the surface of the painting gains an accidental quality of lively contrasts, a mixture of rough and smooth which is quite unlike that produced by the brush even when the paint is put on in successive layers. Under the palette knife such successive layers tend to mix or blend on the canvas itself as the strength with which it is applied literally squeezes the fresh, oily substances together. Yet, while spreading the pigment in this fashion, the spatula frequently obliterates the precise limit of forms.

Courbet had preferred the palette knife for rendering rocks, vegetation, waves, or clouds, since these are usually devoid of linear contours and thus lend themselves particularly to a technique that facilitates the interpenetration of tints and shapes, producing a great richness of nuances and textures. No wonder, then, that some of Pissarro's paintings executed in a similar vein should be suggestive of Courbet, though their colors are brighter and the effects of light are observed with greater subtlety. The vigor with which Courbet had exploited the inherent possibilities of this peculiar mode of execution also pervades Pissarro's canvases but, at the same time, these achieve an intimacy and luminosity that are his own. PISSARRO CATALOGUE NO. 251

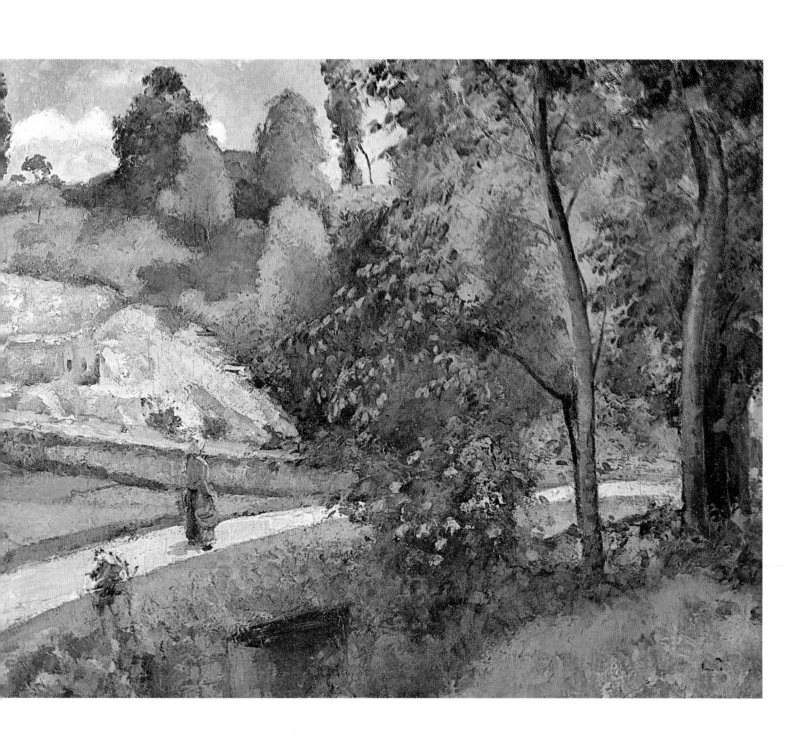

Painted 1875

THE CLIMBING PATH AT THE HERMITAGE, PONTOISE

Oil on canvas, 21 1/4 × 25 3/4"

The Brooklyn Museum, New York (Gift of Dikran G. Kelekian)

If the palette knife favors the interpenetration of pigments (see page 76), it also facilitates the interpenetration of pictorial planes. As applied by Pissarro, it seems to pull together all the features of his landscapes, obliterating distances as well as individual textures. The result is not unlike a tapestry, although the air still circulates freely among the various forms.

In this view of the Hermitage at Pontoise the climbing path to the right is divested of all earthy heaviness and seems to be a luminous ribbon adorning the fresh greens of shrubs and trees. The edge of a rock, barely distinguishable in the midst of these greens, appears on the left side of the path, rising from what looks like a pool behind the tree trunks. But such is the unifying propensity of the palette knife technique that path, rock, pool, and vegetation are barely distinct from each other as they are fused in the glimmering light. Only the houses with their colorful roofs, perceived through an opening among the trees, constitute an easily recognizable element and a distinct accent in this dazzling weave of bright colors and diffuse forms. PISSARRO CATALOGUE NO. 308

78

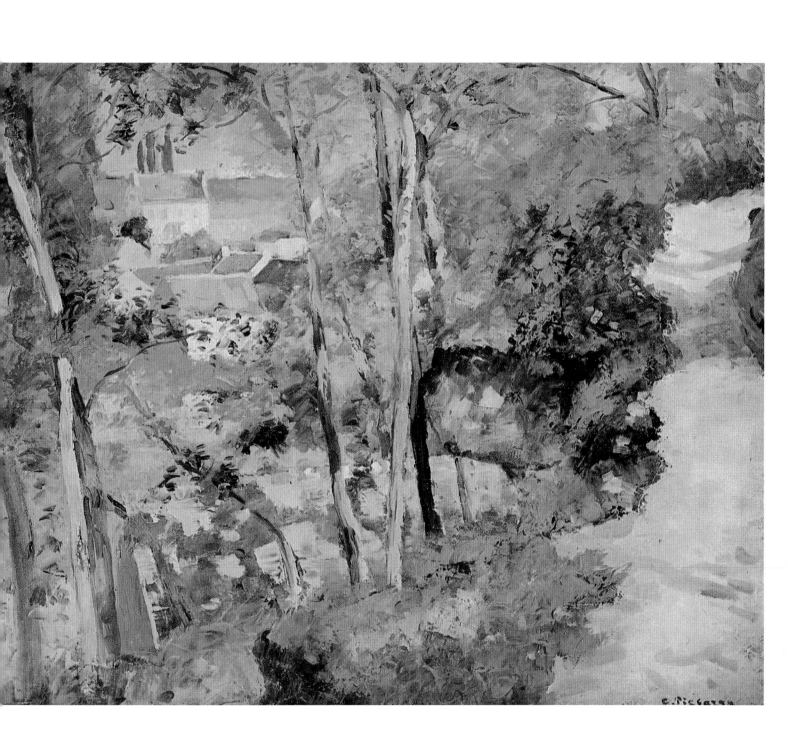

Painted 1876

HARVEST AT MONTFOUCAULT, BRITTANY

Oil on canvas, 25¹/₂ × 36¹/₂″

Musée d'Orsay, Paris (Caillebotte Bequest)

Shortly after his arrival from Saint Thomas, Pissarro had met the painter Ludovic Piette while working in the outskirts of Paris. They became fast friends and Piette, a few years older than Pissarro, repeatedly invited the latter to his large farm at Montfoucault in Mayenne, between Normandy and Brittany, where he himself always spent part of the year. Rather well off since his family owned numerous properties in the region, Piette was able to offer his friend a haven whenever the pressure of daily worries became too great. After the first Impressionist show, which had been a financial fiasco, Pissarro availed himself of Piette's hospitality and spent the winter of 1874–75 with his family at Montfoucault. He returned there again in the fall of 1875 and, for the last time, during the harvest season in 1876 (Piette died the following year, at the age of fifty-one). On each of his sojourns, Pissarro painted numerous landscapes, often with peasants in the fields, some interiors, and also various scenes of peasant women spinning, carrying water, etc.

While his subjects were not different from those he used to treat elsewhere, the colors of his landscapes executed at Montfoucault are frequently unlike those done around Pontoise. Due to the nearness of the Atlantic Ocean, the region boasts fresher greens and a clearer sky. This becomes quite obvious when this harvest scene at Montfoucault is compared to the *Haystack, Pontoise*, painted in 1873 (page 75). The artist adapted himself to the characteristics of Breton landscapes by foregoing his technique of small hatchings in favor of a broader manner that is solid and yet light. Thus, the wheatfield and the trees against the mottled sky are more strongly modeled and Pissarro's customary delicacy is replaced by a more forceful approach.

This new note in his work reveals the wealth of Pissarro's genius and potentialities. At the very moment when critics were saying that his paintings shown in the Impressionist group exhibitions resembled "palette scrapings uniformly put on a dirty canvas," the artist, with a magnificent unconcern for the public's lack of comprehension, produced this joyous fugue. If he had left nothing but this painting, Pissarro would still occupy a place among the great landscapists from Rembrandt to van Gogh. PISSARRO CATALOGUE NO. 364

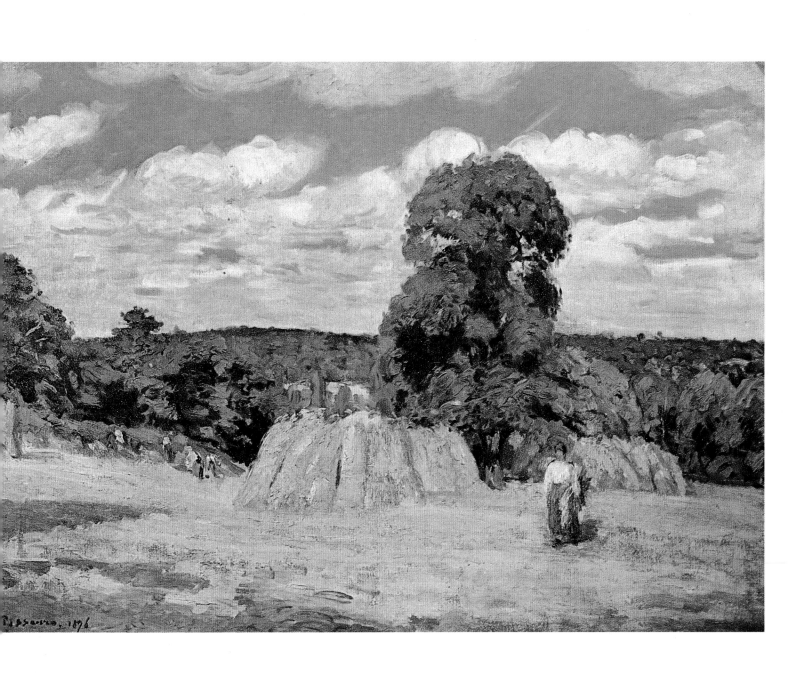

Painted 1877

ORCHARD WITH FLOWERING FRUIT TREES, SPRINGTIME, PONTOISE

Oil on canvas, 25⁵/₈×31⁷/₈″

Musée d'Orsay, Paris (Caillebotte Bequest)

This picture was painted at Pontoise behind the little house on the Quai de Pothuis to which the artist had moved upon leaving the Hermitage quarter. The site, which did not change much until the second World War, also attracted Cézanne, who was then visiting with his friend after having previously worked in his company in 1874–75. Cézanne not only treated the slope with the houses on the summit in several landscapes but actually painted exactly the same view as this one (page 30), having no doubt placed his easel beside that of his former mentor. The two friends repeatedly selected identical motifs, yet it seems that the community of their work was rarely quite as close as when they painted this garden with its blooming trees. Cézanne's canvas appears to have remained unfinished (the petals having doubtless dropped before he was able to complete his work), while Pissarro succeeded in rendering the fragile beauty of the branches covered with their snowy burden.

In contrast to his previous, larger brush strokes and his recent use of the palette knife (pages 77 and 79), Pissarro now evolved a technique of small dots and hatchings that seems particularly appropriate for the reproduction of lively textures. But even with an execution adapted to the specific nature of a subject, how great an effort is needed and how much agony may ensue when the completion of a picture runs the risk of being thwarted by a late frost, an inopportune shower, or a strong gust of wind. Yet through the deftness with which he proceeded, the artist not only overcame all the obstacles but he captured the freshness of his motif as well. If he met problems here, he knew how to deal with them, to the extent that not the slightest trace of them remains in this sparkling hymn to spring. It was nevertheless with some resignation that, a few years later, when his eldest son turned to painting, he advised him: "I recommend one thing to you, and that is always to do one's best to finish what one has begun. However, I know from my own experience the difficulty, or rather the many unexpected difficulties, that assail one while working out of doors."

Cézanne, during the days when he painted at Pissarro's side, benefited from similar and unquestionably more specific advice, which prompted him to say subsequently, "Pissarro was like a father to me. He was a man to be consulted and something like God." PISSARRO CATALOGUE NO. 387

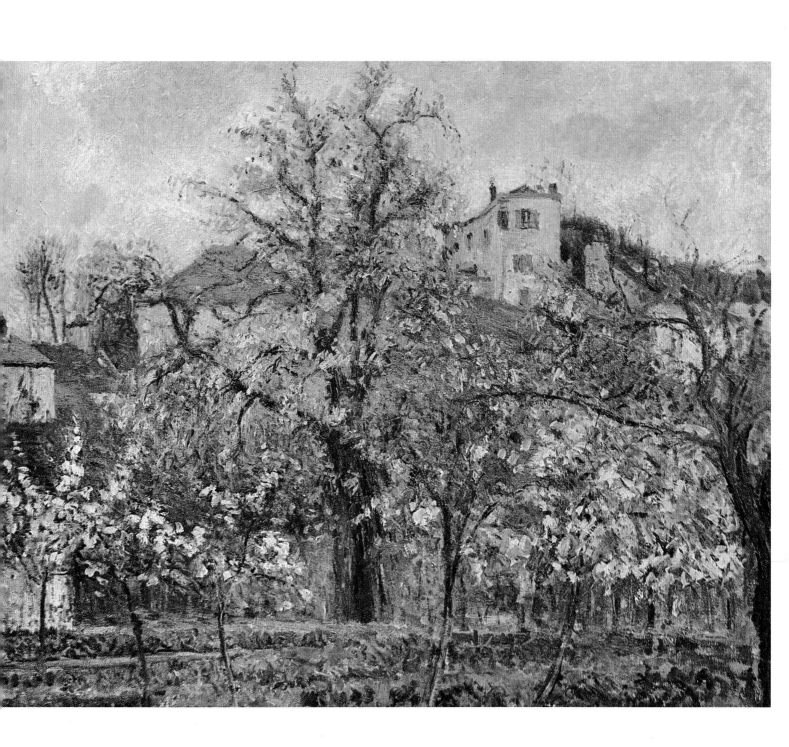

Painted 1877

THE RED ROOFS, VIEW OF A VILLAGE IN WINTER

Oil on canvas, 21¹/₄ × 25⁵/₈"

Musée d'Orsay, Paris (Caillebotte Bequest)

If the picture of the harvest at Montfoucault (page 81) was broadly painted and apparently finished in a single, prodigious effort, this landscape, executed in the same year, shows a totally different aspect and technique. Here the canvas is covered with a multitude of small strokes, forming in places a thick layer (similar to Cézanne's famous *Maison du pendu* of 1873–74), and producing by their density a harmonious effect in which the individual brush stroke disappears as one looks at the picture from a distance. At the same time, the accumulation of tiny strokes in multiple colors provides the painting with a certain relief and a richness of gradation resembling old enamels.

A clue to the artist's attitude and the way in which he proceeded may possibly be provided by a discussion his son Lucien had many years later with an English collector to whom he explained, concerning one of his own landscapes: "When I work I never, or very rarely, consider the execution, and my best things have always been entirely subconscious. It is the color and tone that especially attract me, and to me an atmospheric effect cannot be truly rendered by a bold sweep of paint, but by touches of subtle difference that suggest the delicate variety of nature."

To this the collector replied: "How do you mean you paint subconsciously? Subconscious is a very popular word nowadays and used, or rather misused, I think, in more than one sense. I personally admit that I don't know what it means, unless it is a superior word for imagination or soul. A man must be completely conscious of what he is doing, or perfectly unconscious, unless he is tipsy. . . ."

"I fear," Lucien answered, "I will fall into a trap using the word subconscious about painting, but it describes a state I cannot express otherwise. My father would have said that he painted instinctively, and Monet has actually said that he painted like a bird sings [this was a favorite expression of Corot's]. Your suggestion of tipsiness is not altogether wrong; intoxication would be better. Unconsciousness is used for instinctiveness, which is explained as a process of reasoning so quick that we are not conscious it is working, and when, on rare occasions, one can work so, it is a sort of submerging by the painter in the thing he is painting, and he is for the time not conscious that he is painting at all."

PISSARRO CATALOGUE NO. 384

84

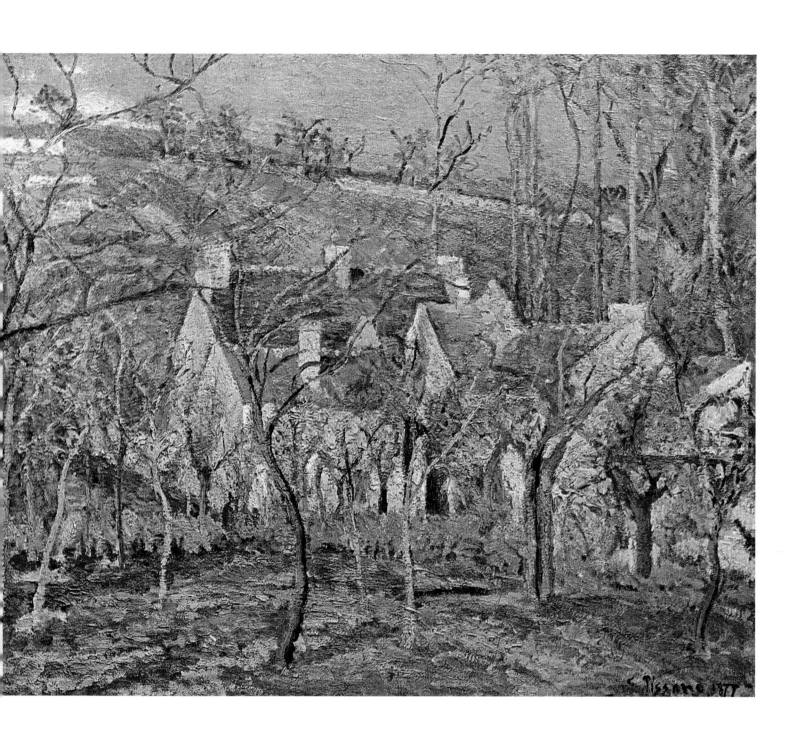

Painted 1878

PARK IN PONTOISE

Oil on canvas, 25¹/₂ × 21"

Collection Mr. and Mrs. Benjamin M. Reeves, New York

The subject is once more a combination of the various elements on which Pissarro liked to dwell: solid forms of buildings opposed to the graceful arabesques of a tree, clouds in a blue sky, the sensation of movement provided by a few figures set against a wall behind which appears the tangle of colorful structures, and throughout, a bright light that bathes the entire scene, brushed vividly and in almost gay tonalities. Yet this direct and apparently spontaneous interpretation of life in a small town was still contrary to what conventional critics expected.

In 1876, on the occasion of the second group exhibition of the Impressionists, one of the most influential reviewers had stated that "those self-styled artists . . . take up canvas, paint, and brush, throw on a few tones haphazardly, and sign the whole thing. . . . It is a frightening spectacle of human vanity gone astray to the point of madness. Try to make M. Pissarro understand that trees are not violet, that the sky is not the color of fresh butter, that in no country do we see the things he paints, and that no intelligence can accept such aberrations!" Such comments did not exactly encourage people to buy Pissarro's pictures; after the close of the exhibition he had once more to appeal to Piette's hospitality.

The artist did not fare much better at the third group show, the following year, and when he auctioned off some of his works, they brought only between 50 and 260 francs apiece. In order to help his friends, Duret published in the spring of 1878 (the year this canvas was painted) a pamphlet devoted to the Impressionists in which he linked them with their great forerunners, to prove that they were continuing the tradition of French landscape painting. Of Pissarro he said that of the group he was "the one in whose work one finds in the most accentuated manner the point of view of the purely naturalistic painters. He sees nature in simplifying it and through its most permanent aspects. . . . His canvases communicate to the highest degree the sensation of space and of solidity; they set free an impression of melancholy." (Speaking of melancholy, a word with which the artist himself concurred—see page 100—Duret neglected the almost frenetic lyricism that appears in this painting as well as in the *Orchard*, page 83).

Duret courageously predicted that the day would come when Impressionism would be generally accepted. Shortly after the pamphlet appeared, Manet informed the author that he had met several of the painters, who had been filled with new hope by his promise of better days ahead. "And they need it badly," Manet added, "for the pressure is tremendous at the moment."

PISSARRO CATALOGUE NO. 442

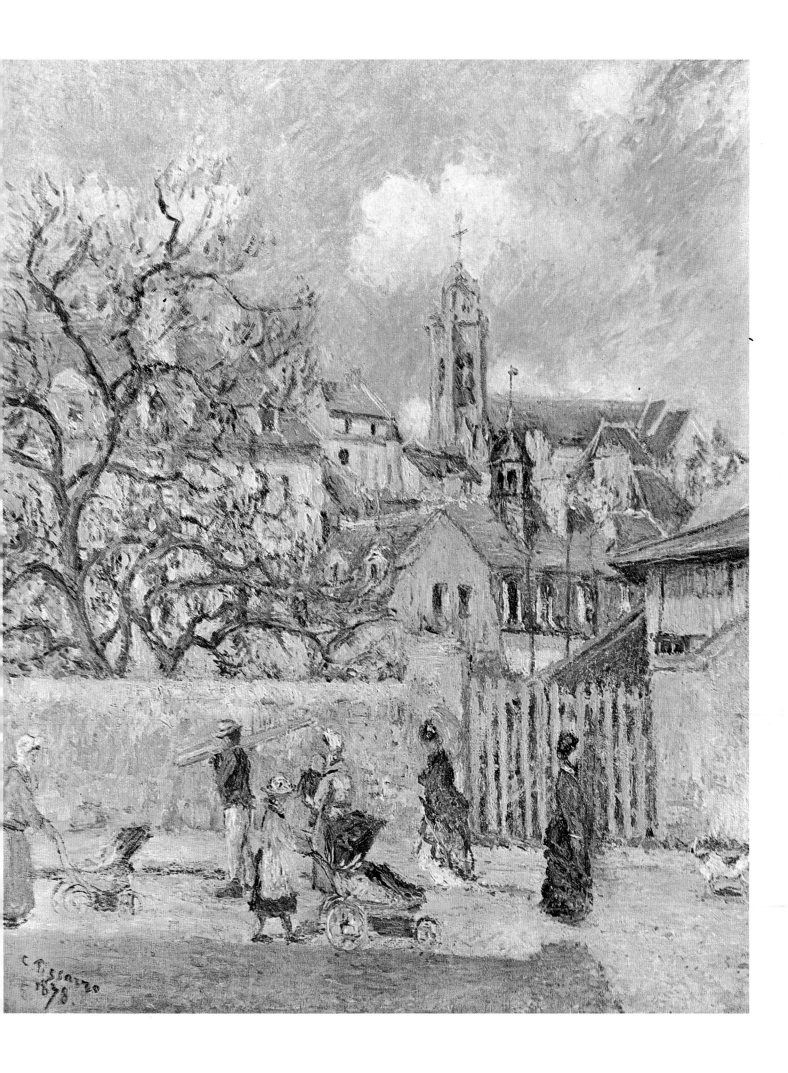

Painted 1879

STREET SCENE, PONTOISE

Oil on canvas, 14³/₄ × 18″

Private collection

In spite of his fondness for fall and winter landscapes, the glories of bright summer light never lost their attraction for Pissarro or for any of the other Impressionists. For all of them, the sun remained the supreme master, lengthening or shortening shadows, stressing or hiding forms, illuminating or softening colors. This sun-drenched view of a street in Pontoise which, in the distance, reaches the open country and doubtless loses itself in the fields, is typical of the summer scenes that Pissarro liked to paint: here are the small houses with their gardens, trees, soft hills in the background, horse-drawn carts, a peasant woman of the kind that appears in so many of his canvases, and above this pleasant vista, the blue sky of a sunny day. Here is rural calm with a discreet hint of animation, a perfect blending of buildings, vegetation, and a few figures. All this is observed with a loving eye that transforms what may have appeared banal to others into an image of peace and quiet living.

Cézanne greatly admired his friend's landscapes painted in midsummer and in full sunshine. One of these actually reminded him of the country around his native Aix and he therefore suggested to Pissarro that it might be good for him, as well as for the health of his children, if he moved to the South of France where he would be able to find many similar motifs. Yet Pissarro did not seem to tire of Pontoise and its surroundings, which presented him with such an unlimited variety of subjects. When he eventually left his house there, in 1882, it was to move to the nearby village of Osny, which did not differ basically from Pontoise. And when he began, a little later, to look for new lodgings, it was not in Provence (which he never visited) but a little farther to the north, in the village of Eragny near Gisors, with its fields and hills, its picturesque steeple, its broad street, its little river, and its rolling countryside, that he found what he wanted.

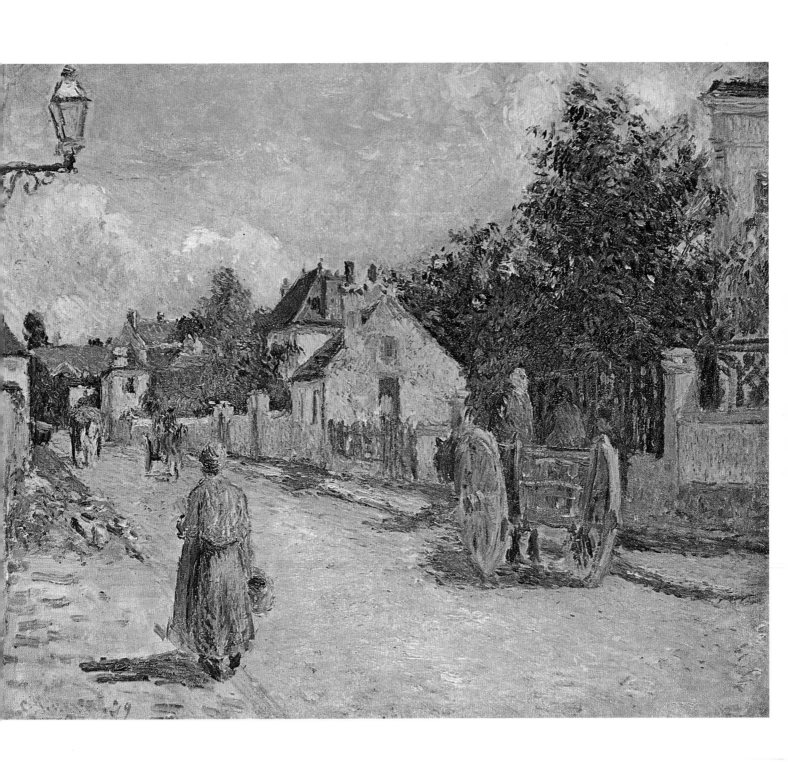

Painted 1880

CHAPONVAL LANDSCAPE

Oil on canvas, 21¹/₄ × 25¹/₂"

Musée d'Orsay, Paris (Caillebotte Bequest)

The region around Pontoise supplied Pissarro with a large number and variety of motifs. The Pente du Choux with its vegetable gardens; the banks of the Oise with chimneys, factories, and boats; the slopes of Valhermeil with their plowed fields; the Hermitage with its chateau behind thick foliage; the road to Auvers with its fruit trees, passing through the village of Chaponval and running parallel to the river—all this did not cease to attract his attention. He would often place his easel in the fields or meadows. The blue sky with clouds floating above the hillocks helps to give this beautiful country its aspect of smiling abundance.

If his occasional collaboration with Cézanne and the ensuing give-and-take has left any trace in Pissarro's work, it may be found in certain structural elements to be noticed in landscapes such as this view of Chaponval, which reveals a tendency to simplification and a more synthesizing concept of nature.

In the late seventies and early eighties Pissarro as well as Monet and Renoir showed a predilection for blue tonalities that exasperated Zola's friend, the novelist J.-K. Huysmans, who in those years tried his hand at art criticism. At first hostile to Impressionism, he accused the painters of "indigomania" and took exception to what he called their tendency of seeing "hairdresser's blue in all of nature." He went so far as to say that the Impressionists "could confirm the experiments of Dr. Charcot on the alterations of color perceptions, which he had observed in the cases of many hysterics . . . and in numerous people afflicted with nervous disorders. Their retinas were sick. . . ."

These comments particularly outraged Paul Gauguin who had met Pissarro around 1877. He had begun to paint at Pissarro's side in Pontoise whenever he could spare any time from his job as a broker, and in 1879 had been invited by his new friend and mentor to join the Impressionist group. For years Gauguin was unable to forgive Huysmans' insinuations, although the latter subsequently commented very favorably on Gauguin's work and conceded that Pissarro was "improving" (while it was actually Huysmans himself who gradually became used to the innovations of Impressionism). Indeed, in 1881 Huysmans wrote: "Pissarro may now [!] be classed among the number of remarkable and audacious painters we possess. If he can preserve his perceptive, delicate, and nimble eye, we shall certainly have in him the most original landscapist of our time."

PISSARRO CATALOGUE NO. 509

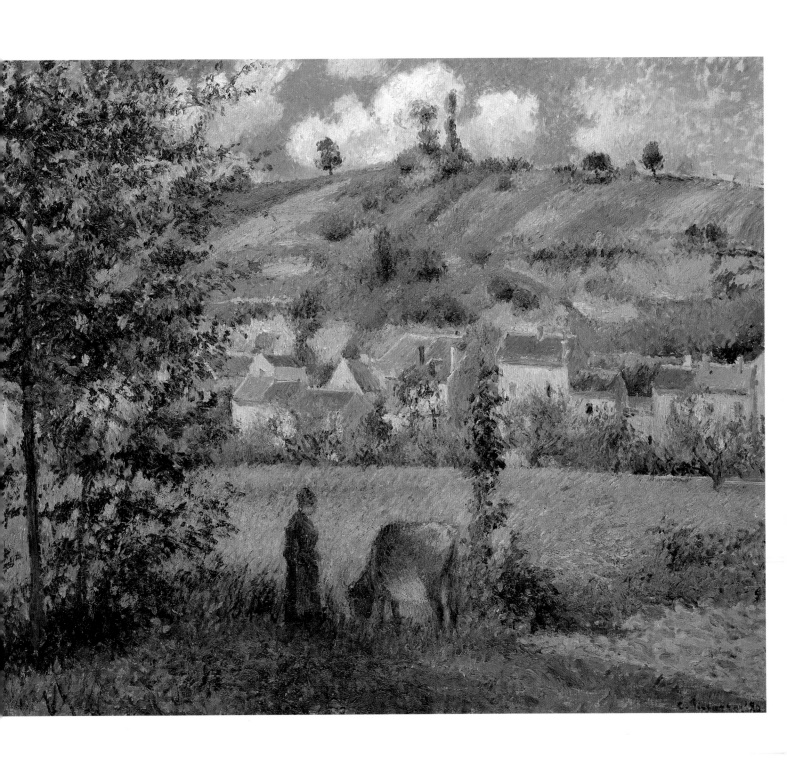

Painted 1880

LA MERE LARCHEVEQUE

Oil on canvas, 28³/₄ × 23⁵/₈″

Metropolian Museum of Art, New York, gift of Mr. and Mrs. Nate B. Spingold

Pissarro liked to say, "It is I who am a Hebrew and it is Millet who is biblical." Indeed, there is usually a sentimental quality about Millet's peasants which is completely absent from similar works by Pissarro. Yet in spite of his tendency to idealize his rural subjects, Millet had met great difficulties in winning acceptance for them. By 1880, however, five years after his death, his work was universally recognized and even brought extravagantly high prices. This belated success established a romantic image of peasantry which Pissarro neither could nor would accept. He went one step further and painted peasants without "glamorizing" them, approaching them with a realistic interest in their features and dress or in their occupations, which was based on his intimate knowledge of their daily life rather than on literary concepts of their hard work. Unlike Monet and Sisley, for instance, who devoted themselves to landscapes without apparently being attracted by the people who tilled the soil or tended the farmyard, churned the butter or spun the wool, Pissarro never separated the fields and woods from those who lived by them.

In this admirable canvas, a peasant woman, one of the artist's neighbors, is portrayed without any grandiloquence. She sits at ease against a plain but stark background; Pissarro has painted her rugged face, her clothes, and the scarf around her head with his eyes concentrated on color, texture, and the accidents of light and shadow. The result is a striking likeness of power and simplicity. Though it is not "biblical" and makes no attempt to symbolize the mysterious link between humanity and the earth, of which Millet was so fond, it is nevertheless a profound and sincere homage to those who, with their hands, provide our daily bread. PISSARRO CATALOGUE NO. 513

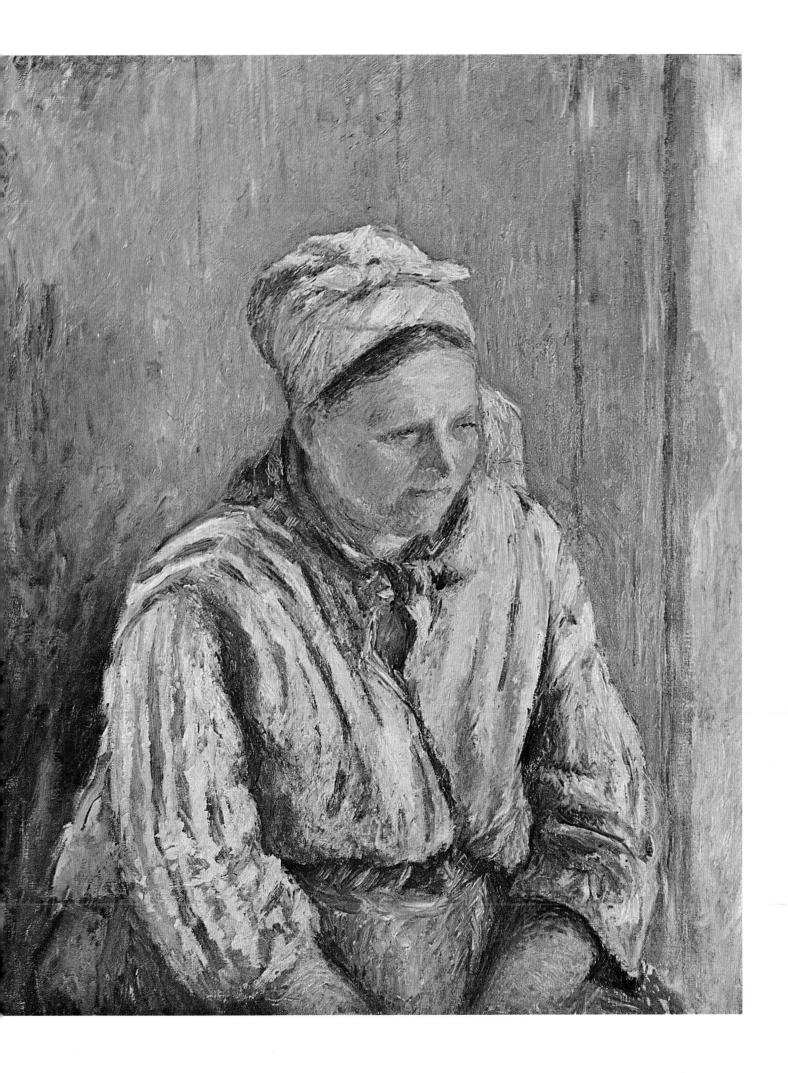

Painted 1881

PEASANT GIRL WITH A STICK

Oil on canvas, 31⁷/₈ × 25⁵/₈″

Musée d'Orsay, Paris (Camondo Bequest)

If in Pissarro's work, nature is above all generous, bringing man the rewards of his labors, the people he represented were simple and robust beings, unseparable from it. Goose girls and little farm maids, peasant women at the village market (page 109) or harvesters, women gathering apples (page 99) or young girls pushing wheelbarrows—he was in love with them all. And he painted them with a deep understanding that was not devoid of poetry and emotion, with a keen eye that observed without sentimentality their awkward poses and timid looks, their plain clothes and typical gestures that have a grace all their own.

At the seventh Impressionist group show, in 1882, Pissarro exhibited, next to a number of landscapes, a particularly impressive series of these "portraits" of peasants which prompted Huysmans—suddenly rallied to the new cause—to exclaim: "Now this painter reveals himself to us under an entirely new aspect! As I have written before, I believe, the human figure, in his work, often took on a biblical allure [the artist did not altogether agree with this interpretation; see page 92], but not anymore. – M. Pissarro has freed himself completely from recollections of Millet [in reality Huysmans by now had freed himself from certain misconceptions]. He paints his country folk without false grandeur, simply, as he sees them. His charming girls in red stockings, his old women with kerchiefs, his shepherdesses and washerwomen, his peasant girls breakfasting [page 101] or gathering weeds are truly little masterpieces."

But no one has characterized the touching beauty of these beings better than Degas, when he said that Pissarro's peasant women were like "angels who go to the market."

PISSARRO CATALOGUE NO. 540

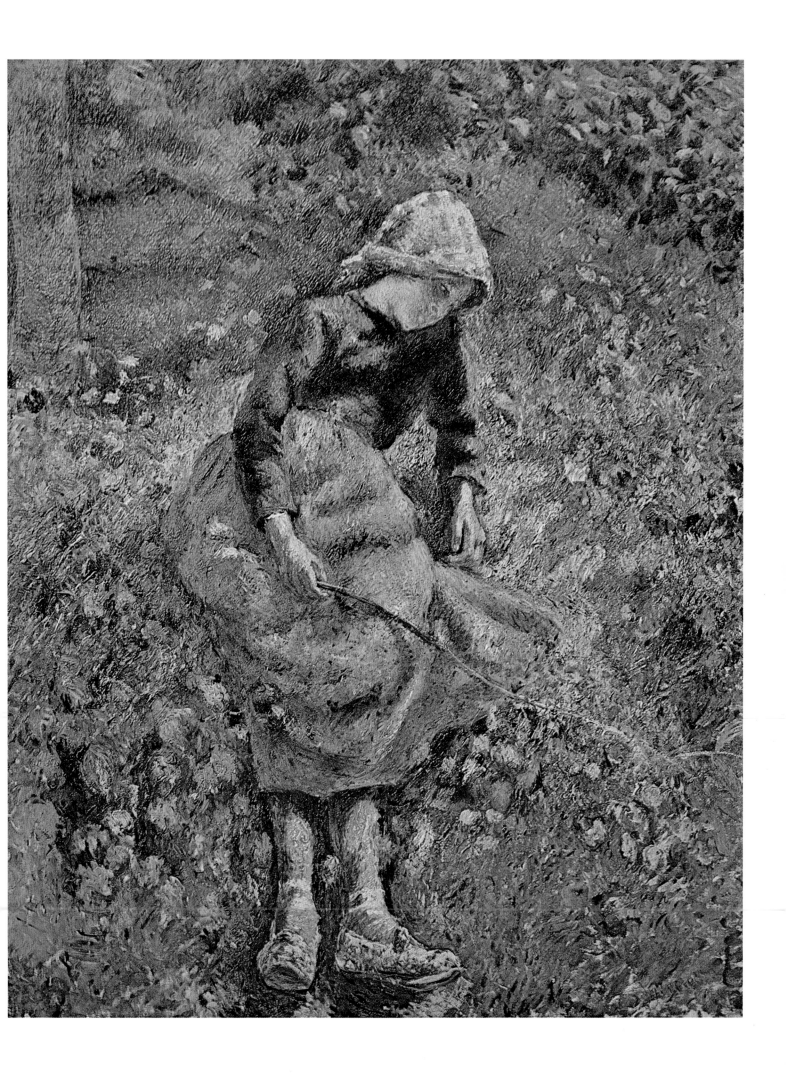

Painted 1881

PEASANT WOMAN

Oil on canvas, 28³/₄ × 23⁵/₈"

National Gallery of Art, Washington, D. C. (Chester Dale Collection)

The French novelist Octave Mirbeau, a close friend of the Impressionists and particularly of Pissarro and Monet, once said that the human figure was in certain ways also a landscape, especially when treated by Pissarro as a "form being enveloped by light, that is, through the plastic expression of light—on objects that bathe in it, and through the space it fills."

"Nobody," Mirbeau wrote, "has analyzed with more intelligence and penetration the character of things, as well as that which is hidden behind the living appearance of figures. And the power of his art is such, its equilibrium is so harmoniously combined, that the minute analysis and the innumerable details, juxtaposed and merged in each other, produce a synthesis for the astonishment of our minds: a synthesis of plastic and of intellectual expressions, in other words, the highest and most perfect form of a work of art.

". . . The particular occurrence, the accidental, the individual [in Pissarro's work] occupy strictly the place they should hold in a largely conceived ensemble. The eye of the artist, like the thought of the philosopher, discovers only the broad aspects of things, the totality, the harmony. Even when he paints figures or scenes of rustic life, man always remains in the perspective of a wide, tellurian harmony, reduced to his function of a human plant. In order to describe the tragedy of the soil and to move us, M. Pissarro has no need for violent gestures, complicated arabesques or sinister branchings against livid skies. . . . Life is evoked, the dream rises, hovers, and that which is so simple, nevertheless, and so familiar to our sight, transforms itself into an ideal vision, is amplified and lifted until it becomes the realization of great, decorative poetry."

In spite of the typically Impressionist technique of lively brushwork, the momentary effects of light were not pursued by Pissarro into the regions where forms are dissolved in the subtle play of sunshine and shadow. He used the Impressionist execution, as in this portrait of a peasant woman, the better to endow with rich nuances the solid volumes that detach themselves from the vividly textured background. PISSARRO CATALOGUE NO. 547

N. B. *This canvas, unsigned and undated, was part of the artist's estate. The signature and date (1880) which now appear in the lower right corner were added later, possibly by Pissarro's son Georges.*

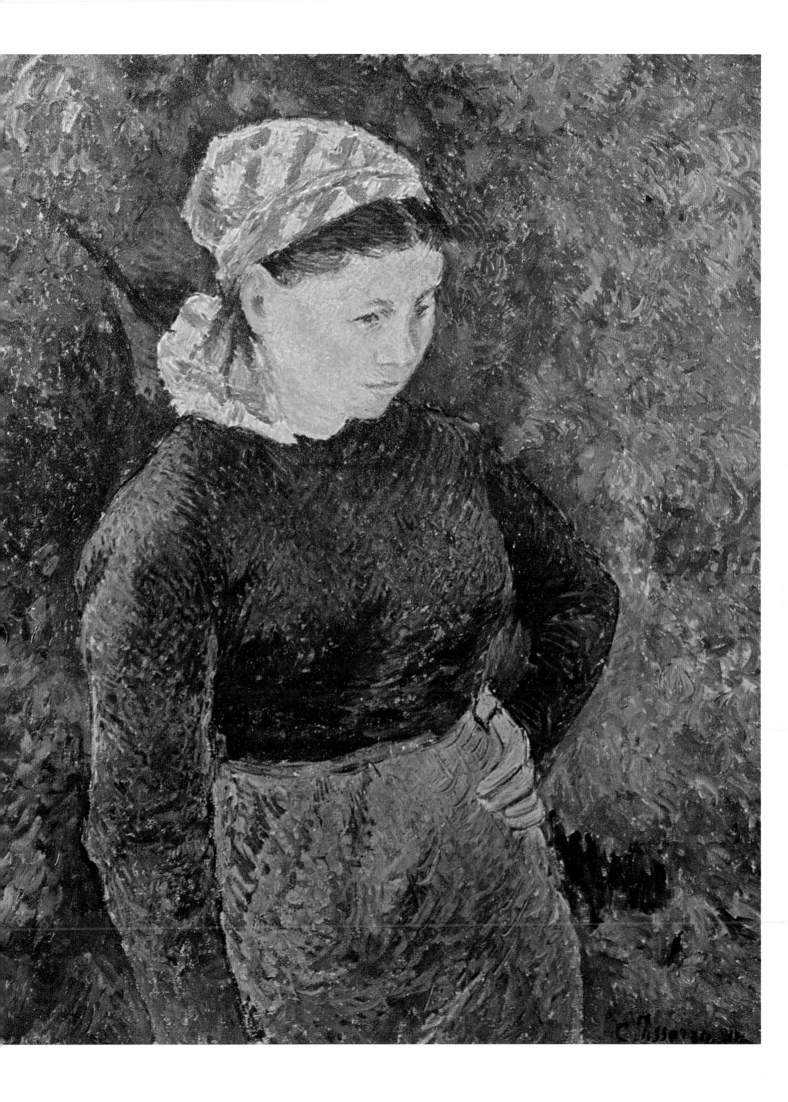

Painted 1881

THE APPLE PICKERS

Oil on canvas, 25⁵/₈ × 21¹/₄″

Collection Mrs. Melvin Hall, New York

One of the essential tenets of Impressionism was, of course, to free the artist from the yoke of preconceived ideas or dead traditions, in order to help him attain an individual expression through intimate contact with nature and direct observation of its phenomena, translated on canvas with utmost spontaneity. But since the Impressionists were all friends and occasionally even worked side by side, they sometimes produced works that show marked similarities. Although Pissarro was not particularly close to Monet and Renoir, in this painting he has studied the special effects of light with which they had been preoccupied around 1875. Placing their models under trees so that they were dappled with spots of sun rays falling through the foliage, Monet and Renoir had endeavored to reproduce the shimmering reflections on faces, bodies, and dresses. Their models had become merely another means for observing and representing curious and momentary effects of light and shade, which partly dissolve forms and offer the gay and capricious spectacle of dancing sunbeams.

In his *Apple Pickers* and a few other canvases, Pissarro has followed a similar course. His appealing composition, established with the care he always took to integrate harmoniously groups of figures with outdoor settings, is sprinkled with blue shadows. These, however, are more discreet than is usually the case in the paintings of his friends and therefore do not detract from the landscape and the women in their typical attitudes.

Five years later, when he adopted Seurat's divisionism, which preconized the methodical separation of nature's elements—light, shade, local color, the interaction of colors—and their delicate fusion through a pointillist execution, Pissarro returned to the same subject or rather redid completely another version, also begun this year and on which he had worked again in 1883, once more using the two figures at the left (see Pissarro Catalogue No. 695). This second version, despite, or perhaps, because of, the fact that it had been so long in the making, and also due to its less spontaneous technique, appears more static, the immediate charm of the subject that had originally seduced the artist having been lost in the process. PISSARRO CATALOGUE NO. 545

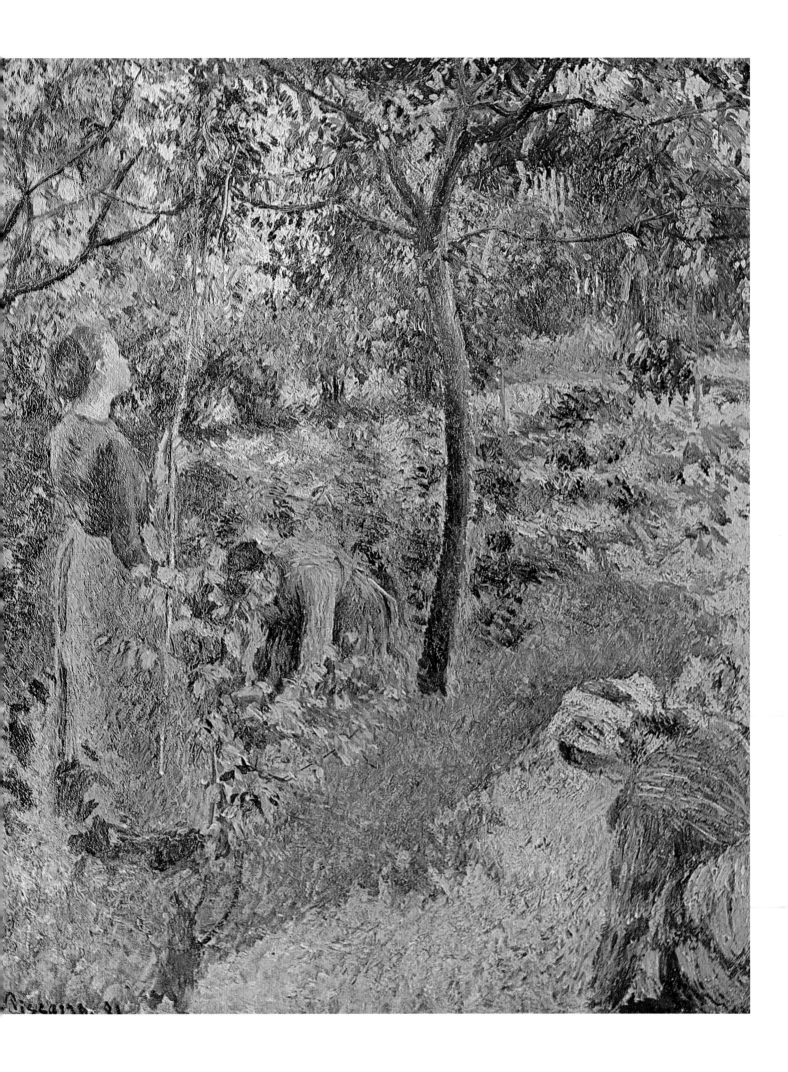

Painted 1881

YOUNG PEASANT WOMAN TAKING HER MORNING COFFEE

Oil on canvas, $25^1/_8 \times 21^3/_8{''}$

The Art Institute of Chicago (Potter Palmer Collection)

In 1883 Durand-Ruel organized an exhibition of Impressionist paintings in London which was only moderately successful. When Lucien Pissarro discussed the question of such shows with his father, the latter wrote him, in the fall of that same year:

"You tell me that I should send my best things to London, if I show there [again]. That sounds simple enough, but when one reflects and asks oneself: 'What are the best things?' one is, you may believe me, greatly perplexed. Didn't I have in London the *Peasant Woman Taking Her Morning Coffee near a Window* and the *Girl with a Stick* [page 95]? Alas, I shall never do more careful, more finished work. Nevertheless, these paintings were regarded as uncouth in London. So it is not improper selection that explains why my work offends English taste. – Remember that I have a rustic temperament, that I am melancholy, that my paintings have a harsh and savage aspect. Only in the long run can I expect to please, provided those who look at my pictures have a grain of indulgence; but the eye of the passer-by is too hasty and sees only the surface—being in a hurry, he will not stop for me! . . .

"I have just concluded my series of paintings; I look at them constantly. I who made them sometimes find them horrible. I understand them only at rare moments, a long time after having finished and lost sight of them, on days when I feel kindly disposed and fairly merciful toward their poor maker. Sometimes I am horribly afraid to turn a canvas around. I always fear to find a monster in the place of the precious gem I thought I had created! . . . Thus it does not astonish me at all that the critics in London relegate me to the lowest rank. Alas! I fear that they are only too justified. – However, at times I come across works of mine that are soundly done and truly in my style, and in such moments I really find great solace. But no more of that. Painting, art in general, enchants me. It is my life. What else matters? When you put all your soul into a work, all that is noble in you, you cannot fail to find a kindred spirit who understands you; one doesn't need legions of them. Is that not all an artist should wish for?"

PISSARRO CATALOGUE NO. 549

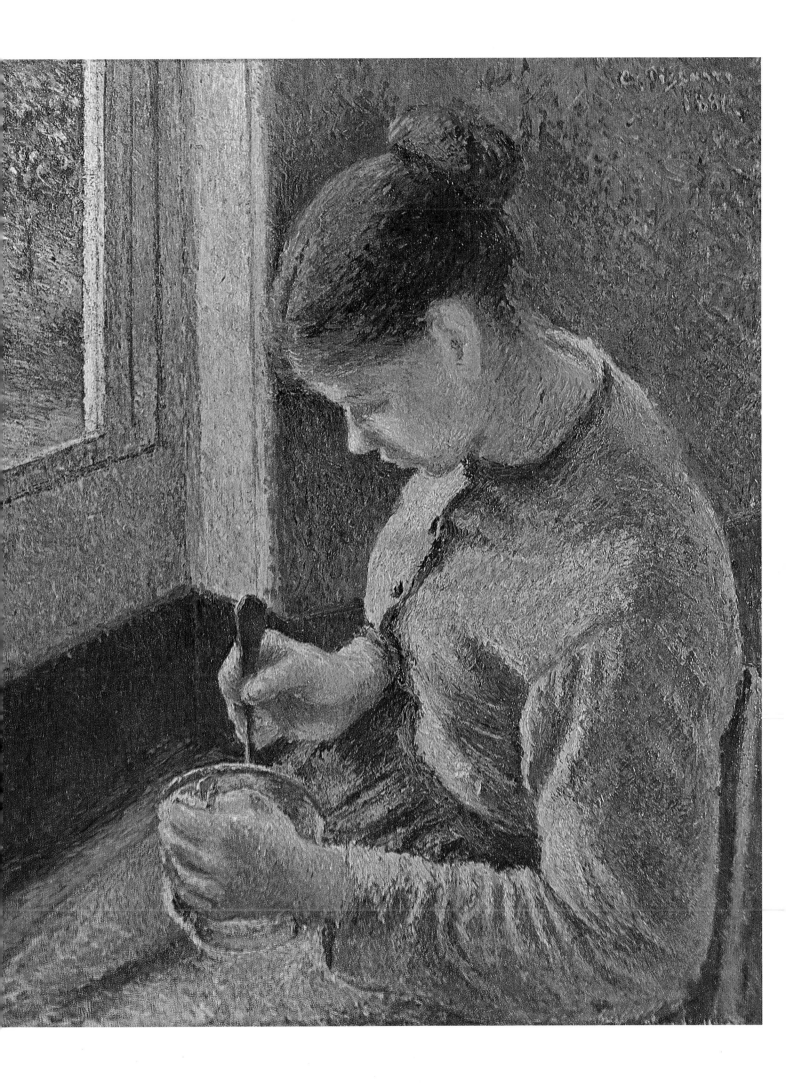

Painted 1881

PORTRAIT OF FELIX

Oil on canvas, 21³/₄ × 18¹/₄"

Reproduced by courtesy of the Trustees of the Tate Gallery, London (Bequest of Lucien Pissarro)

Like all Pissarro's portraits, this likeness of his third son, Félix-Camille, known at home as Titi, has an exquisite quality of warmth and directness. The boy was seven years old when his father painted him in an uncontrived pose, lovingly framing the little face with a dense network of small strokes that establish firmly, though without any dryness, the figure and the richly textured background.

When, in 1897, Félix died of tuberculosis at the age of twenty-three, Octave Mirbeau published a moving tribute to the boy and his father:

"I have just received sad news. One of the five sons of Camille Pissarro . . . has died. He was a very young man, almost a child, with a serious and handsome face and expressive eyes, who gave everyone hope of being one day a very great artist. More than hope—certainty! Only rarely have I met someone more gifted than he was. Ardent imagination, originality, love of great visions, and a delicate taste—it was enough that Félix wished to do something and he accomplished it immediately: oils, watercolors, etchings, woodcuts, or metal sculpture; with a rusty nail and a piece of zinc fallen from the roof, he made dry points of the most ingenious arrangements. He certainly did not yet completely possess an art that demands long and patient study, but he would have acquired it quickly. His hand was as supple and expert as was his mind, which, despite his silent attitude, was enthusiastic and lively. My confidence in Félix Pissarro's future was extreme, but nothing remains of all the beautiful dreams to which the poor child had given rise!

". . . In his great wisdom the father let his son go where he wished. He did not even try to calm his transports, which—occasionally—went beyond the models provided by nature; he knew, indeed, that age would soon enough harness these unbridled imaginings And all this is no more today!

"An admirable family, which takes us back to the heroic days of art. Surrounding an old man, still youthful and venerated, five sons, all artists, and all different! Each one follows his own nature. Their father does not impose upon them his theories, his doctrines, nor his way of seeing and feeling. He allows them to develop by themselves, encouraging them to depend on their visual sense and on their individual intelligence. . . . Everyone, whether young or old, cultivates the rarest flowers of beauty. And all this without noise, without publicity, in proud and joyous independence. Joyous? – Alas, joy doesn't last anywhere! It always contains some fissures through which tears infiltrate and flow!"

PISSARRO CATALOGUE NO. 550

102

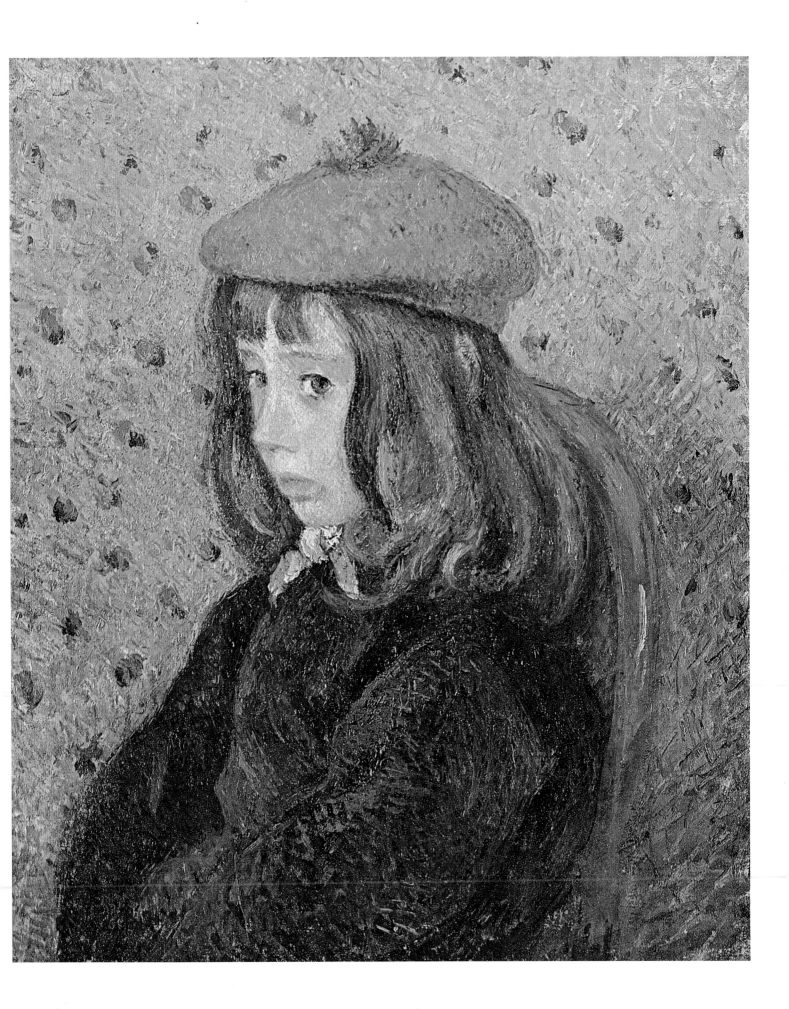

Painted 1882

WOMAN AND CHILD AT A WELL

Oil on canvas, 32×26"

The Art Institute of Chicago (Potter Palmer Collection)

As early as in the winter of 1874, while he was staying at his friend Piette's in Montfoucault, Pissarro had written to Duret: "I have started to do figures and animals. I have several genre paintings but am venturing *timidly* into this field of art, which has been distinguished by artists of the first order. It is a rather audacious undertaking in which, I fear, I shall fail completely."

Pissarro's first genre paintings, as he called them, were "timid" in so far as in most of them the human figure still played a secondary role. The animal studies he mentioned consisted mainly of landscapes in which sheep or cows were represented on a minor scale. When he subsequently began to paint larger figures, they were generally conceived as real portraits in which the artist concentrated on heads and busts while the background frequently remained neutral (see pages 93, 97, 101). But around 1881 he started to place peasants in their natural setting, as in his *Apple Pickers* (page 99), and to tackle the problem of dividing his attention equally between the scenery and the protagonists.

This composition of a woman and a child near a well is an excellent example of this new approach. Resolutely putting the verticals of the well to the left and the little girl to the far right, Pissarro let the center of the canvas remain empty, except for the glance exchanged by the two figures which establishes an invisible link between them. The horizon is kept so high that the sky can scarcely be seen; the entire space around and behind the young woman and the girl is brimming with vegetation in which, here and there, appear touches of red that repeat the color of the stones of the well, of the woman's bonnet, and of the child's hair. A few houses in the distance take up these reddish tonalities once more and at the same time, through their solid shapes, relieve the intricate maze that fills the middle ground. But most important, the artist's brush does not distinguish between these various features but treats them all with an identical technique that refuses to create any contrasts and accents other than those of color. Thus, a complete integration of all elements is achieved, the painter repeating here the very process of nature whose light is spread over everything without differentiation. PISSARRO CATALOGUE NO. 574

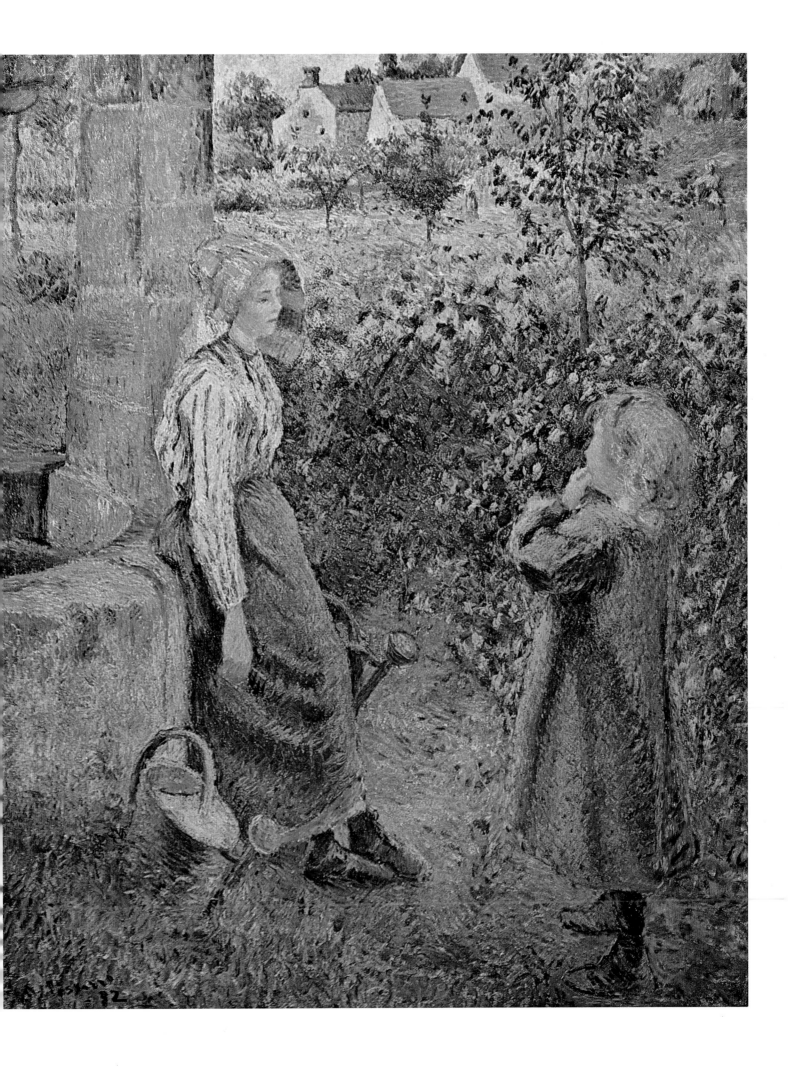

Painted 1882

THE LITTLE COUNTRY MAID

Oil on canvas, 25 × 20⁷/₈"

Reproduced by courtesy of the Trustees of the Tate Gallery, London (Bequest of Lucien Pissarro)

Just as Pissarro was now striving for a more intimate integration of large figures in his landscapes (see page 104), in the rare interiors he painted there is a similar preoccupation with blending harmoniously his models and their surroundings. But it would be difficult to say that the young maid in the center of this picture is its most salient feature, since the bright half-circle of the table at the right which leads subtly to the small child in the background, even the door and the wall, and the two chairs to the left, can rightly claim their share in the composition. As a matter of fact, every object represented has its definite place and contributes to the perfect balance of this domestic scene in which the most ordinary things play their roles as though they were actors in an elaborate production. However, for all the care with which they have been distributed in the small space of a dining room, there is no air of contrivance but rather one of the casual, to which the broom held by the girl somehow gives a final confirmation.

Late in 1882 Pissarro left Pontoise and its dampness to settle in the nearby village of Osny, farther removed from the Oise River. Here this charming interior was painted (and here Gauguin frequently came to visit and to work with the friend whom he called "professor").

Maids were always something of a problem in the Pissarro household with its irregular funds and its many children. In 1882 there were five children, ranging from Lucien, the oldest, already nineteen, to Jeanne, not yet six months (to be followed in 1884 by Paul-Emile). The youngster in the corner of this painting is Ludovic-Rodo, who had just turned four. Frequently, on his trips to Paris, which he undertook mostly to try to find buyers for his paintings, Pissarro also had to interview prospective servants, and almost as frequently his extremely demanding and hard-driving wife was dissatisfied with the "pearl" he thought he had discovered. It was certainly not an easy job to attend the children, who grew up like wild flowers (not to say like weeds), to work in the garden, to clean the house, and occasionally even to pose for the master. Yet this young girl, who seems to have submissively done all that was expected of her, thus gained a modest claim to immortality. PISSARRO CATALOGUE NO. 575

106

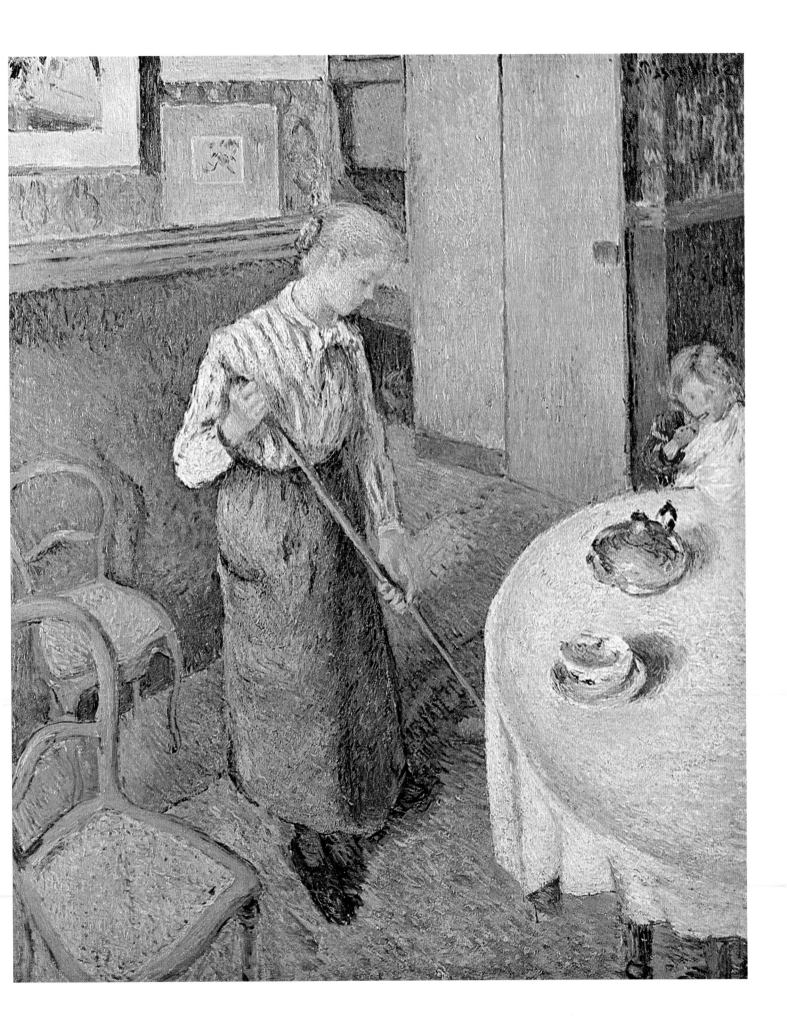

Painted 1883

THE PORK BUTCHER—MARKET SCENE

Oil on canvas, 25⁵/₈ × 21³/₈″

Reproduced by courtesy of the Trustees of the Tate Gallery, London (Bequest of Lucien Pissarro)

In 1881, Pissarro had become interested in scenes of rural markets, which he studied in Pontoise. After moving to Osny late in 1882, he continued to be preoccupied with this new subject and, in February 1883, reported to his son Lucien, who had just left for London, to try his luck there: "I do not budge from here; I work as much as I can on the landscapes I have started and on my picture, *The Market*, which I have changed completely." When bad weather prevented him from painting out of doors during the summer of that year, he turned once more to market scenes, occasionally using his niece Nini (Eugénie Estruc, daughter of his wife's sister) as a model. In July he informed his son: "I am obsessed with the desire to do certain paintings of figures, which are hard to compose with. I am doing some kind of little preparatory studies; once I have chewed the thing over sufficiently, I go to work. I had Nini pose for butchers girls . . . that will, I hope, have a certain naïve freshness. The backgrounds, there is the difficulty."

X-ray photographs of this canvas have confirmed that the composition underwent a number of changes; the woman on the right was originally shown in profile, bending to the left, and the figure in the foreground had an older head, over which the artist superimposed the features of his niece. Assembled from elements that Pissarro had studied separately rather than executed on the spot (although he had, of course, frequently observed the various aspects of markets in Pontoise), the picture is masterfully composed. The white apron of the central figure creates a solid plane in the midst of a multitude of forms and lines, and the figures detach themselves subtly from the background while remaining perfectly integrated in their lively setting.

Pissarro's fascination with this subject was such that picturesque market places became an important factor as, late in 1883, he began hunting for a new home. When he finally decided to rent a house in the village of Eragny, two hours by train from Paris, the fact that the neighboring town of Gisors boasted an interesting market was one of the reasons he settled in the region. He subsequently painted several more oils and gouaches of market scenes.

PISSARRO CATALOGUE NO. 615

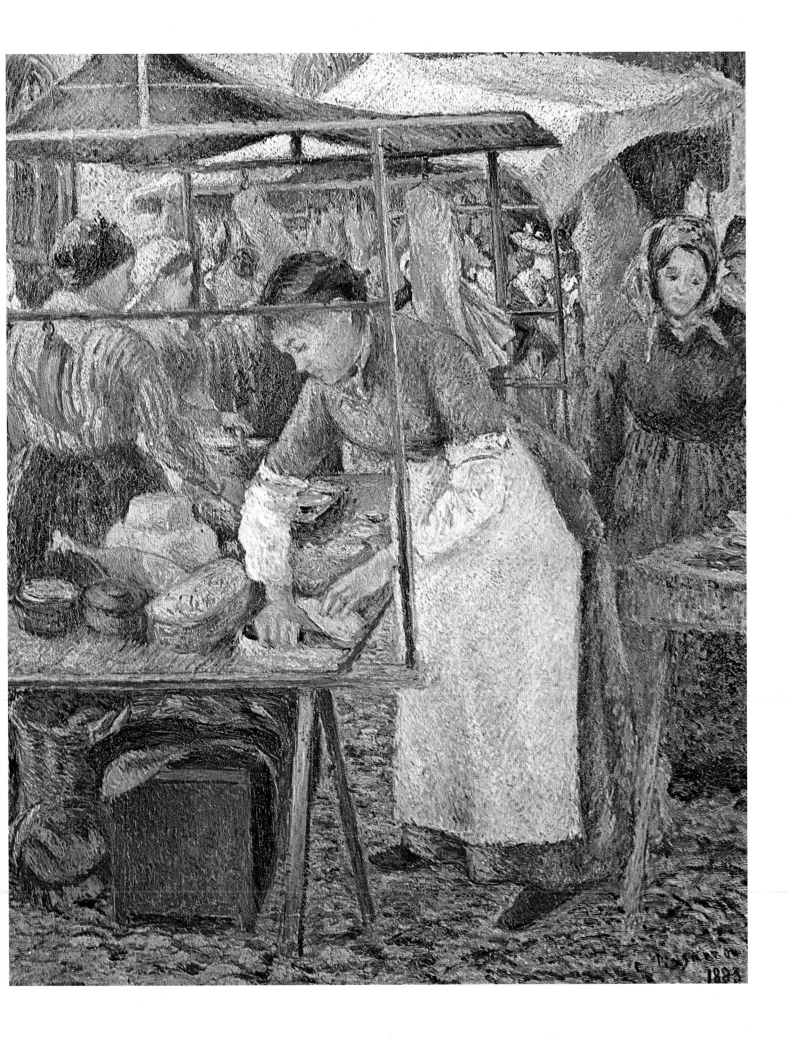

Painted 1888

RIVER—EARLY MORNING
(formerly *Ile Lacroix, Rouen—Effect of Fog*)

Oil on canvas, $18^1/_4 \times 21^7/_8''$

The John G. Johnson Collection (*Philadelphia Museum of Art*)

When Pissarro, dissatisfied with what he called the "roughness" of his execution, decided in the winter of 1885–86 to adopt Seurat's divisionist theories, he did so mainly because these enabled him to replace the "disorder" of Impressionist brush strokes with a meticulous technique of carefully posed dots. This procedure was supposed to allow the artist to reproduce more faithfully the various interactions of color on the basis of the *contraste simultané* propounded by the French scientist Chevreul. Indeed, Pissarro now referred to his former comrades as "romantic Impressionists" while he enthusiastically embraced the "scientific Impressionism" of his new friend. But this necessarily slow execution precluded all spontaneous work from nature; pictures had to be painted in the studio, since direct sensations were less important than submission to the rigors of optical laws by which each tone posed on the canvas almost automatically dictated the colors that were to surround it. No wonder that Pissarro now took up several paintings which had remained unfinished, such as a second version of his *Apple Pickers* (see page 98).

This view of the Seine at Rouen also seems to be based on an earlier work, for the artist did *not* go to Rouen in 1888, the year of its execution. The painting is closely linked to an etching from his first stay in Rouen in 1883, during which he mostly painted "pure" landscapes in the vicinity of the city and did not explore the aspects of Rouen itself.

It seems quite natural that Pissarro should have selected this subject for an application of his new technique. The pointillist execution was particularly appropriate for the effect of fog, which obliterates all distinct forms and throws an almost transparent veil over the motif; at the same time, this view provided the artist with individual features and masses—the chimney, the mast, the barge at left and the factory at right—that resist annihilation by the mist and thus constitute welcome accents, both of color and of shape, in this generally low-keyed composition. The few pronounced verticals seem to pierce the softness of the atmosphere, asserting their substance in contrast to the enveloping haze. Yet such was Pissarro's delicate eye and his long familiarity with nature, that even while using a technique he shared with Seurat and Signac, his personal vision, less rigid than Seurat's, less flamboyant than Signac's, still remains discernible.

Nevertheless, the slowness of this execution hampered Pissarro's freedom of expression to such an extent that he gave it up after a few years.

PISSARRO CATALOGUE NO. 719

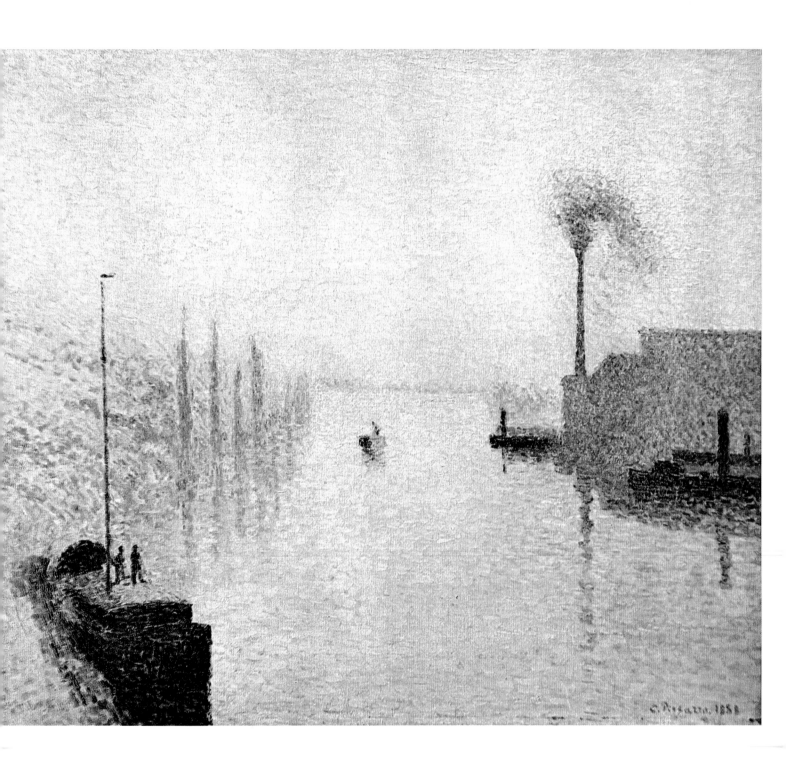

Painted 1895

BATHER IN THE WOODS

Oil on canvas, 23³/₄ × 28³/₄"

The Metropolitan Museum of Art, New York

(Bequest of Mrs. H. O. Havemeyer, 1929. The H. O. Havemeyer Collection)

Pissarro painted very few nudes. In the small rural places where he lived it was impossible for him to find models, and even had he been fortunate enough to do so, he would most certainly not have been able to pose them out of doors. Moreover, his wife frowned upon his working from the nude. Only once, Pissarro's son Lucien later remembered, was his father able to persuade an itinerant gypsy to pose, in his Eragny studio, yet the well-proportioned and lithe young girl failed to return after the first sitting. She may have been the model for the nude seen from the back that appears in one of his canvases (Pissarro Catalogue No. 936) done the same year as this *Bather in the Woods.*

In general, the series of nudes bathing outdoors singly or in groups which Pissarro did between 1894 and 1896 had to be painted from imagination, since he had long since stopped making occasional drawings from life on his trips to Paris.

The composition of this particular canvas preoccupied Pissarro. In 1894 he executed a first version, in which a dressed peasant girl washes her feet in a brook while rubbing her left leg with a small towel (Pissarro Catalogue No. 901). The following year he not only repeated the same subject (see page 42), but painted a dressed girl in his studio, pulling up her stocking, her skirt pushed over her knee (No. 935). These figure studies, although they only afforded him the perception of arms and legs, doubtless helped him prepare the painting of this nude whose pose is identical to those in the two canvases with the dressed girl dipping her feet in the water.

During his short divisionist phase Pissarro had had to work in his studio, but when he abandoned pointillism, he was anxious to paint again in the open and to revert to a more spontaneous technique. That the pigment in this canvas is so heavy and lusterless, with small touches amalgamating into a thick layer, giving it a rough surface which apparently results from a long and painful effort, would seem to be an indication that the artist found it extremely difficult to overcome divisionism and to work without actually observing what he was representing.

In those years Cézanne also dreamed of painting nudes out of doors, yet he, too, had to execute his compositions of bathers in his studio, and mostly either without models or from males who consented to pose for him. In 1896 Pissarro wrote to his son, "I am making gouaches of bathers and, for lack of a model, am posing myself." PISSARRO CATALOGUE NO. 904

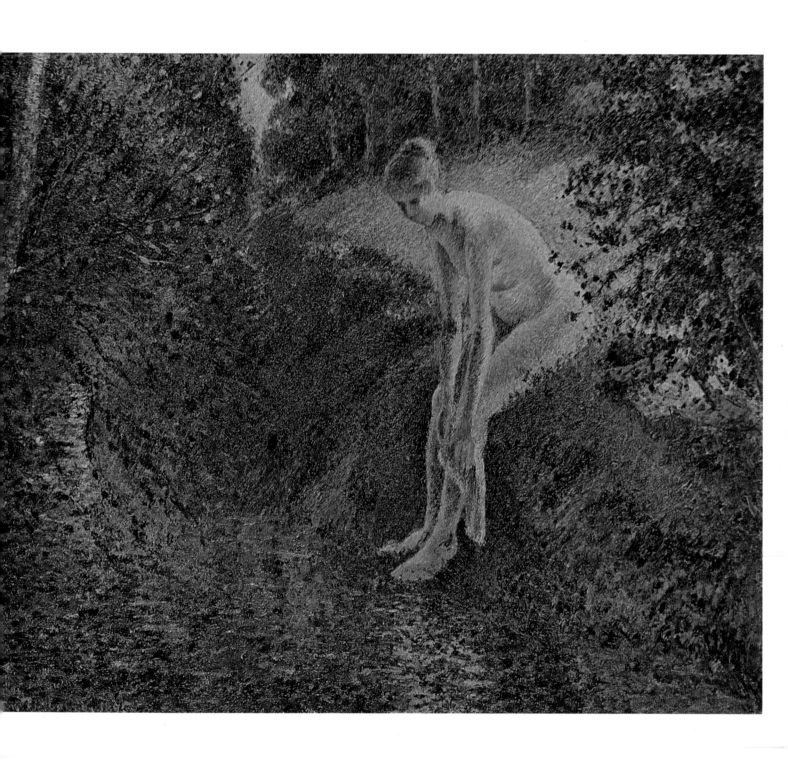

Painted 1896

ROOFS OF OLD ROUEN IN GRAY WEATHER *(The Cathedral)*

Oil on canvas, 28¹/₂ × 36″

The Toledo Museum of Art (Gift of Edward Drummond Libbey, 1951)

The story of this picture is contained entirely in a series of letters Pissarro addressed to his son Lucien in London:

Rouen, February 26, 1896: I think I shall stay here until the end of March, for I found a really exceptional motif in a room of the hotel facing north . . . ice cold, and without a fireplace. Just imagine: the whole of old Rouen seen above roofs, with the Cathedral, St.-Ouen church, and fantastic gables, really amazing turrets. Can you picture a large canvas filled with ancient, gray, worm-eaten roofs? It is extraordinary!

Rouen, March 7, 1896: I saw M. Depeaux [the Rouen collector] yesterday. . . . He confirmed the purchase of my *Roofs of Old Rouen* . . . but didn't speak to me about the price . . . and it didn't occur to me to bring this question up. Would he give me 5,000 francs? . . . He bought a Cathedral from Monet for 15,000. It seems to me such a price will seem fair enough to him.

Rouen, March 17, 1896: Did I write you that the brother-in-law of M. Depeaux came to see my pictures, found them superb and was anxious to have one of the best? I was timid, I asked for 4,000 francs. He offered 3,000, which I rejected. . . . I don't know whether Depeaux will accept my price; so much the worse for him if he doesn't, I feel like keeping the *Roofs of Old Rouen* for us. I don't want to show it on account of Monet's Cathedrals; I am afraid it isn't good enough to stand the comparison, although it is quite different. You know how much backbiting is going on. [Pissarro had worked in Rouen since 1883, some ten years before Monet had begun his paintings of the Cathedral; Monet's series had attracted great attention when shown in Paris by Durand-Ruel in 1895 and Pissarro obviously did not wish to be accused of imitating his friend.]

Rouen, March 24, 1896: You will remember that the Cathedrals of Monet were all done with a veiled effect that, by the way, gave a certain mysterious charm to the edifice. My *Roofs of Old Rouen* with the Cathedral in the background was done in gray weather, everything being clearly outlined against the sky. I liked it well enough; it pleased me to see the Cathedral firm, gray, and clear under a uniform sky in wet weather. Well, Depeaux doesn't care for the sky!

Rouen, March 28, 1896: At this moment I am packing my canvases without having seen my collector Depeaux.

Rouen, April 4, 1896: I am leaving for Eragny this morning to retouch and send off my pictures to Durand-Ruel. I am very apprehensive. . . . I hope that once framed and hung they will produce a better effect.

Eragny, April 8, 1896: Arsène Alexandre [the critic] came Monday to see my pictures. He found my *Roofs of Old Rouen* very beautiful and was very insistent that I exhibit it. I decided to do so. And what the deuce, it is so different from Monet that I hope my comrades will not regard me as spiteful for showing it.

Paris, April 16, 1896: All my friends say the exhibition is very beautiful. Degas told me that no matter what the "great masters" of the young generation, who treat us as dolts, say, we still have the upper hand. . . . I have reserved the *Roofs of Old Rouen* for myself. In my opinion, in that of Degas, etc., it is the outstanding work. I don't understand how I was able to get this completely gray picture to hold together! Now Camondo wants to have it. . . . I expect to ask 10,000 francs or keep it. Depeaux could have had it for 4,000, but hesitated. He won't get it. [Camondo did not get it either. Pissarro kept the painting.]

PISSARRO CATALOGUE NO. 973

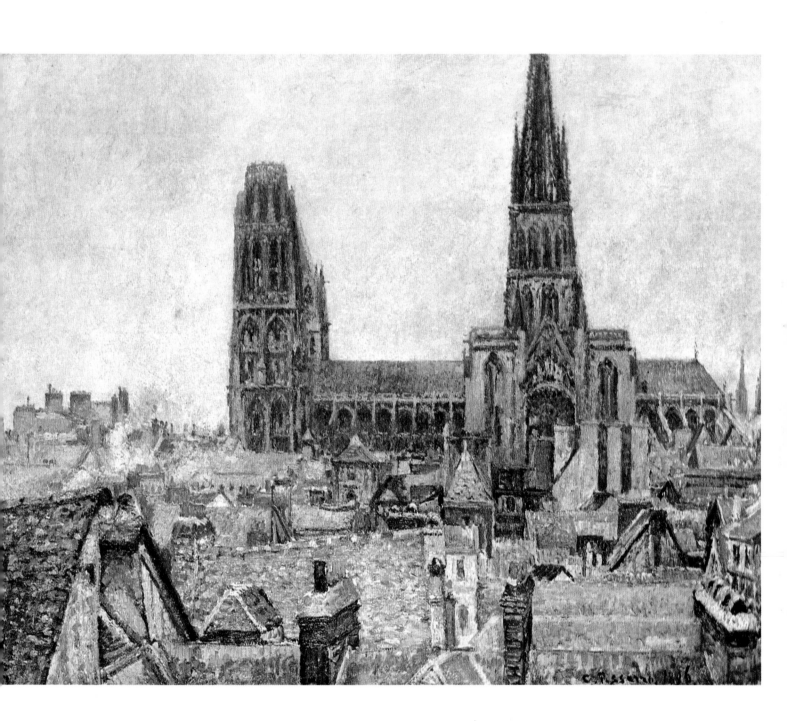

Painted 1896

THE YOUNG MAID

Oil on canvas, 24×19⁵/₈″

Collection David Bensusan Butt, London

Unlike Pissarro's previous canvas of a similar subject (page 107), this composition has been stripped of all incidental objects, so that the attention is focused on the young girl shyly standing in the doorway. An armchair that originally occupied the lower left corner has been painted over in order to leave a straight panel and to enhance through the rhythm of unbroken verticals and plain surfaces the impact of the lone figure. Pissarro could treat the same subject repeatedly, since each time he subtly altered the compositional elements and shifted the viewpoint, constantly renewing the artistic problems with which he dealt so masterfully. The cluttered interior of which the little maid with the broom had been merely one feature among others has here been changed into a practically bare room. This very bareness constitutes a fascinating frame for the young woman, the more attractive because there are various planes, a perspective, and a source of light in the distance, so that despite the large surfaces of the backdrop, the space is alive and the figure is perfectly integrated in it.

Pissarro was sufficiently pleased with this painting to include it in his exhibition of 1896, in which he also showed his recent views of Rouen. This show met with considerable success, attesting as it did to the adventurous mind and freshness of vision of the artist who was now close to sixty.

"Camille Pissarro," commented Gustave Geffroy, ". . . is above all a poet of the intimate; he extols the delights that surround us, the sweetness of life that he can savor at home, at his door, in the yard, in the garden. He does not feel the need to go very far to discover the decor of happiness. He knows that everywhere light visits all things, endows them with splendor or softness, reveals them with liveliness to our eyes and our spirit."

And two years later the same writer was to say: "There is something altogether touching and beautiful which distinguishes this artist, that is the example of his perpetual renewal. At bottom, all criticism has to do is demonstrate the deficiency of those who, having found a semblance of personal style and the surprise of success, cease to observe, to think, to work, in order to devote their efforts to the poor imitation of themselves. . . . Camille Pissarro is very far from those imperturbable painters. As on the first day, he is anxious to know, he has the faith and the ardor, and a beautiful desire to realize the admirable spectacles that enchant him!" PISSARRO CATALOGUE NO. 943

116

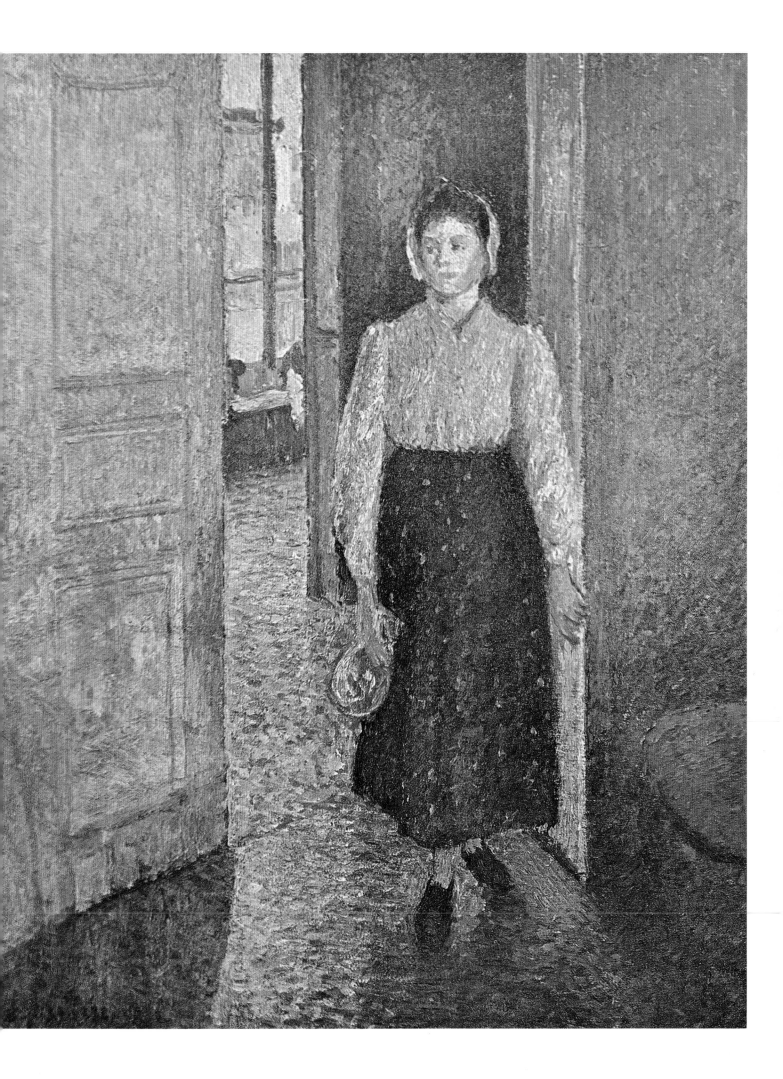

BOULEVARD DES ITALIENS, PARIS— MORNING SUNLIGHT

Oil on canvas, 28⁷/₈×36¹/₄″

National Gallery of Art, Washington, D. C. (Chester Dale Collection)

The year after his series of Rouen, Pissarro decided to explore the busy Parisian boulevards. He had already painted a few street scenes of Paris in 1893, but it was in 1897 that he began to work on a great number of views from the windows of various hotels. His dealer, Durand-Ruel, approved of the projects, and the artist informed his son Lucien in February: "A series of the boulevards seems to him a good idea, and it will amuse me to overcome the difficulties. I have engaged a large room at the Grand Hôtel de Russie, 1 Rue Drouot, from which I can see the whole sweep of boulevards." Some time later Pissarro reported with satisfaction: "My pictures are progressing, but certain effects are holding me back. In two months I have set fourteen paintings on my easel and fairly well developed all of them; I have even fifteen . . . and you know, they have been thoroughly worked. . . . I paint only two hours in the morning and two in the evening . . . even less sometimes."

It was while working on this series that Pissarro explained how he proceeded, by giving the following advice to a young painter, Louis Le Bail: "The motif should be observed more for shapes and colors than for drawing. There is no need to tighten the form, which can be obtained without that. Precise drawing is dry and hampers the impression of the whole; it destroys all sensations. Do not insist on the outlines of objects; it is the brush stroke of the right value and color which should produce the drawing. In a mass, the greatest difficulty is not to establish a minute contour but to paint what is within. – Don't work bit by bit, but paint everything at once by placing tones everywhere. . . . The eye should not be fixed on a particular point but should take in everything, while simultaneously observing the reflections that the colors produce on their surroundings. Keep everything going on an equal basis; use small brush strokes and try to put down your perceptions immediately. Do not proceed according to rules and principles, but paint what you observe and feel."

Pissarro's lively and yet tightly knit image of the Boulevard des Italiens is an excellent example of the way in which he put these concepts into practice.

PISSARRO CATALOGUE NO. 1000

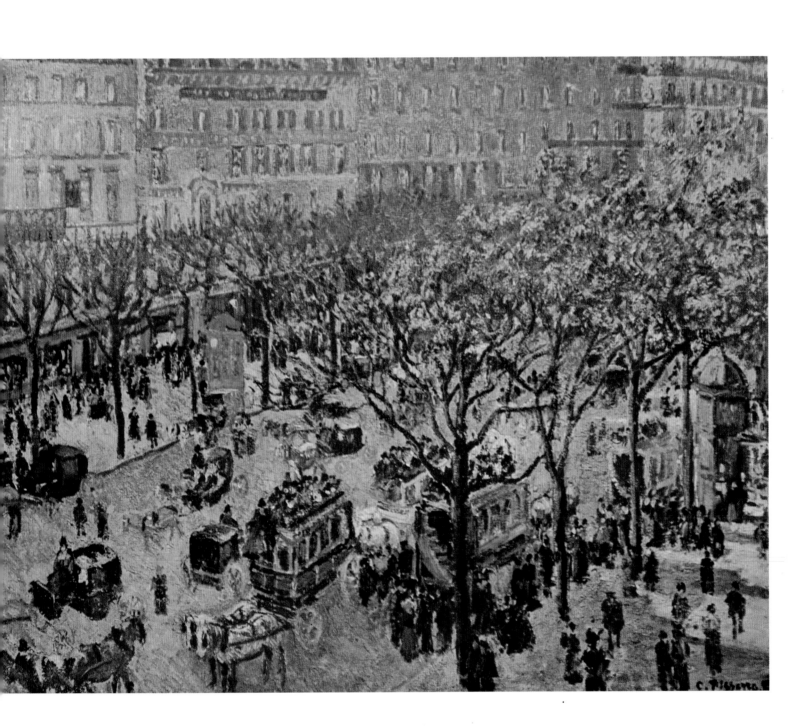

Painted 1898

PLACE DU THEATRE FRANÇAIS, PARIS, IN THE RAIN *(Avenue de l'Opéra)*

Oil on canvas, 28³/₄×36¹/₄″

The Minneapolis Institute of Arts (William Hood Dunwoody Fund, 1918)

Toward the end of 1897, shortly after the death of his young son Félix (see page 103), Pissarro apparently felt that work was his only distraction and decided to undertake a new "series." Those were extremely trying days, for he not only mourned a cherished child but was worried about the health of Lucien, who had been seriously ill, and—if this were not enough—there was also the Dreyfus affair whose ugly implications did not fail to concern him. Yet it was almost with cheerfulness that in December of that year he informed Lucien: "I found a room in the Grand Hôtel du Louvre with a superb view of the Avenue de l'Opéra and the corner of the Place du Palais Royal [Théâtre Français]! It is very beautiful to paint! Perhaps it is not really aesthetic, but I am delighted to be able to try to do these Parisian streets which people usually call ugly, but which are so silvery, so luminous, and so vital. They are altogether different from the boulevards. This is completely modern! My show will be in April."

Pissarro painted a few views from his window before the year was over and —after a holiday season overshadowed by grief—returned early in January 1898 to paint thirteen more pictures, many of them large. They were finished by April 11 and exhibited by Durand-Ruel in June, the show having obviously been delayed by the ardor with which the artist had undertaken his new task.

Unlike Monet who, in his "series," worked successively on a great number of canvases, each showing the same subject at a different instant, the painter following methodically the incessant changes his motif underwent throughout a single day, Pissarro was not interested in the systematic exploration of one subject under various conditions. On the contrary, he endeavored to vary his point of view, sometimes glancing farther to the left or to the right, placing the Avenue de l'Opéra symmetrically in the center of his picture or, as is the case here, counterbalancing its wide sweep by the massive structure of the Théâtre Français to the right. Occasionally he even concentrated on the pavement beneath his window for "close-ups" of the traffic or of blooming trees (page 44). He also selected a wide range of atmospheric conditions: snow, rain, winter sun in the morning or in the afternoon, and finally spring. While for Monet, each painting had represented a fleeting phase among many other fleeting phases, Pissarro strove to put down a variety of aspects in such a way that each would provide a completely self-sufficient composition.　　　　PISSARRO CATALOGUE NO. 1030

120

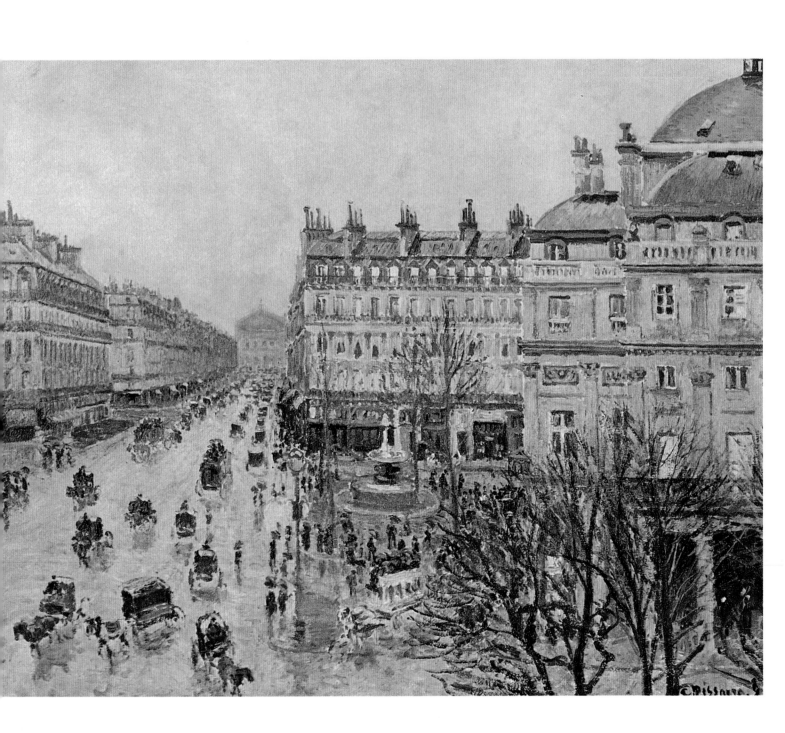

Painted 1898

RUE DE L'EPICERIE, ROUEN—
MORNING, GRAY WEATHER

Oil on canvas, 31⁷/₈ × 25⁵/₈"

Metropolitan Museum of Art, New York. Purchase. Mr. and Mrs. Richard J. Bernhard Gift, 1960

In August 1898 Pissarro was back in Rouen for a two months stay. Despite the assiduity with which he had worked there on various occasions, the city did not seem to lose its attraction for him. This time he painted another series of views of the harbor quays and the bridges, as well as a few "pure" landscapes of the banks of the Seine, and also discovered an entirely new motif to which he devoted three canvases: the ancient Rue de l'Epicerie leading toward the Cathedral whose Gothic towers dominate the huddled roofs of numerous small houses.

Whereas his recent views of the Avenue de l'Opéra had been mostly "silvery" (to use his own word), this narrow street provided Pissarro with an opportunity to ally vivid colors with the many-faceted planes of his architectural motif: red and blue roofs, white, brownish, and yellowish walls, dark store façades, bright awnings, and even a cluster of multicolored posters. Here and there are a few small figures whose silhouettes help define the empty space of the foreground. With astonishing mastery he has managed to treat, through accords and oppositions of colors, a subject that is primarily composed of lines and cubes. Without neglecting any feature, he has nevertheless completely integrated every last gable, window, lantern, and chimney into a composition ample and strong enough to assert itself above its multiple components. While Monet frequently used an over-all effect of softening light to obtain the unity of his pictures, Pissarro achieved this unity without sacrificing any details to the enveloping atmosphere.

As Pissarro was to explain a few years later: "I see only spots of color. When I begin a painting, the first thing I try to put down is the accord. Between sky and ground . . . there is necessarily a relationship. It can only be a relation of accords, and there lies the great difficulty of painting. What interests me less and less in my art is the material side of painting, the lines. The big problem to be solved is to submit everything, even the slightest details of a picture, to the over-all harmony, that is, to the accord."

That Pissarro should have painted during his last years so many views of city streets and of monuments despite his weariness of linear structure, seems both a challenge and a miracle; a challenge that his youthful spirit met resolutely, and a miracle that his lifelong experience and constantly renewed vision helped him to perform superbly. PISSARRO CATALOGUE NO. 1037

122

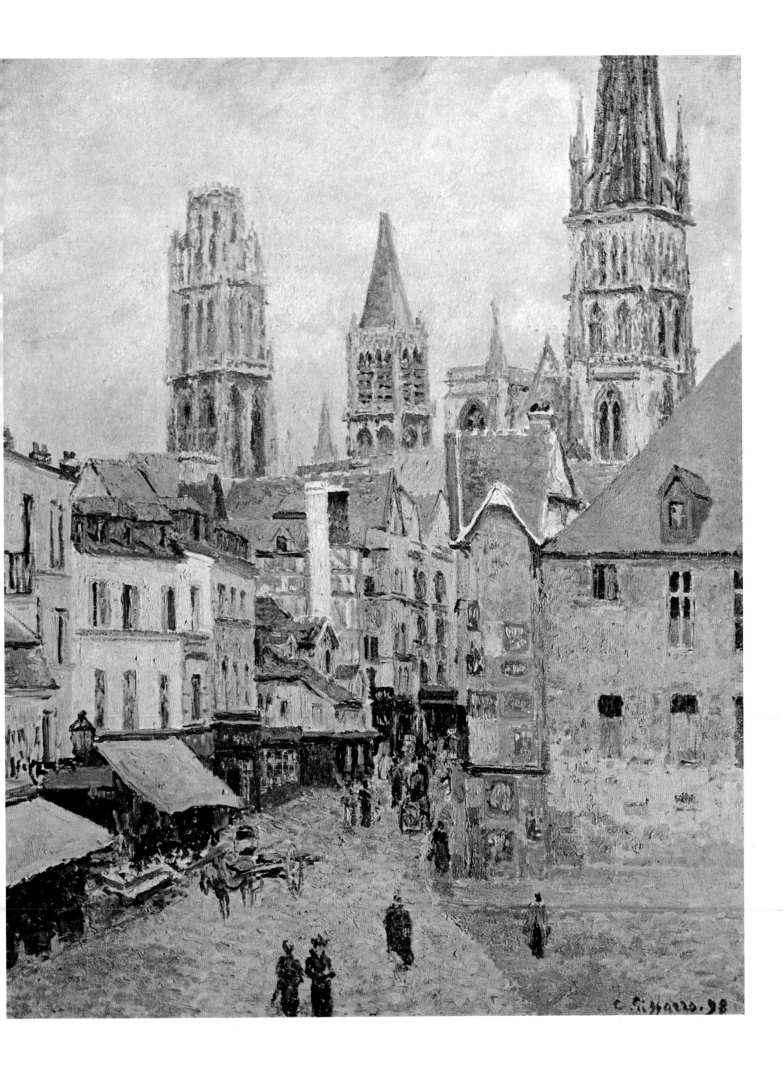

THE SEINE AND THE PONT DES ARTS, PARIS

Oil on canvas, 18¹/₈ × 21⁵/₈"

Kunstmuseum, Basel (R. Staechelin Foundation)

Having found it difficult to live and work in hotel rooms, in January 1899 Pissarro finally rented an apartment on the Rue de Rivoli where his wife and younger children could be with him while he devoted himself to yet another series of Parisian landscapes: the Tuileries Gardens and the Louvre. He painted these intermittently until the summer of 1900. Later that year he moved to another location, 28 Place Dauphine, on the second floor of the historic "maison de Mme Roland," one of the quaint houses on the Île de la Cité which border the Pont Neuf, with an incomparable view of the two aisles of the old bridge, the verdure of the tip of the island (the so-called Vert-Galant with the statue of Henri IV), the Seine, the Pont des Arts, and the façade of the Louvre running parallel to the river. Wherever his eyes turned, they discovered splendid vistas, open spaces, grandiose architecture, lively traffic, or broad expanses of water. Never had he been presented with such a diversified choice of enticing motifs, unfolding around a single spot. The result was an almost staggering number of canvases in which Pissarro, now past seventy, explored these new subjects; there are at least thirty paintings of the Seine and the perspective of the Louvre executed between 1900 and 1903, showing them in various forms and under different conditions. Besides these, there are two dozen other works representing the Pont Neuf, the Vert-Galant, etc.

As his young admirer, Georges Lecomte, later wrote, the artist "could be perceived from morning to evening—for he worked without respite and with joy, or better still, naturally, as one breathes . . . at his open window or behind the glass panes with curtains raised, depending on the season and the temperature—before his easel, his palette in hand, a beret on his head, his glance quick but calm. . . . The passers-by who, accidentally, raised their eyes toward Camille Pissarro had no idea that this old man with the long, white beard whom, from dawn to dusk, one saw at his task, attending only to his work, was one of the greatest original painters of our time."

Fired by the magnitude and beauty of his subjects, Pissarro infused his views from the Pont Neuf with such delicacy and liveliness, such a superb mixture of intimate observation and broad execution, that they found grace even before his critical eyes. "These pictures are the best I have made," he admitted.

PISSARRO CATALOGUE NO. 1160

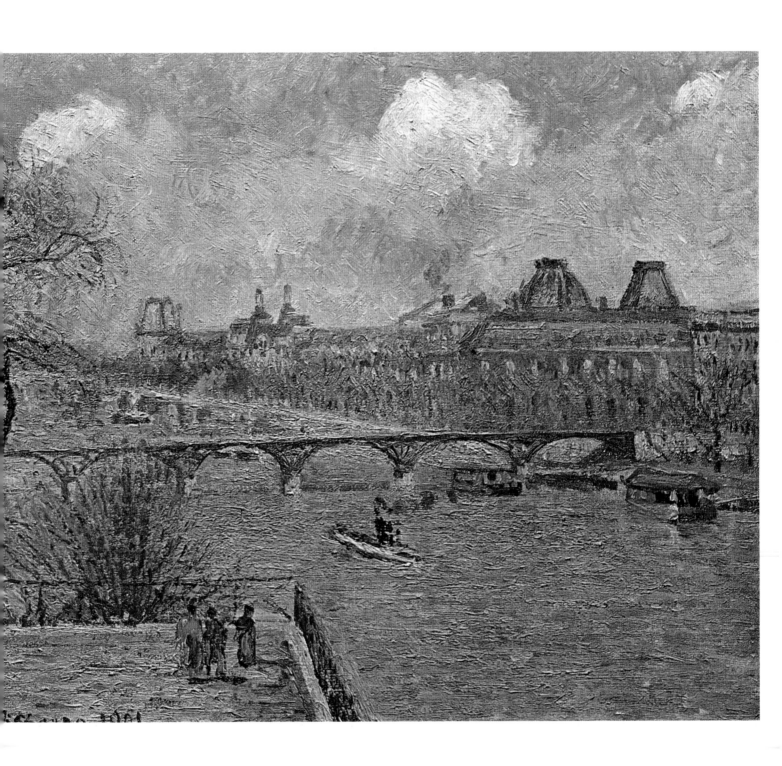

THE PONT ROYAL AND THE PAVILLON DE FLORE, PARIS

Oil on canvas, 21 × 25⁵/₈"

Musée du Petit Palais, Paris

Having finally exhausted the views from his apartment near the Pont Neuf, Pissarro, in March 1903, temporarily crossed the bridge to the Left Bank, where he rented a room at the Hôtel du Quai Voltaire (he planned to move in the fall to new lodgings on the Boulevard Moreland, for still another series of Paris views). From his room at the hotel he saw, to the right, the Seine quay with the cupola of the Institut de France in the distance, and to the left, the Pont Royal and the extremity of the Louvre complex with the Pavillon de Flore. "Superb motifs of light!" he exclaimed in a letter to Lucien.

The paintings Pissarro did from this new location show colors and brushwork that are quite different from his previous canvases. The colorations appear softer, more akin to pastel tones, the strokes are broader, more heavy with pigment, so that they fuse readily, at the same time providing an uneven texture. From under a sweeping brush that proceeds with great deftness there emerges a surface that is both thick and wonderfully rich in nuances. This new departure is yet another sign of the vitality of a man ready to evolve new techniques when his subjects inspire him to do so.

Many of his last pictures are among the finest Pissarro created, making a worthy finale to his long and varied career. Nothing betrays his age and his suffering, nor the need and scorn he had known for several decades. If anything, his love for nature, his capacity for emotion, and his technical proficiency seem to have increased with the years; everything is fresh, painted so originally and felt with such enthusiasm, such optimism, and youthfulness that it inspires veneration.

Pissarro reached his last apartment in Paris but not to paint anymore, only to die there of blood poisoning, in November 1903. When, four years after his death, his widow complained that even some of his former friends now considered him "old-fashioned" (the Fauve movement had come to the fore and Picasso had just painted his *Demoiselles d'Avignon*), her son Lucien comforted her:

"Don't worry about father, *he will never be forgotten*. Like Corot and Millet, when he does come up, it will be for good. Father is, among all the Impressionists, the man who represents the nineteenth century most significantly. His philosophy, which you know so well, can be perceived in his art. . . . So don't worry, dear mother, his day will come. It will be a day of glory, I assure you."

PISSARRO CATALOGUE NO. 1286

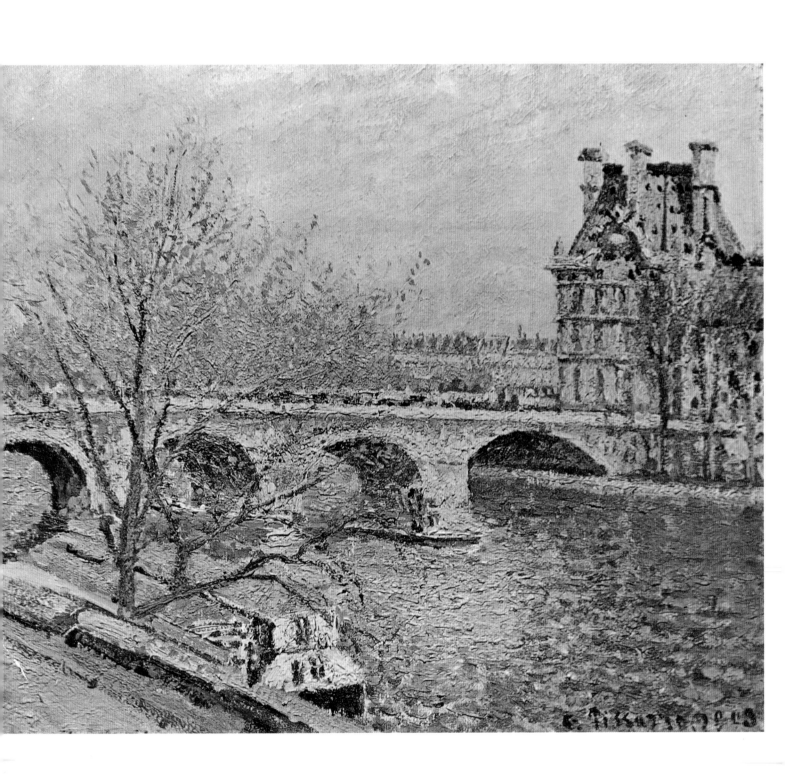

SELECTED BIBLIOGRAPHY

For a more comprehensive, annotated listing, the reader is directed to the bibliography in the author's *History of Impressionism*, rev. ed., New York, The Museum of Modern Art, 1961, pp. 608ff.

GENERAL WORKS

BORGMEYER, C. L. *The Master Impressionists*. Chicago: Fine Arts Press, 1913.

DEWHURST, W. *Impressionist Painting, Its Genesis and Development*. London: G. Newnes, 1904.

DURET, T. *Critique d'avant-garde*. Paris 1885; Duret, *Peintres impressionnistes*, Paris, 1923.

DURET, T. *Manet and the French Impressionists*. London: G. Richards; Philadelphia: J. B. Lippincott, 1910.

GEFFROY, G. *Histoire de l'impressionnisme* (La Vie artistique, 3rd series). Paris: E. Dentu, 1894.

HAMERTON, P. G. *The Present State of the Fine Arts in France*. London, 1892.

HUYSMANS, J.-K. *L'Art moderne*. Paris, 1883.

LECOMTE, G. *L'Art impressionniste, d'après la collection privée de M. Durand-Ruel*. Paris: Chamerot et Renouard, 1892.

MAUCLAIR, C. *The Great French Painters and the Evolution of French Painting from 1830 to the Present Day*. New York: E. P. Dutton, 1903. Reprinted as Mauclair, *The French Impressionists (1860–1900)*, London. 1911.

MEIER-GRAEFE, J. *The Development of Modern Art, Being a Contribution to a New System of Aesthetics*. 2 vols. London: W. Heinemann, 1908.

REWALD, J. *The History of Impressionism*. New York: The Museum of Modern Art, 1946; 1955; rev. and enlarged ed., 1961.

REWALD, J. *Post-Impressionism—From van Gogh to Gauguin*. New York: The Museum of Modern Art, 1956.

SIGNAC, P. *D'Eugène Delacroix au néo-impressionnisme*. Paris: Revue Blanche, 1899.

VENTURI, L. *Les Archives de l'impressionnisme*. 2 vols. Paris-New York: Durand-Ruel, 1939.

WILENSKI, R. H. *Modern French Painters*. New York: Reynal & Hitchcock, 1940.

THE ARTIST'S OWN WRITINGS

BAILLY-HERZBERG, J., ed. *Corréspondance de Camille Pissarro: 1865 - Vol. I*. Paris: Presses Universitaires de France, 1980.

BAILLY-HERZBERG, J., ed. *Corréspondance de Camille Pissarro: 1886–1890 Vol. II*. Paris: Editions du Valhermeil, 1986.

BAILLY-HERZBERG, J., ed. *Corréspondance de Camille Pissarro: 1891–1894 Vol. III*. Paris: Editions du Valhermeil, 1988.

Camille Pissarro: Letters to His Son Lucien. Ed. with the assistance of Lucien Pissarro by John Rewald. New York: Pantheon Books, 1943. French ed., Paris, 1950.

WITNESS ACCOUNTS

BAILLY-HERZBERG, J., ed. *Mon cher Pissarro: Lettres de Ludovic Piette a Camille Pissarro*. Paris: Editions du Valhermeil, 1985.

LECOMTE, G. *Camille Pissarro*. Paris: Bernheim-Jeune, 1922.

MEADMORE, W. S. *Lucien Pissarro, Un cœur simple*. London: Constable, 1962.

MIRBEAU, O. "Famille d'artistes," *Le Journal*, December 6, 1867. Reprinted in Mirbeau, *Des Artistes*, Paris, 1924, vol. II, pp. 39–45.

OEUVRE CATALOGUES

BRETTELL, R. and LLOYD, C. *Catalogue of the Drawings by Camille Pissarro in the Ashmolean Museum, Oxford*. Oxford: Clarendon Press, 1980.

DELTEIL, L. *Le Peintre-graveur illustré*, vol. XVII, *Camille Pissarro, Alfred Sisley, Auguste Renoir*. Paris: Printed for the author, 1923.

Pissarro exhibition. Catalogue with contributions by: J. Rewald, R. Brettell, C. Lloyd, A. Distel, F. Cachin, J. Bailly-Herzberg, B. Stern Shapiro. The Arts Council of Great Britain, 1980.

PISSARRO, L. R. and VENTURI, L. *Camille Pissarro: Son art—son œuvre*. 2 vols. Paris: P. Rosenberg, 1939.

BIOGRAPHIES

ADLER, K. *Camille Pissarro: A Biography*. New York: St. Martin's Press, 1977.

SHIKES, R. E. and HARPER, P. *Pissarro: His Life and Work*. New York: Horizon Press, 1980.

TABARANT, A. *Pissarro*. New York: Dodd, Mead and Co., 1925.

STUDIES OF STYLE

BROWN, R. F. "Impressionist Technique: Pissarro's Optical Mixture," *Magazine of Art*, XLIII, January 1950, pp. 12–15.

LLOYD, C. *Camille Pissarro*. New York: Rizzoli International Publications, Inc., 1981.

MIRBEAU, O. "Camille Pissarro," *L'Art dans les deux mondes*, January 10, 1891, pp. 83–84.

MIRBEAU, O. "Camille Pissarro," *Le Figaro*. February 1, 1892. Reprinted in Mirbeau, *Des Artistes*. Paris, 1922, vol. I, pp. 145–53.

NICOLSON, B. "The Anarchism of Pissarro," *The Arts* (London), No. 2, 1946, pp. 43–51.

REWALD, J. "Camille Pissarro, His Work and Influence," *Burlington Magazine*, LXXII, June 1938, pp. 280–91.

RODO, L. [LUDOVIC-RODO PISSARRO]. "The Etched and Lithographed Work of Camille Pissarro," *The Print Collector's Quarterly*, IX, October 1922, pp. 274–301.

REPRODUCTIONS

FRANCASTEL, P. *Monet, Sisley, Pissarro* (Masterpieces of French Painting. XIX Century). Paris: A. Skira, 1939.

JEDLICKA, G. *Pissarro*. Bern: Scherz, 1950.

KUNSTLER, C. *Camille Pissarro* (Collection "Les Artistes nouveaux"). Paris: G. Crès & Cie., 1930.

LLOYD, C., ed. *Studies on Camille Pissarro*. With Contributions by: L. Nochlin, J. House, R. Shikes, M. Reid, A. Distel, C. Lloyd, F. Cachin, K. Adler, M. Melot, B. Shapiro. London: Routledge & Kegan Paul Ltd., 1986.

REWALD, J. *Camille Pissarro at the Musée du Louvre*. Paris-Brussels: The Marion Press, 1939.